T0284797

1

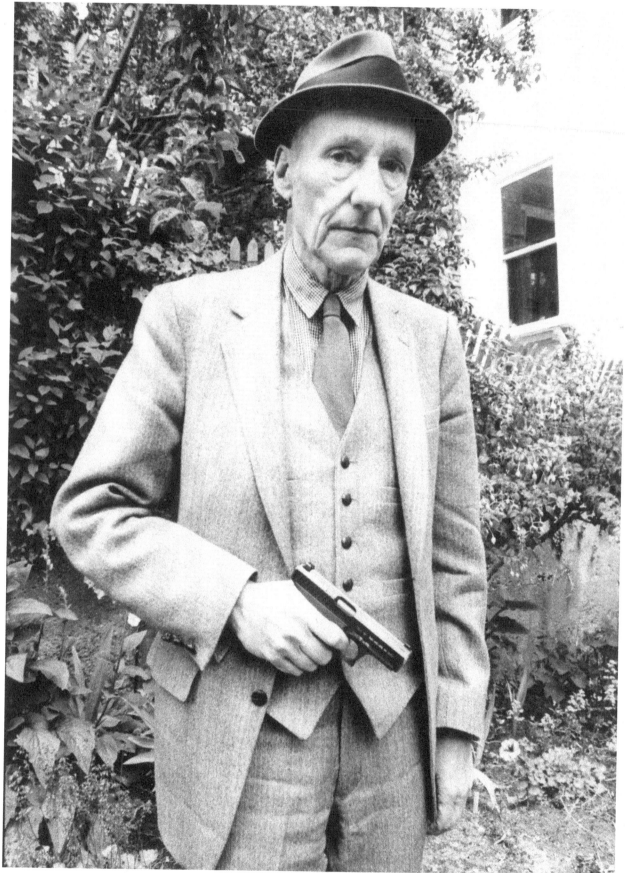

William S. Burroughs in a San Francisco garden.

# RE/Search #4/5

**A SPECIAL BOOK ISSUE**
**WILLIAM S. BURROUGHS, BRION GYSIN AND THROBBING GRISTLE**

**EDITOR**
V. Vale

**PUBLISHER**
RE/Search Publications

**1979 STAFF**
Francisco Mattos
Enrico Chandoha
Paul Mavrides
Mindaugis Bagdon
Ruby Ray
Stanislaw Sobolewski

**2018 STAFF**
Marian Wallace
Francisco Mattos
Robert Collison

**CONTRIBUTORS**
Antony Balch
Lynda Burdick
Ulrich Hillebrand
Brian Beresford
Suzan Carson!
Rieko
Terry Wilson
Simon Dwyer
Charles Gatewood
Ruth Brinker
Stan Bingo
Jon Savage
Michael Granros
Clay Holden
David Brooks
and Tom

**SPECIAL THANKS**
Betty Thomas, James Grauerholz
and Scott Summerville

**COVER PHOTO**
Ruby Ray

## WILLIAM S. BURROUGHS

## BRION GYSIN

## THROBBING GRISTLE

RE/Search Publications
20 Romolo #B, San Francisco CA 94133
TEL: (415) 362-1465
info@researchpubs.com
http://www.researchpubs.com

BOOKSTORE DISTRIBUTION:
PGW/Ingram

NON-BOOKSTORE DISTRIBUTION:
contact us directly

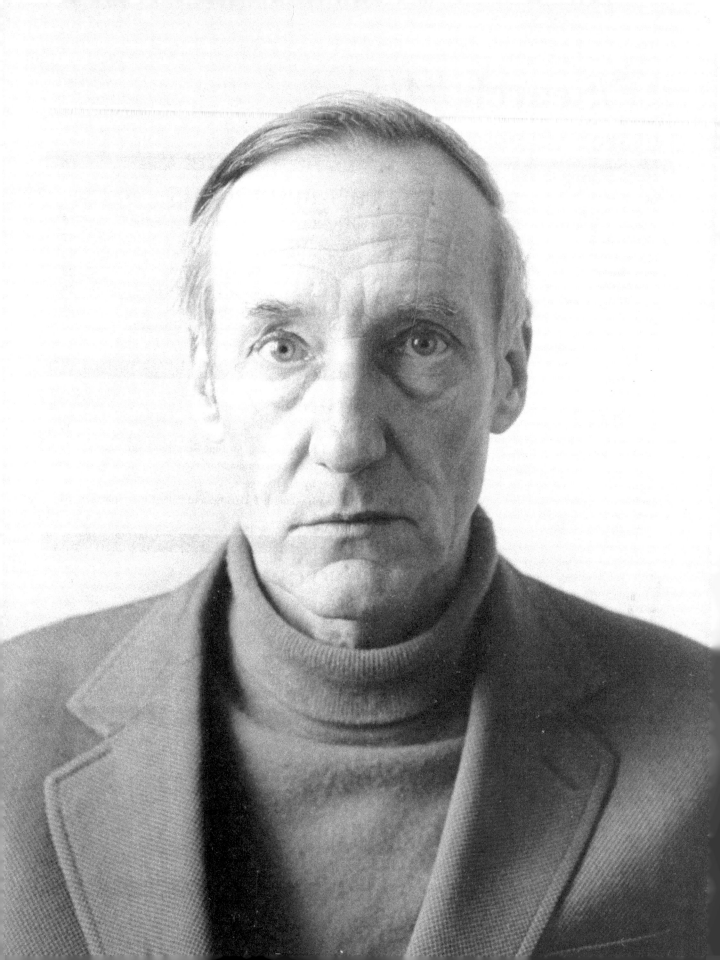

# THE REVISED BOY SCOUT MANUAL

A transcript from *The Revised Boy Scout Manual*, a novel in the form of three one-hour cassettes. Copyright 1970 by William S. Burroughs. Our thanks to W.S.B. and James Grauerholz for permission to excerpt...

(bought in '23)

## REVOLUTIONARY WEAPONS AND TACTICS

Since World War I, revolutionary weapons and tactics have undergone a biologic mutation to survive the invention of heavy weapons. Anyone can make a sword, a spear, a bow and arrow in his basement or spare room workshop. He can make some approximation of a small arm. He *cannot* make automatic weapons, tanks, bombers, fighter planes, destroyers, artillery. These heavy weapons are in the hands of reactionary forces, which give them an overwhelming advantage in direct combat. With heavy weapons, five percent of the population can hold down ninety-five percent by sheer force. This advantage, which did not exist before heavy weapons, must now be taken into account.

A belated development to be sure. The stupidity of the military mind is unbelievable. Towards the end of the Civil War in the States, a crude machine gun and a crude tank were rejected by President Lincoln's military advisors as *impractical*. Now these weapons were primitive to be sure, but quite usable, and all the elements were there. In World War II, General Gamelin thought that tanks were unimportant, until they poured around the end of his Maginot Line. General Gamelin did not like tanks.

So, plinking around the streets with a Beretta .25 is little to the purpose. And still less a Colt Army .45, a handgun so inaccurate it is more dangerous to friend than enemy—your friends being closer to it. It is a very *myopic* handgun. Bombs in the post office and the police stations—

(PHOTO ON LEFT PAGE) CHARLES GATEWOOD

what is this, the IRA in 1916? Blow up the Statue of Liberty would you? Have you any idea how much good gelignite it would take to explode that old beast? The same explosive material, discreetly placed, could bring down the economic system of the West. The Boy Scout Manual will show you how...

The extent to which revolutionary theory and tactics is disadvantageously shaped by *opposition* is something few revolutionaries like to think about, being for the most part as bigoted and impervious to facts as those whom they think they oppose. In 1848, a world-wide liberal movement was ruthlessly crushed in Europe and vitiated in South America. Consider how present-day revolutionaries are being *Che Guevara'd* back into the nineteenth century to repeat the mistakes of Garibaldi and Bolivar. Bolivar liberated a large section of South America from Spain. He left intact the Christian calendar, the Spanish language, the Catholic church, the Spanish bureaucracy. He left Spanish families holding the wealth and land.

He must have loved the conquistadores in some corner of his being to treat them with such exemplary consideration. It is a familiar pattern: *the oppressed love the oppressors and cannot wait to follow their example*. Morocco, independent from France, takes over the inefficient French bureaucracy. Arab countries liberated from England retain the barbarous English method of execution. Cannot a revolution make a clean sweep of all this old garbage?

To achieve independence from alien domination and to consolidate revolutionary gains, five steps are necessary:

1) PROCLAIM A NEW ERA AND SET UP A NEW CALENDAR,
2) REPLACE ALIEN LANGUAGE,
3) DESTROY OR NEUTRALIZE ALIEN GODS,
4) DESTROY ALIEN MACHINERY OF GOVERNMENT AND CONTROL,
5) TAKE WEALTH AND LAND FROM INDIVIDUAL ALIENS,

Suppose that Bolivar had followed this program:

1) He sets up a new calendar with no reference to A.D./B.C. No saint days, no Christian holidays, no more *Semana Santa*.

2) There are thirty-five mutually incomprehensible Indian dialects in Peru alone. South America constitutes a Tower of Babel. Unifying language is essential, but not the colonial languages Spanish and Portuguese. Bolivar decides that the language of South America will be Chinese. Several considerations dictate this choice. He has been impressed by the equanimity of the Chinese, their quiet self-possession in the dreariest and most forbidding places.

There is a town in the high Andes, a gloomy windy pass. Thin air like death in the throat. From the low sod huts with no chimneys the sullen bestial inhabitants peer out, eyes red with smoke. No trees, windswept grass, little terraced fields above which the mountains tower to stone and snow. The proprietor of the one general store, an old Chinese. He

5

has been there many years you can tell. Unmarried and old, he fills the order for provisions. All places are alike to him. This quiet possession of his own space can only be attributed to the structure of the Chinese language.

There are also aesthetic considerations. A river town in coastal Equador malarial faces like dirty gray paper. Down the mud street steps a girl naked to the waist black as ebony with fine Mongoloid features straight hair. Negro and Chinese full calves zowie! Chinese characters look better on signs or on a printed page. His main consideration is to build up the economy by attracting the frugal and industrious Chinese settlers. Chinese will be taught in all schools. Place and street names will be Chinese.

3) It is not necessary to track whiskey priests through the brush. Lands and property of the church confiscated. No religious instructions in schools. Simply make it disadvantageous and uninteresting to be a Catholic.

4) The Spanish bureaucracy, which starts with one incompetent, lazy, dishonest, superfluous bastard who then fills an office with all his incompetent relatives all filling out senseless forms, must be attacked at its roots. All forms and records to be destroyed.

5) Land and property of resident Spaniards confiscated. Those who choose to remain must integrate into the working community. Their children will not speak Spanish or kneel in any Christian church.

So the face of history has changed. To return in this illustrative fantasy, consider the weapons and tactics available to present-day revolutionaries in the West: small arms and similar weapons. Most useful all-around handgun is the pig .38 Special. Anyone with reasonable coordination can be taught in twelve rounds to hit a foot-square target at thirty feet. And that's practical pistol shooting! The lightweight models with two-inch barrels are quite accurate, which makes this gun one of the lightest and most compact of all powerful handguns.

Handguns can be traced. Possession is a crime and serves as provocation. Homemade weapons are useful and every good scout will be tinkering with crossbows and rubber band guns, homemade flame throwers and laser guns, cyanide injectors and blowguns. Matchlock and flintlock pistols shooting a load of crushed glass and cyanide crystals are quite effective at six feet. The simplest cyanide injector has a large plunger that can be grasped in the whole hand. You shove the needle in and push plunger home in the same thrust.

A more sophisticated model looks like a toy pistol. Needle is unscrewed from end of barrel, the pistol cocked by drawing back spring attached to plunger. A sponge soaked in cyanide solution is inserted in the barrel, the needle and cap screwed back into place. When trigger releases the spring, the massive dose of cyanide solution is squeezed into the flesh causing instant death. When not in use, needle is capped by a Buck Rogers death ray. If you can catch the target with mouth open, you can jet it in from ten feet like a spitting cobra. This is not hard to do. They are always ranting on about permissiveness, marijuana, anarchy, ill-bred attacks on Her Majesty, bring back hanging, bring back flogging, heavier penalties for drug offenses, heavier penalties for drug offenses, ban smut, etc. And of course the injector is at home in bars and restaurants. Instead of *canard a l'orange* he gets a mouthful of prussic acid.

A bolo made from a bicycle chain with lead weights at each end... knives with a blade that flies off propelled by a powder charge or powerful spring in the handle... and vibrating knives with a vibrator in the handle. A double-edged knife on a spring that can be whipped back and forth. Ingenuity will turn up many novel designs. Crossbows... rubber band guns powered by a powerful rubber band can shoot a lead slug with considerable force and accuracy up to twenty yards... long-range blowguns, etc. These weapons are useful for individual assassination.

## ASSASSINATION BY LIST (*ABL*)

So who do you assassinate by list? Not the obvious targets the politicians narcs and pigs. They are servants who obey orders. So the targets are not the front men but the higher-ups behind the scene. You announce that you have a list of these secret controllers and that they will be killed one after the other. The list is guesswork of course but the real higher-ups will soon expose themselves. So for a start we assassinate a Swiss banker never wrong on that. Just get a list of high Swiss bankers and pull his name out of a hat. This is Assassination By List (*ABL*). The rich and powerful cower behind guards and electric fences.

## RANDOM ASSASSINATON (*RA*)

Ingenious concept of random assassination has been proposed by Brion Gysin. Five people a day in five districts of the city are killed. Category of person and district are determined by lot. One way would be to shuffle a pack of cards listing various categories *housewife bowler-hat-and-umbrella nun meth-drinker lavatory attendant anyone driving or riding in a Bentley etc.* Then shuffle another pack of city areas arranged into districts that do not correspond to the actual boroughs or wards. Since the choice is completely random there is no pattern and the assassinations cannot be predicted or anticipated. Exempt from this daily lottery are the police and the military. The reason: they are accorded this position of privilege to stir resentment in the populace and so set the stage for a subsequent accusation that rightist plotters carried out *RA* to create an emergency and seize power.

*RA* applied to group units could paralyze the economy of the West and this brings us to...

## BOMBS AND EXPLOSIVE DEVICES

Post offices, public buildings and monuments are quite useless targets in most cases. With less risk and less outlay of material you could paralyze the whole communications system.

Like this: two Israeli passenger planes recently exploded, probably as a result of bombs planted in freight or luggage by terrorists. Already these lines are banned and nobody will fly on the planes. Now suppose you plant five bombs a day at random. How long before no one flies or ships freight by air? And you won't have to do it all yourself... you will find anonymous little helpers who will start planting bombs on planes just for jolly—wouldn't *you* after reading all about it? They know it's the thing to do. And every device intercepted increases the terror. Then you hit trains and ships, buses and subways inside the cities. You make truck driving the most dangerous profession, with special attention to food trucks. Then you can hit the power stations and water reservoirs.

7

## CHEMINCAL AND BIOLOGICAL WEAPONS

For random terror attacks, gas bombs are often more effective than explosives. They're also cheaper and easier to make. A container of sulphuric acid concealed in package or briefcase. You press down a plunger which drops sodium cyanide into the acid and leave your package in the subway at the rush house or in a theater or political rally or revival meeting. Chemical and biological weapons could be made in the basement lab if you know how.

In *The Wild Boys*, I proposed to transfer desirable species of plants, animals, fish and birds from present distribution to other areas where conditions are sufficiently similar to insure growth and reproduction. Look at the map and always remember your subjects may be more adaptable than you realize.

Consider the walleyed pike, which is not a pike. The species is a perch and undoubtedly one of the greatest fresh-water pan fish. Found in the lakes and rivers of Minnesota and Canada and in clear cold streams down into Missouri and Arkansas. And consider the smallmouth black bass of similar distribution. Both species will live in cold water anywhere. They would thrive in the lakes and rivers of England and Scotland and Northern Europe. The large-mouth black bass tolerates quite warm waters and could be extended to the vast waterways of the Amazon basin to the lakes of Africa and Southeast Asia.

The yage vine could grow in the jungles of Southeastern Asia, in Africa, and probably in Louisiana, Florida and Texas. The delicate lemurs of Madagascar, shy little wood spirits, would enhance any rain forest. Certainly the enchanting flying fox deserves wider circulation.

Look at the map again. Introduction of a new species into an area where they were hitherto unknown can have far-reaching consequences. This aspect of biologic warfare has been neglected.

Here is the bushmaster from Panama south through the Amazon basin. He may reach a length of fourteen feet and attack a human. twisting about his thighs while he strikes at the chest and throat walking his great fangs that can shoot half a glass of venom. No amount of anti-venom can save him—there isn't time for it to act.

Florida, East Texas, Louisiana, jungles of Africa, Southeast Asia, the East Indies and back along the same trade routes... the Black Mamba of Africa that will also attack unprovoked, sliding down from trees. Leopards and tigers released in South America would soon be driven to man-eating by the scarcity of game, and they would eat the CIA men first since they are bigger and slower. *The good gray lard* they call it, licking the blood off each other's faces. Plentiful, helpless, no fur—the ideal food animal.

The fresh water shark of Nicaragua and the piranha fish would do well in the lakes and rivers of Africa in the southern United States and in Southeast Asia. For arid regions, the desert cobra, the rattler and the gila monsters, and the incomparable tiger snake of Australia. And wolverines for Siberia—they are a perfect curse, known to trappers as "the little fiend." And microscopic and sub-microscopic life of course, which brings us to...

## BIOLOGIC WARFARE PROPER

The deadly *Naga* virus is up for grabs. Nobody knows how it is transmitted, and that gives the virus an advantage which any virus well knows how to take. You immunize your own boys and turn the virus loose. Then another... another... until you make the world safe for men of your caliber. No, you don't have to dream up anything from science fiction—the old standbys will go a long way... cholera, typhoid, hepatitis. It was *General Hepatitis* who stopped Rommel in North Africa in World War II. There were cartoons depicting *General Mud* and *General Mountains*. General Mud, if I remember correctly, was supposed to stop Hitler in Poland, but his performance was not impressive.

Consignments of ticks carrying Rocky Mountain spotted fever, typhus lice, and of course you go on looking for the big one—Australian smallpox which thrives on vaccination. Or, suppose you could speed up the *time* of the process. Instead of symptoms spread over a week they are compressed into hours. People swell up with cancer and rot with galloping leprosy on commuter trains...

And now, introducing two promising newcomers that deserve your attention... easily and cheaply assembled... readily available materials: Infrasound for infrasound, and DOR—opportunity knocks...

## INFRASOUND

This weapon is fully described *The Job*, published by Grove Press of New York. So much for the commercial. Infrasound is sound at frequency below the level of human hearing which sets up vibrations in any solid obstruction including the human body. Professor Gavreau who discovered this novel weapon says that his installation, which resembles a vast police whistle eighteen feet long, can kill up to five miles in any direction...knock down walls and break windows, and set off burglar alarms for miles around. His device is patented and anybody can obtain a copy of the plans on payment of two hundred francs at the patent office. So why be a small-time sniper?

## DEADLY ORGONE RADIATION (*DOR*)

...Produced when *any* fissionable material is placed in an orgone accumulator. An orgone accumulator is constructed by lining any container with sheet iron or steel wool. The container must be of organic material, and for full concentration many alternate layers can be used. For full description see the collected works of Dr. Wilhelm Reich. In the chapter entitled "Orgone Physics" Reich says, "There is no protection whatsoever against *DOR* since it penetrates everything, including lead or brick or stone walls of any thickness."

A criminal hater of mankind or a political enemy, if he knew about this, and if the USA did *not* know about it or did *not* study these effects, could easily drop activated oranur devices looking simply like metal-lined boxes. These could infest a whole region if not a whole continent. Each person falling ill would react to his or her specific disease or disposition to disease, driving the symptoms to high acuity and then curing them if properly and conscientiously applied. However, if used with malignant intent, such infestation of the atmosphere would surely kill or at least immobilize many people. Exposure on a gradient scale gives immunity.

Be prepared!

## WEAPONS OF DISRUPTION, AGITATION AND SUBVERSION

A French revolutionary sets forth a method by which one man with an unlimited expense account can bring down a government. He invents an underground, planting stickers and slogans. Acts of sabotage at widely separated locations give an impression that the underground is widespread and well-

organized. All disturbances, strikes, accidents, are claimed by the mythical underground. This method might work in an old-style dictatorship like Spain, Greece, Santa Domingo, Haiti. For the complex set-up in America and Western Europe, you need a whole script and eventually a whole film set.

## NOTES ON WRITING
## WORLD REVOLUTION
(written March 25, 1970, Paris, France)

### GENERAL PLAN:

1) An independent republican or reform party of exemplary behavior and moderation, staying always within the law. Personnel must be at all times above reproach, at least in the initial stages of the operation.

2) A terrorist underground complete with detailed personnel and methods of operation. Post films of underground drilling can be leaked to press. The police can be allowed to capture extensive files taken from a telephone book, and while they drag bewildered citizens from their beds, the underground, which consists of a small group of expert saboteurs, can strike somewhere else.

3) A terrorist reich complete with personnel. Any outrage can be attributed to these characters. You can see how this works out in present-time Brazil where any murder of underworld figures can be laid to the terrorist police organization. The script is different for every country or area of operation, but it's always a *one-two-three* …

Here's the schema for the United Kingdom …

1) An English Republican Party (*ERP*). Offices in Bedford Square. Vis-

ible personnel must be above reproach. Appeal is rational, stressing economic factors. The monarchy is simply out of keeping with the realities of modern life. Time to forget a dead empire and build a living republic. Stabilize economy, cut expenses, especially defense. Let the Yanks and NATO carry that ball—it's too heavy for us. Build up tourist trade by giving them some place to eat and room service 'round the clock and food fit to eat. Start bringing England into the twentieth century. Attract foreign capital, stabilize population by setting up liaison committees to facilitate immigration from the U.K. to South America, the only underpopulated country. Smooth patter, discreet lunches at Rules and Simpsons. Scrupulously abstain from any personal attack on the royal family.

2) We prepare a pamphlet with obscene cartoons covering the royal family with vile abuse. We send it out to members of all the best clubs, conservative M.P.'s, officers and gentlemen on Her Majesty's Service. The first wave takes a heavy toll in heart attacks and apoplexy in the halls of drafty clubs… muttering imprecations at yellowing tusks on the wall… walking down country lanes swinging umbrellas and sticks at the air. England is in ferment like a vast vat of bitters.
3)

> *This vile attack on Her Majesty*
> *Put an end to permissiveness*
> *Bring back hangings*
> *Bring back floggings*

The piper plays "Bring Back My Bonnie To Me" on a tin flute down Kings Road.

1) *ERP* deplores pamphlets as sophomoric and calls on the invisible author to desist, which he does of course. The right hand sees what the left hand is doing. A lull, during which *ERP* consolidates gains. *ERP ERP ERP* ghoul expert patter belching it out all over England. After all why all this fuss about something left over from the Middle Ages? Just a question of getting people used to it like a new ten-shilling piece. I mean, when we can cut rates and give decent housing they'll forget all about it… the new generation never heard of such a thing. Turn Buckingham Palace into a luxury hotel, one of a chain… and that's where your firm comes in. The Royal Family is to be absorbed into the diplomatic service which is also due for cutbacks and drastic overhaul. Old style diplomacy dates back to the eighteenth century. We want to see less goodwill tours and handshaking and

more understanding on basic exchange of goods and services. Yes, the whole structure needs overhauling. Why not bring England into the twentieth century? Scrap the licensing laws—food and service 'round the clock. Good middle-priced restaurants like Horn & Hardart.

*ERP ERP ERP.* Skinheads? Street gangs? We'll give them something better to do than Paki-bashing and fighting each other. There's useful work for these boys to do…

2) Infiltrate street gangs as first move towards taking over the streets. We send our boys trained in every technique of hand-to-hand fighting, the use of weapons and demolition procedures. Jimmy the doctor with a scalpel up his sleeve. Electric Kris ready in his boot. These boys assume leadership of street gangs. Why fight each other? Why not fight the bastards who keep you here in your cold gritty dank slums? I said, "*BUGGER THE QUEEN!*" and anybody doesn't like it just step forward and say so.

These boys have a double mission: first, to put street fighters in the street when we give the word… riots burning cars broken windows. That is the work of the rank and file. Second, they will sift street gangs for the smartest, sharpest, hardest boys to forge the SS, the Palace Guard of *ERP*. The boys will be exhaustively trained in all fighting techniques, in psychological warfare, in crowd control. At the right time they will be provided with uniforms, motorcycles, armored cars and automatic weapons. There is useful work for these boys to do.

## START ASSASSINATION BY LIST

We drop quite a few red herrings of course… always leave the door open to blame it all on rightist plotters. Besides, enigmatic assassinations are more upsetting, somehow. We have a tentative list of the real higher-ups in England. As we start working through it, other higher-ups will betray themselves to the trained observer, so the list keeps growing. We will need that list when the time rolls around for mass murder, mass assassination (*MA*), and we turn our boys loose.

Now we need a scenario for the rightist plot. Officers and gentlemen, they call themselves (*OG*). Using American techniques of thought control they will make the Queen a goddess. Her power is absolute. Every citizen must display at all times on his lapel, hatband, shirt or other garment where it can be plainly seen, the Queen's Rating. *QR* determines

position in her society… at all times. Her favorites all have "Top Rating." They can walk into any restaurant and the manager has to provide a table. They can walk into any hotel and ask for a suite and the manager just has to move somebody out. Intolerable little Cockney faggot in eighteenth century costume with a powdered blue wig and snuffbox full of cocaine: "Get this low-rate riffraff out of my suite!" And so it goes on down the scale to ths dreaded pariah rating (*PR*) which is tattooed in red ink on the forehead like the brand of Cain. Anyone can refuse to serve food, grant lodging, or take in any public transport a *PR*. And so her loyal and loyalist subjects think twice about incurring her serene displeasure. And it is well to remember that her favor is not to be taken for granted but must be earned anew each day. Actually the Queen is simply a holograph symbol of subservience manipulated by American know-how. Vulgar chaps, by and large, but they do have the technology…

Recent experiments with rhesus monkeys have demonstrated that fear, rage, excretory processes and sexual response can be brought under pushbutton control. The Chinese delegate screams his rage and shits in his pants on TV… the Soviet delegate masturbates uncontrollably… early answer to use on anyone considering to interfere. We set it all up with top secret documents, statements from a former CIA man who must for his own safety remain anonymous. And we put our *rumor boys* into the street with tape recorders…

1) England is taking orders from the CIA and the American narcotics department like a Central American banana republic. Wouldn't surprise me to see the marines land. Look at this drug problem they've dumped in our lap. Go after the pushers—you arrest one pusher and ten more will take his place. The one man the narcotics industry can't do without is the addict on the street who buys it. Treat the addict in the street and you will put the pusher out of business. The apomorphine treatment started in England—why not give it a chance in England?

And let's give these kids something better to do. Why not reverse the brain drain? It isn't just more money that takes our best research brains to America—it's better equipment and opportunities for more advanced research. The new work in autonomic shaping carried out in America by Drs. Bernard Engel, Joe Kamiya, Neal Miller and Peter Lang. They are teaching subjects to control

brain waves, rate of heartbeat, blood pressure, digestive processes and sexual response. This could lead to trips without drugs and solve the drug problem. Is England picking up? Is similar research being carried out? … the Bristol Neurological Foundation by Professor Grey Walter? If so we haven't heard about it. Is England *afraid* of any research that could turn up something basically new? Is England muddling through or simply muddling steadily downhill? Is the mismanagement we see here part of a deliberate plot? It's beginning to look that way.

2) Riots and demonstrations by street gangs are stepped up. Start random assassination. Five citizens every day in London but never a police officer or serviceman. Patrols in the street shooting the wrong people. Curfews. England is rapidly drifting towards anarchy.

3) We send out our best agents to contact army officers and organize a rightist coup. We put rightist gangs into it like the Royal Crowns and the Royal Cavaliers in the street. 1. *Time for ERP!* 2. *Come Out In The Open!*

The trouble in England is: it is run by old women of both sexes. We have a list of these people. We will not allow them to use the army to overthrow constitutional government and impose a dictatorship under pretense of controlling the disorders which they themselves have caused. It is time for young England to strike, and strike hard.

We turn our palace guards loose. An armored car draws up in front of Claridge's. Youths with tommy guns jump out and block off the street. A TV crew unloads. The whole scene goes out live on TV.

Steps through the silent dining room… stop by a table. A burst of machine gun fire. A woman screams.

"Shut up you whore! And now, will you all please stand up—*that's right*. Now all of you sing *God Save The Queen*. Boys, walk around the dining room. You there—*louder… more soul!*"

The car stops in front of the best club of them all. It's not White's, I'm told, but we'll be around to White's later. They'll be waiting… the old gentlemen in their armchairs muttering about permissiveness… in the writing room writing letters towards the restoration of hanging and flogging. The boys leap out in their natty blue uniforms with the skull-and-crossbones at the lapel that glows in the dark.

"Are you a member, sir?" The boy shoots him coldly in the stomach with a P-38 *(it's nice for city wear, so much more elegant than a revolver)*. Quick, purposeful young steps down drafty halls. Tussle over the wall… the improbable hyphenated names. The members are frozen.

"What *is* this outrage? When a gentleman is reading his *Times*?" They expect the club steward to come in and throw the bouncers out *perhaps it's even a case for the bobbies*. The steps stop in front of an armchair.

"Are you Lord Stansfield?"

"I am."

"He is the most intelligent person in the room. Intelligent enough to know that this is serious." The boy is very elegant and disengaged. Lord Stansfield decides to try a paternal approach.

"Son…" The boy gives him a short burst across the chest. Diving bell from the nineteenth century shattered by a boy's bullets. The members are numb from the shock wave. TV camera, floodlights, the boy paces around the vast lounge looking at the pictures. He points the gun at a steward's stomach.

"You there. Bring champagne."

"Champagne, sir?"

"Yes, champagne. And glasses for all the officers and gentlemen, the servants as well, and don't be forgetting the military." The trembling steward passes around the clicking glasses.

"You there! Pick it up!"

Now the boy stands in front of the Queen's picture. He raises his glass. "*BUGGER THE QUEEN!*" He throws the empty glass at the picture, shards of glass sticking into the Queen's face. The members are frozen. The boy unslings the tommy gun and shoots down five members in a random sequence pivoting

from the hip. He picks up another glass. "And now, all you officers and *gentlemen*, gather 'round here. *That's right.* I want to hear it, I want to hear it good and loud."

"*BUGGER THE QUEEN!*"

████████████████████████████

All over England, the elite guard carry the message of death. They have some natty uniforms with trick gadgets: a skull-and-crossbones in the lapel and helmet that winks on and off, and blue revolving skull lights on the cars. And some frantic faggots get themselves up in skeleton suits of course. Sweeping down country roads thirty boys on motorcycles draw up in front of a stately home.

"You, sir?"

"Where's the old bitch?"

The butler's face does not change. "Mrs. Charington is in the garden, sir." And there she is, in her trowels and slacks, digging away at her roses.

"What do you want, young man?" She thinks he will quail before a good woman's gaze. He doesn't.

"*Lebensraum*, you old hag. You poison the air we breathe."

Mrs. Charington bleeds into her roses. The butler is busy with the wall safe…

They sweep up to a baronial Scottish estate.

"You'll have to wait, constable, the family is at dinner.:

"Good, we'll join them." He jabs the butler in the stomach with his tommy gun. The lord and lady die in their seats, faces in the grouse. The children, a boy of eighteen and a girl of sixteen, sit there, faces blank with shock. Slowly the boy's face glows and sharpens with calculation. His lips part and his eyes shine. "Due truths are told as happy preludes to the swelling act. And now for my unfortunate brother."

Lead boy calls in two footmen. "Bring mattresses. You and you, go along and see they don't get lost."

Television cameras set up. The mattresses brought in and dropped on the floor in front of the fireplace.

Next scene shows the other boys gang-fucking the girl while the new boy tries on his new uniform.

All over England under the searching guns pubs echo to "*BUGGER THE QUEEN!*" Taken up by junkies, meth heads, hippies… played back on recorders… live on TV.

"*BUGGER THE QUEEN!*" rises to the pale English sky. Whole regiments scream it out.

"*BUGGER THE QUEEN!*" and murder their officers straightaway.

Boy packs with tommy guns march down the street and blast every shop window that bears the hated placard, "By Appointment To Her Majesty The Queen." And everyone they meet had better scream it out loud…

"*BUGGER THE QUEEN!*"

They march into offices, schools, factories, department houses.

"All right, all of you, stick your head out the window and show some respect."

"*BUGGER THE QUEEN!*"

All over England, heads pop out of windows screaming,

"*BUGGER THE QUEEN!*"

Languid young officers on flower floats parade through the streets as the delirious populace chants,

"*BUGGER THE QUEEN!*"

"Bugger the Queen" is now the national greeting.

████████████████████████████

*ERP* occupies Buckingham Palace to protect and advise the Royal Family. Decimated by assassination and deprived of psychic support, the army falters. The Queen abdicates while the elite guard languidly polish their nails on skull lapels. And who is *that*… a very natty tailor-made uniform?

… I think there is a residue of fair-minded people in England who will read it as it is intended: as an empirical sociological observation. If an image or symbol is widely venerated in a population segment, the desecration and shattering of that image or symbol will shatter the social structure insofar as that structure is based on the image or symbol. It's a very old rule: shatter the idols, and you move in this gain. Shatter the idols and you shatter the social structure. The idols are not often as easy to find. "Bugger Nixon" just doesn't do it at all. No shock value there.

The cut-ups date from the Dadaist movement and Tristan Tzara pulling a poem out of a hat. So you will see, this is actually a repetition of "Burn the Louvre!" And everybody says, "So, who cares?" You don't have a basically important symbol. The tactic must shock and enrage, preferably to the point of madness. That is what this tactic is about: *desecration, madness.*

████████████████████████████

"No, it was not a difficult decision to issue these licenses for rape and murder. Nothing more ominous than a difficult decision in the Pentagon. And nobody

does more harm than he who feels bad about doing it. Sad poison nice guy more poison than nice wept when he saw the Hiroshima pictures. What a drag. When we murder somebody we want to have fun doing it."

This license was dictated by a consideration taken into account by prudent commanders throughout history. *You have to pay the boys off.* Even the noble Brutus did it: "The town is yours, boys." Tacitus describes a typical scene: "If a young girl or good-looking boy fell into their hands they were torn to pieces in the struggle for possession. And the survivors were left to cut each other's throats." Well, there's no need for it to be that messy—why waste a good-looking boy? Mother-loving American army run by old women, many of them religious my god hanging American soldiers for raping and murdering civilians.

"*WHAT THE BLOODY FUCKING HELL ARE CIVILIANS FOR?*"

Old Sarge bellows from here to eternity: "Soldiers' pay!"

The CO stands there and smiles. Just ahead is a Middle Western American town about 200,000. Pretty town on a river, plenty of trees. The CO points, "He's all yours, boys! Every man, woman and child of it. Anything in it, living or dead."

"Now just a minute boys. Listen to Old Sarge. Why make the usual stupid scene kicking in liquor stores grabbing anything in sight. You wake up with a hangover in an alley, your prick tore from fucking dry cunts and assholes, your eye gouged out by a broken beer bottle when you and your buddy wanted the same one—no fun in that. Why not leave it like it is? They go about their daily tasks and we just take what we want when we want it, cool and easy, and make them like it. You see what I mean? Five thousand of us, two hundred thousand of them."

The young lieutenant in camouflage sees what he means. Boys—school showers and swimming pools full of them…

So we lay it on the line. "There's no cause for alarm, folks, proceed about your daily tasks, But one thing is clearly understood—your lives, your bodies, your properties belong to us whenever and wherever we choose to take them." So, we weed out the undesirables and turn the place into a paradise… gettin' it steady year after year…

████████████████████████████

(END OF TAPE ONE, SIDE B)

# EARLY ROUTINES

## Routine: May 30, 1956

A drastic simplification of U.S. law has thrown thousands of cops and narcotic agents out of work: The DFs—Displaced Fuzz—overran the Placement Center snarling and whimpering like toothless predators: "I don't ask much out of life. Just let me give *some* citizen a bad time."

A few of them were absorbed by Friendly Finance:

DF 1: "Now, lady, we wouldn't *want* to repossess the iron lung, what with your kid in such a condition like that, not being able to breathe."

Alternative: "Now, lady, we wouldn't want to repossess the artificial kidney, what with your husband in such a condition like that, not being able to piss."

DF 2: "Anna innarest."

DF 1: "Anna carrying charges."

DF 2: "Anna upkeep."

DF 1: "Anna wear and tear onna appliance."

DF 2: "Depreciation whyncha?"

DF 1: "Check, *and* the depreciation."

DF 2: "It's like you're delinquent already... Mmmm. *Quite* a gadget."

DF 1: "Quite a *gadget*."

DF 2: "Not the sort of thing you could make out of an old washing machine in your basement."

DF 1: "If you had an old washing machine."

DF 2: "Anna basement."

Lady: "But what am I to do? I been replaced by the automation."

DF 2: "I'm not Mr. Anthony, lady..."

DF 1: "You might peddle the kid's ass if he'll stand still for it, haw haw haw... lady, we'd like to help you... You see,—"

DF 2: "—We got a job to do is all..."

Alternative: DF 1: "You should be able to save sumpin'..."

DF 1: "Maybe he pisses it all down the drain. Haw haw haw..."

A DF can still get his kicks with Friendly Finance. But what about the other DFs?

One of them obtained a sinecure as lavatory attendant in a Greyhound Ter-minal and maintained his self-respect by denouncing occasional improprieties and attempts to tamper with or circumvent the pay toilets. To this end he concealed himself in the towel receptacle, peeking out through a hinged slot...

Another worked in a Turkish Bath and equipped himself with infrared binoculars:

"All right there in the North corner. I see you." He couldn't actually denounce the clients or throw them out, but he did create such an unnerving ambiance, prowling about the halls, poking into the steam room, switching on floodlights, sticking his head into the cubicles through hinged panels in the walls and floors, that many a queen was carried out in a straitjacket.

So he lived out a full life and died at an advanced age of prostate cancer.

Another was not so fortunate. For a while he worked as a concierge, but he harried the tenants beyond endurance so they finally banded together and were preparing to burn him alive in the furnace—which he habitually either over- or under-stoked—when the police intervened. He was removed from office for his own protection. He then secured a position as a subway guard, but was summarily dismissed for using a sharpened pole to push people into the cars during the rush hour. He subsequently worked as a bus driver, but his habit of constantly looking around to see what the passengers were doing precipitated a wreck from which he emerged shattered in mind and body. He became a psychopathic informer writing interminable letters to the FBI which J. Edgar used as toilet paper, being of a thrifty temperament. He sank ever lower and ended up Latah for Cops, and would spend his days in front of any precinct that would tolerate his presence, having been barred from the area in and about Police Headquarters as a notorious bringdown.

# EARLY ROUTINES

From a forthcoming book by William S. Burroughs, *Early Routines*, scheduled for Fall 1981 publication by Cadmus Press...

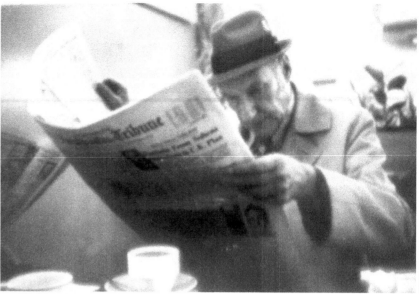

UDO BREGER

Waiting for the train to Paris. Brussels, end of Oct 1979, Midi-train station.
The Trib on left side read by Brion Gysin.

I have a feeling that my real work I can't or, on a deep level, won't begin. What I do is only evasion, sidetrack, notes. I am walking around the shores of a lake afraid to jump in, but pretending to study the flora and fauna—those two old bags—I must put myself, every fucking cell of me, at the disposal of this work.

Oh, God! Sounds like posthumous biographical material. Lee's letters to his beloved friend and agent. You write back the work must develop in its own way, and reveal as much of itself at me as I am able to interpret and transcribe. I have but to act with straight-aheadedness, without fear or holding back.

At this time the creative energies of Lee were at lowest ebb. He was subject to acute depressions. "At times," he writes in a letter to his agent, "my breath comes in gasps," or again, "I have to remember to breathe."

Civilian casualties of those books on Combat Judo and Guerilla War. Country Club cocktail party: A man who had been a great athlete in his youth, still powerful but fattish, a sullen-faced ash blonde with droopy lips, stands in front of another man, looking at him with stupid belligerence.

"Bovard, I could kill you in thirty seconds. No, in ten seconds. I have a book on Combat Judo... like this..." He leaps on Bovard, planting a knee in his back

"I hook my left middle finger into your right eye meanwhile my knee is in your kidney and I am crushing your Adam's apple with my right elbow and reaching around to stamp on your instep with..."

Sharp words with the *criada*. Half an hour past breakfast time. I ring and ask for breakfast, the silly little bitch comes on sulky and surprised, like I was out of line.

I say sharply, "Look, *senorita*," (there is no English equivalent for *senorita*, which means a young, well-brought-up, unbanged young lady, I mean a virgin. You even call sixty-year-old whores *senorita* as a politeness—especially if you want something from them, you dig? I shouldn't take it upon myself to imply she *isn't senorita*) so I say, "Look *senorita*, breakfast is at eight. It's now eight-thirty."

I am not one of those weak-spirited, sappy Americans who want to be liked by all the people around them. I don't care if people hate my guts, I assume most of them do. The important question is what are they in a position to do about it. My affections being concentrated on a few people, are not spread all over Hell in a vile attempt to placate sulky, worthless shits. Of course, they could cut off my junk. That happened once and I beefed loud, long and high up, straight to the head croaker of this crummy trap (I'm about the only cash customer they got. If I'd claimed to be half-Jewish I would be here for free). My purpose in beefing was

just in case somebody on the premises lifted the ampule and gave me a shot of water, though the stuff was probably cut at the factory like Jewish babies, like all babies now. There is a night nurse who looks like junk, but it's hard for me to be sure with women and Chinese. Anyhoo she gave me a shot of water one night and I don't want her ministering to me no more.

Actually I savor like old brandy, rolling it on my tongue, the impotent hate of people who cannot, dare not retaliate. That is, you dig, if I am in the right putting them down, if they really have come up lousy. My epitaph on Old Dave the Pusher who died last year in Mexico, D.F.: "He looks like junk as he would catch another user in his strong coils of grace."

This place is *mad*. There are six people in my room now, washing the floor, putting up a mirror, taking the bed out and putting another one in, hanging curtains, fixing the light switch, all falling over each other and yelling in Spanish and Arabic, and the piss-elegant electrician only deigns to speak French—in Interzone it is a sign of class to speak nothing but French. You ask a question in Spanish, they answer in French which is supposed to put you in your place. Citizens who come on with the "I only speak French" routine are the sorriest shits in the Zone, all pretentious, genteel—with the ghastly English connotation of lower middle class phony

elegance—and generally don't have franc one. This electrician looks like a walking character armor with nothing inside it. Of course he must have some hideous protoplasmic core. I can see some Reichian analyst who has succeeded in dislodging the electrician's character armor. The analyst staggers back, blasted, blighted, a trembling hand covers his eyes: "Put it back! For the love of Christ put it back!!"

████████████████

I met Mark Bradford the playwright. He says, "I didn't catch your name."

"William Lee."

"Oh!" He drops my hand. "Well... uh excuse me." He left Interzone the following day.

To a person in the medium of success Willy Lee is an ominous figure. You meet him on the way down. He never hits a place when it is booming. When Willy Lee shows, the desert wind is blowing dust into empty bars and hotels, jungle vines are covering the oil derricks. A mad realtor sits in a spectral office. A famished jackal gnaws his numb, gangrened foot: "Yes, sir," he says, "This development is building right up."

A successful composer says to his protege, a young Arab poet: "Start packing, Titmouse. I just saw Willy Lee in the Plaza. Interzone has had it."

"Why, is he dangerous? You don't have to see him."

"*See* him—I should think not. It's like this. A culture gets a special stamp, Mayan, Northwest Coast, North Pacific, probably from one person or small group of people who orginally exuded these archetypes. After that the archetypes are accepted unchanged for thousands of years. Well, Lee goes around exuding his own archetypes. It isn't done anymore. Already the Interzone Cafe reeks of rotting, aborted, larval archetypes. You notice that vibrating soundless hum in the Plaza? That means someone is making archetypes in the area and you'd best evacuate right now... Look, I am a success because I mesh with existing archetypes... I accept or even get to know Lee's archetypes... and his routines!!" The composer shudders, "Not me. Get packing, we're meeting Cole in Capri..."

Love,
W. Lee

████████████████

Now your letter: I just lit up... A very dangerous party, Miss Green. Just one long drag on the unnatural teat she's got under her left arm and you are stoned,

pops... In Mexico once I picked up on some bum kick weed, and then got on a bus. I had a small pistol, a .41 caliber double-barreled Remington derringer in a holster tucked inside my belt so it was pointing just where the leg joins the body... Suddenly I could feel the gun go off, smell the powder smoke, the singed cloth, feel the horrible numb shock, then the pit-pat of blood dripping like piss on the floor... Later I examined the gun and found the safety half-cock was broken and such accidental discharge was quite possible.

████████████████

I see the Un-American Committee has got around to Chris G. About time. I knew him when, dearie. A rank card-carrying Scumunist. Queer of course. He married a Transvestite Jew Liz who worked on *Sundial*, that left wing tabloid. You recall the rag folded when their angel, an Albanian condom tycoon who came on like an English gentleman, the famous Merchant of Sex, who scandalized the International Set when he appeared at the Duc de Ventre's costume ball as a walking prick covered by a huge condom—went broke and shot himself during World War II. He couldn't get rubber, and Alcibiades Linton, the Houston Bubble Gum King, beat him out on Mexican chicle—perhaps these long parentheses should be relegated to footnotes.—I don't know why Chris married her. Probably for the looks of the thing, not knowing exactly how such things do look... Did I ever tell you about my *New Yorker* cartoon? One State Department pansy visiting another. Kids crawling all over both of them, so the visiting swish says to the other: "Really, my dear, this front thing can be carried too far."—Anyhoo, his Liz wife was killed by Kurds in Pakistan—the reference is not to sour milk, but to a species of Himalayan bandit—So Chris comes back with his dead wife in a jeep and says: "Poor Rachel. She was the life of every party. Kurds, you know." Kurds indeed. He liquidated her on orders from Moscow. Fact is she "had taken to living on a slope of aristocracy," and ultimately "became crude and rampant"—I quote from the Moscow ultimatum. I am leaving a reference to Turds for Milton Berle or anyone else who wants it...

Two fags passing noseless woman: "My dear, these people lose their noses though sheer carelessness..."

████████████████

Interzone is crawling with paedo-

philes, citizens hung-up on pre-puberty kicks. I don't dig it. I say anyone can't wait till thirteen is no better than a degenerate,

Above notes under file head T.B.W.I.: To be weaved in. A routine starts here concerning a rich writer who employs an extensive staff to do menial work like "weaving." I have a group of men and women, "My Eager Little Beavers" as I call them... So this writer is a sadistic tyrant you dig?... I come and supervise the work maintaining nauseous fiction they really are beavers, and they have to wear beaver suits and stand a roll call... "Sally Beaver, Marvin Beaver, etcetera etcetera..."

"And watch you don't get caught when a tree falls," I say jovially holding up a finger stub.

Sort of a horrible *tour de force* like the books of Anthony Burgess. Nobody gives those people who write children's books credit for what they go through with.

I have discovered a certain writer of children's books is a great Kafkian figure. He chose to hide himself in child stories as a joke.

████████████████

For example, there was a story of Old Grumpy Stubbs who said he needed subsidiary personalities—Subs he calls them—to keep his psyche cleaned out and other menial chores around the "farm".

"So just sign here my friend. You'll never regret this as long as you live."

But poor Albrecht the wood cutter did regret it as soon as he got back to his little proviso apartment, that is an apartment that has already been leased to someone else, or on which the lease has expired, so you can only hope to stall a few days until they get the necessary papers for dispossessing you. Albrecht has lived in provisos all his life...

Well, even though he couldn't read clause 9-(v) of the contract—which can only be deciphered with an electron microscope and a virus filter—Albrecht knew somehow he had done a terrific thing to sell out to Old Stubbs, so-called because he had cut off all but two of his fingers in an effort to amuse his constituents. "I get it back!" he would say, jovially rubbing his mutilated hands together. "I get it back!"

"I just don't know," Albrecht reflected. "Now Old Stubbs he talks real nice and he did cut off a thumb for me... It isn't every Sub can say he got a thumb off the old man. Some of them didn't get nothing."

████████████████

# THE PLACE OF DEAD ROADS

From a forthcoming book by William S. Burroughs, *The Place of Dead Roads*. Copyright 1981. Special thanks to W.S.B. and James Grauerholz...

Paul Christmas, the perfect CIA man, turned into one of the shabbier streets of Aman. He tossed a coin to a handless leper who caught it in his teeth. Paul's cover story is taking over. He is Jerry Wentworth a stranded space pilot. It is a standard medina lodging house... white washed cubicle rooms... wooden pegs in the wall to hang clothes... a pallet, a blanket, tin washbasin and water pitcher... built around a courtyard with a well, some fig and orange trees. In such lodgings every man who can afford it sleeps with a bodyguard.

Jerry sat up and hugged the army surplus blanket around his skinny chest. It was cold and his Reptile in bed beside him was sluggish. That was the trouble with a reptile bodyguard. But Jerry heard the old man approaching with earthen bowls of hot coals, hooked on both ends of an iron balance, rather like Justice and her scales Jerry thought. He ordered bread and hot schmun a sweet concoction of tea and khat. Good way to get started in the morning. He closed the door and soon the heat from the bowl permeated the room and his Reptile stirred languidly and peeled off the covers. It is a Mamba addict in the most advanced stage, skin a smooth bright green, eyes jet black, the pubic and rectal hairs a shiny green black. He squirms his legs apart and his eyes light up with lust as his ass flushes salmon pink, mauve, electric blues, reeking rainbows. The boy dresses sulkily. He needs the green. They cut out to the nearest snake house.

Through the open doorway drifts the snake house smell, heavy and viscid as languid surfeited pythons, somnolent cobras in Egyptian gardens, dry and sharp as a rattlesnake den and the concentrated urine of little fennec foxes in desert sand, smell of venomous sea snakes in stagnant lagoons where sharks and crocodiles stir in dark oily water.

The snake house is a narrow room cut into the hillside. There are stone benches along the walls impregnated with generations of reptile addicts. In the center of the floor towards the back is a manhole cover of patina'd bronze giving access to a maze of tunnels and rooms that had housed the mummies of the Pharaohs and others rich enough to belong to that most exclusive club in the world: I.L. (Immortality *Limited*).

The reptiles are waiting on the Snake. The Snake is late as usual and the reptiles hiss desperately. A few are already molting and pulling strips of skin off each other with shrill hisses of pain and ecstasy. Paul's reptile turns away in disgust. Some of the reptiles are clad in ragged cloaks of reeking leather, others wear snakeskin jockstraps and the ever popular hippopotamus-hide knee-length boots, many are naked except for spring shoes with razor sharp Mercury wings for a deadly back kick.

There sits an exquisite coral snake, his banded red and white phallus up and throbbing, and opposite him is a copperhead, his pointed phallus smooth and shiny, his skin like burnished copper. They hiss at each other and their throats swell. "Doing the cobra" it's called and it's dangerous. If you don't get sex right away with someone in your cock group you will die of suffocation in a few seconds. The waiter rushes up with a pallet and hurries to open the manhole cover. The bodies heat up, glowing copper red white and orange, and the boys shed their skins in a sweet dry wind that wafts up from the spicy mummies.

"All natural products from pure venom."

He sweats out:

*'Shredded incense in a cloud*
*from closet long to quiet vowed*
*Moldering her lutes and books among*
*as when a Queen long dead was young.'*

"Here comes the *Snake!*"
The reptiles hiss with joy.
Actually the Snake has a burning down flea habit and looks like Blake's Ghost of a Flea. He wears a tight pea green suit and a purple fedora. He passes it out and pulls it in with his quick dry claws lined with razor sharp erectile hairs that can brush flesh from the bone. Recall this out-of-towner made a crack about 'Bug Juice' and the Snake slapped him. He puts a hand up to feel the side of his face and he doesn't have any face on that side. The waiters bring coffee tables and water and cotton and alcohol. Some of the reptiles have little snake jaw syringes and they go through an act of biting each other. The latest slither is ampoules to pop when you come, it's a game of chicken with the kids. A full blow of King Cobra is fatal about half the time, same way with Tiger Breath from tiger snakes. The reptiles are slithering around and constricting each other but Paul's green mamba takes a quick fix and they walk out.

They pass a swampy pool green with algae where alligator addicts wallow in mindless depravity. Paul sniffs and he can feel the *smell brain* stir deep in his pons with a delicious dull ache... what a kick for an uptight Wasp! Mindless garden of our jissom... parking lot... he should be down... belches the taste of eggs... this is it... *magnificent*... Sput Sput Sput...It's a lovely sound, the sound of a silenced gun... a sound you can *feel*... good clean there we are in one asshole... stale night smell... mindless trance on porches the air like cobwebs... the lake... fish... the sky was clouded over... here... cleaned the fish at grass... unwashed sheets belching we ease into the normal boy at sunrise... along any minute now... watery sunlight watery sunlight... sitting job... the boy was here before the job... like cobwebs the job... the job? oh it. Low velocity 9 millimeter... sundown... boy awake... military purposes... Paul sniffed the rotten belches of a python... boys shed their skins in a sweet Sput Sput Sput... a musky zoo smell permeates the animal street lingering in your clothes and hair... a skunk boy pads in beside them...

"Got *wolverine* poppers..."

They walk on and the boy gives them a squirt of skunk juice...

"Chip Americans!"

They pass the massive metal lattice gate to the Insect Quarter... faceted eyes of the insect addicts peer out from dark warrens. The smell doubled them over like a blow to the stomach. They hurried on heading for the port.

They are on the outskirts of the town. Ledges and terraces cut into the hill side with markets and cafes and lodging houses... stone steps and ramps lead from one level to the other... abandoned cars here and there eroded to transparent blue shells as if nothing remains but the paint. At the top of the hill the Sea of Silence stretches away into distance. Along the shores are driftwood benches sanded smooth... it is said that every man sees the flotsam of his own past here... Cottonwoods along an irrigation ditch at Los Alamos Ranch School... a wispy skittish space horse by a desert fort from *Beau Geste*...

# THE PLACE OF DEAD ROADS

Kim bought some clothes and a thin gold pocket watch. Coming out of the jewelry store he ran into the Sanctimonious Kid who was casing the store in a halfhearted way.

"Don't try it," Kim told him.

"Wasn't going to…"

Kim noted the frayed cuffs, the cracked shoes.

"It gets harder all the time."

The Kid was always soft-spoken and sententious, known for his tiresome aphorisms.

"It's a crooked game, Kid, but you have to think straight."

"Be as positive yourself as you like but no positive clothes."

The Kid was considered tops as a second-story cat burglar and he had made some good smash and grabs. Kim sensed something basically wrong about the Kid and never wanted anything to do with him. Under pressure he could blow up and perpetrate some totally mindless and stupid act. Now in the afternoon sunlight Kim could see it plain as day: hemp marks around the Kid's neck.

The Sanctimonious Kid was later hanged for murder of a police constable in Australia. It gave Kim a terrible desolate feeling when he heard about it years later… the bleak courtroom… the gallows… the coffin.

"See you at the Silver Dollar."

Kim took a carriage to the outskirts of town. He got out and strolled by his rooming house, very debonair with his sword cane the flexible Toledo blade razor sharp on both edges for slash or thrust, his Colt .38 nestled in a tailor-made shoulder holster, a back-up five-shot .22 revolver with a one-inch barrel in a leather-lined vest pocket. He couldn't spot a stakeout. Maybe they fell for the diversion ticket to Albuquerque he had bought making sure the clerk would remember. But sooner or later they would pick up his trail. Old Man Bickford had five of Pinkerton's best on Kim's ass 'round the clock.

Kim was headed for Salt Chunk Mary's place down the tracks… solid red brick two-story house, slate roof, lead gutters…

Train whistles across a distant sky.

Salt Chunk Mary… Mother of the

B.G. and W.S.B.

ANTHONY BALCH

Johnson family. She keeps a pot of pork and beans and a blue porcelain coffee pot always on the stove. You eat first then you talk business, rings and watches slopped out on the kitchen table. She names a price. She doesn't name another.

Mary had more "nos" than any woman Kim ever saw and none of them ever meant yes. She kept the money in a cookie jar but nobody thought about that. Her cold gray eyes would have seen the thought and maybe something goes wrong on the next lay. John Law just happens by or John Citizen comes up with a load of 00's into your soft and tenders.

Mary held Kim in high regard.

"Hello," she said. "Heard you was back in town."

Kim brought out a pint of sour mash bourbon and Mary put two tumblers on the table. They both drank half a tumbler in one swallow.

"He's down on his luck," she said. "Stay away. It rubs off."

"He should quit," Kim said, "He should quit and sell something."

"He won't."

No, Kim thought, not with that mark on him he won't. "I hear Smiler went down."

She drained the tumbler and nodded. "Young thieves like that think they have a license to steal. Then they get a sickener."

"Scares a lot of them straight. What did he draw?"

"A dime."

"That's a sickener all right."

They drank in silence for ten minutes.

"Joe Varland is dead. Railroad cop tagged him."

"Well," Kim said, "the Lord gave and the Lord hath taken away."

"What could be fairer'n that?"

They finished the whiskey. She put a plate of pork and beans with homemade bread on the table. Kim would later taste superb bean casseroles in Marseilles and Montreal but none of them could touch Salt Chunk Mary.

They were drinking coffee out of chipped blue mugs.

"Got something for you." Kim laid out six diamonds on the table. Mary looked at each stone with her jeweler's glass. She took the glass out.

"$2,800."

Kim knew he could probably do better in New York, but he needed the money right then and Mary's good will counted for a lot.

"Done."

She got the money out of the cookie jar and handed it to him, wrapped up the diamonds and put them in her pocket.

███████████████████

"Who's over at the Cemetery?" Kim asked.

Kim called his rooming house the Cemetery because the manager was a character known as Joe the Dead. Kim's place was a hideout for Johnsons with an impeccable reputation, most of them recommended by Salt Chunk Mary... con men... bank robbers... jewel thieves... high class of people.

Kim didn't take much risk since Denver at the time was a "closed city." You only operate with police protection and pay off. Kim paid so much a month. He threw some weight in Denver. He knew some politicians and a few cops. The cops called him the "Professor" since Kim's knowledge of weapons was encyclopedic. He could always tune into any cop.

███████████████████

"Jones was there last week."

Jones was a bank robber. He was a short rather plump wax-faced man with a mustache who looked like the groom on a wedding cake. He would walk into a bank with his gang—a ninety-pound Liz known as Sawed Off Annie with a 12-gauge sawed-off, and two French Canadian kids—and say his piece.

"Everybody please put your hands up high."

It was the sweetest voice any cashier ever heard. He became known as the bandit with the sweet voice. But when he said "Hands up high" you better believe it.

Jones confided in Kim that when he killed someone he got "a terrible gloating feeling." Said with that sugary voice of his, it gave Kim a chill. It's a feeling in the back of the neck rather pleasant actually accompanied by a drop in temperature that always gives notice of a strong psychic presence. Jones was creepy but he paid well...

███████████████████

The last thing that Kim could ever do in this life or any other was con. He held con men and politicians in the same basic lack of esteem. So the news that the Morning Glory Kid was currently staying at the Cemetery elicited from him an unenthusiastic grunt. The Morning Glory Kid worried him a bit. He knew that big time con artists like that often kept some piece of information up their sleeves to buy their way out. Of course the Kid had nothing on Kim except renting him a room but *watch that fucker* he thought.

███████████████████

Kim remembered the first time he hit Salt Chunk Mary. Ten years ago.

"Smiler sent me."

She gave him a long cool appraising look.

"Come in kid."

She put a plate of salt chunk on the table with bread. Kim was a delicate elegant creature. He ate like a hungry cat. She brought two mugs of coffee.

"What you got for me kid?"

He laid the rings and pendants out on the table. It was good stuff for a kid. It was a good score for a kid...

She named a fair price.

He said "done" and she paid him.

Mary looked over Kim's slim-to-willowy young good looks. "You'd have a tough time in stir kid."

"Don't aim to go there."

She nodded. "It happens. Some people just aren't *meant* to do time. Usually they quit and do well in legitimate."

"That's what I aim to do."

And he was doing it. They both knew this was the last time Kim would ever lay any ice on Mary's kitchen table.

"Stop by any time you're in town."

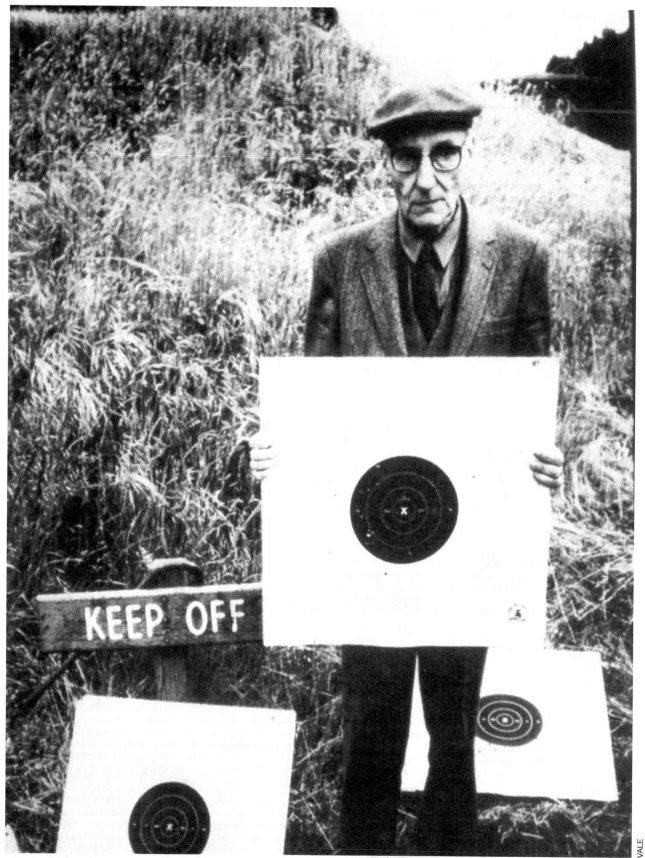

**William Burroughs at Chabot Range, Oakland.**

VALE

W.S. Burroughs talked to Vale and Mindaugis on a Sunday afternoon. Thanks to James Grauerholz who aranged it all.

R/S: *You see Outer Space as the solution to this cop-ridden planet?*

WSB: Yeah, it's the only place to go! If we ever get out alive... *If* we're lucky.

But it isn't just *cop-ridden*, it's ridden with every sort of insanity.

Of course, all these nuts make the cops necessary. In New York there was one guy who was going out and pushing people in front of subways. Another guy— the Mad Slasher—he had a meat cleaver, he carried it around in a little bag, and he suddenly started cutting people up. He cut a guy's ear off. They got *two* mad slashers, another with a knife—a big hunting one—he killed about three or four people.

R/S: *In New York?*

WSB: Just suddenly on the street, he started cutting up! Stabbing everybody in sight. Just like the *amok* in Southeast Asia, just exactly the same phenomenon. He just went around and killed people. He escaped. Usually, with the amok it was a form of suicide, and they were usually killed. Everybody starts yelling out, "Amok! Amok!" and rush up with whatever weapons they have and they finally kill the amok. But this one got away and may do it again... You know, just one thing like that after another...

R/S: *Have you witnessed any altercations recently?*

WSB: Well, yeah...very often you see someone freaking out, on a subway. I saw this guy he had a wild look in his eye, he was sort of swinging from one strap to another—he'd start at one end of the car and go to the other end. As soon as the subway stopped *everybody* got off! The last I saw there were about four cops on their way in to subdue him.

R/S: *It seems this sort of thing is escalating. What role do the media play in this? Are they passively reporting or—*

WSB: I don't know, because they don't have this problem in other places. They don't have this problem in Paris.

R/S: *In Tokyo they have a huge popula-*

tion, overcrowding, yet—

WSB: I know. In Paris they've got poor people, they've got everything, but it doesn't seem to express itself in that way. Doesn't seem to make any sense. That's what you're *really* worried about, the people that are just nuts, that don't have any rationality.

R/S: *Usually the solution is to "beef up the police"—*

WSB: The police, my god, the police have taken such a beating since New Year's. Some guy got in an argument with a cop and took his gun away and killed him. Another guy beat a cop almost to death with his own nightstick. These things happen all the time! Maybe you read about it: you see, the cops pulled this van over and two guys in the van jumped out and started shooting with 9-millimeters, those 15-shot Browning. Man, they just riddled the car, both cops had about 5 bullets in them. They were slow on the uptake! You see somebody jump out— you'd better jump out too in a hurry! But they didn't. One of them's dead (the other will recover). He was shot in the brain, he lived about five days. Finally had to pull the plug.

R/S: *I think criminals are raising their aiming point since so many cops wear Second Chance (body armor) now.*

WSB: These guys knew what they were doing—they weren't muggers and they weren't lunatics. They knew how to use the guns, they had the two-hand hold... were really pouring it in there.

R/S: *Ever had a desire to go to the Cooper School, Gunsite (a progressive arms training school in Arizona)?*

WSB: Well...yeah, you'll get some tips there, I think. By and large it's just getting out on the range and doing a little practicing. What I do is, I start as close as I need to get, in order to get 'em all in the black, then start moving back. Then see what's wrong, if you're shooting high or low (I'm shootin' a little to the left on my 9-millimeter). Then move on back to fifteen yards. It's not very practical to bother with anything beyond twenty-five yards—there's no point.

R/S: *That's seventy-five feet—*

WSB: Seventy-five feet, that's far enough... Most anything to do with self-defense is going to be not fifteen yards

but *five* yards.

R/S: *It seems like it's going to get worse...*

WSB: Well, some company has a shock stick—it's supposed to give someone a paralyzing shock. But I've never seen one. They also have this thing—it's just like a flashlight—it develops a tremendously bright flash that will blind someone, particularly in the dark. See, if someone came on you in the dark straight, and you give them a flash of that, they're all completely blinded long enough for you to either run...or give them a kick or two!

R/S: *How would you use your cane?*

WSB: There's *all sorts of things* you can do with a cane—practically anything except *that* [demonstrates using it as a club]. That's only a feint. If you ever do that with a cane you go like *that*. When he puts his hand up, you slice down to the knee. That cane of mine's not very heavy. Of course, if a guy's got something in his hand then slap the hand. Jam it into his solar plexus or adam's apple, or anywhere...

S. Clay Wilson just gave me a spring steel unit. I wouldn't carry it because I want a cane with a hook on it. It's incredibly inconvenient to have a cane that doesn't have a hook on it. You want to buy something, the cane's always slipping down, hitting somebody...

R/S: *Society seems to be trending toward new survival requirements... you once mentioned that you yourself have three lines of defense. That seems to be thought out for a reason.*

WSB: Yeah. A mace gun, a cobra and a cane are my three lines of defense. It's something new. This didn't used to be true, you know. I talked to people in Los Angeles who said they used to leave their doors open and not worry about it, and now they've all got security systems and all the rest of it. I draw the line at keeping a fuckin' dog! I don't like them anyway—particularly not vicious ones— 'cause they're always biting other people. [A friend] has a dog in New Mexico, outside of town. Well the dog bit three people who were friends of his—finally it killed his cat. He had to get rid of it.

But...if you don't have a dog, everybody knows it. And they know, of course, when you're going to town—how long

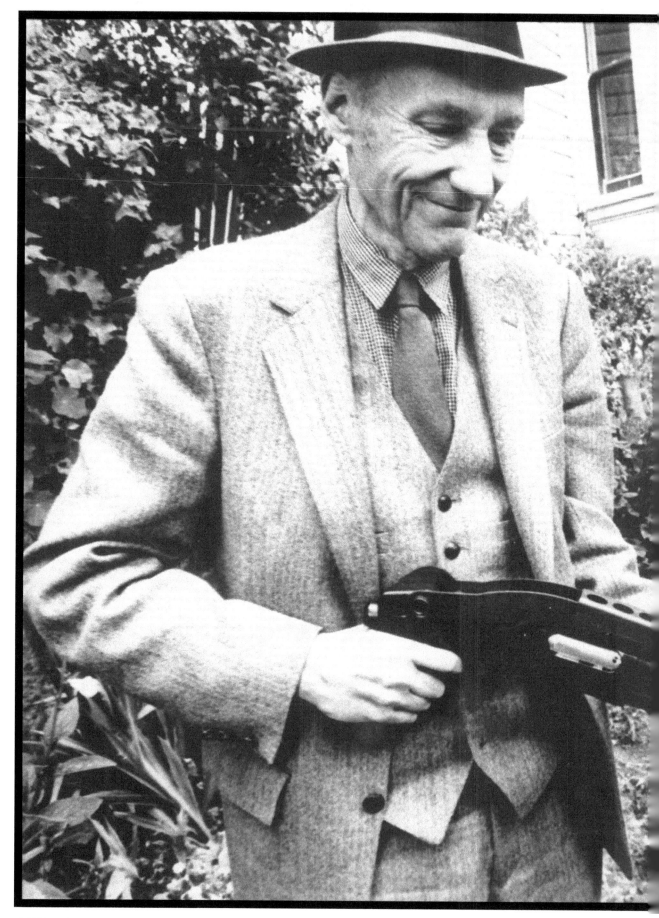

**William Seward Burroughs.**

it's going to take you to get there and back—so you just get ripped off for everything you own. I don't know what you can do, what substitute there is. That's what dogs are for.

Another thing they do: they alert you if anyone is coming. And they know about three hundred yards away. It's amazing. Two or three hundred yards, all the dogs start barking. They know somebody's coming long before you would have any knowledge. And *that*'s what they're for.

R/S: *It seems a general state of alertness would be the first condition of being out in the Bowery where you live.*
WSB: The Bowery house base is so watched. The Bowery itself, there's nothing there, just bums; they're harmless. That's a safe neighborhood—safer than the posh neighborhoods. The Upper West Side and the East Side—that's where they have the *real* trouble, where they got these big apartment houses, because the muggers feel they *can* get something there. Not in the Bowery; there's no muggers in the Bowery. But, when you go down in the subways, of course, well then anything can happen.
R/S: *You stay away from them?*
WSB: No, no! I travel on them practically every day. If I have to get uptown for my various reasons, it's the only way to travel. Oh yeah, I travel on subways all the time.
R/S: *Have you taken any special precautions for your YMCA in New York? (WSB lives in a former YMCA)*
WSB: That's quite secure, it has no windows. It has some windows that open on a shaft—we've got bars on them. And there are four doors between me and the street. And in the daytime there's a guy downstairs with a pistol guarding the furniture store there. And they check people that come in and out. If someone comes in and asks for me, they look him over. So that's pretty good, I haven't had any trouble with people breaking in.

R/S: *Do you ever practice with an air pistol?*
WSB: I've got one, yeah. A *Diana*, I believe. It's got a gas cylinder. I'd rather have one that didn't have a gas cylinder; you're always running out of them. And it doesn't work exactly, I've got to put in some sort of a wad in it to make it engage. But it's all right. I practice with it a lot.
R/S: *Just shooting at targets?*
WSB: Yeah, I've got a loft, and the walls are three feet thick. So there's no hassle.

Max Corso and godfather.

Usually I put up a telephone book as a backing. It'll chew up a telephone book to pieces in about... oh, several days of shooting and the telephone book is in shreds! It's pretty powerful, it'll imbed itself in wood, soft pine... It's good practice.
R/S: *Except you don't get the feel of recoil...*
WSB: Somebody says that he solved the whole problem of recoil by balancing the forward movement and the backward movement so there's no recoil. I saw a picture of this in *Soldier of Fortune*—that's all I know about it.

But of course, I'd like to see a smoothbore shotgun revolver...even in .410. If it was good and heavy you could even have it up to 20-gauge. After all, they're shooting these Thompson Contenders with really high-powered rifle cartridges—why couldn't they do the same with a shotgun? In other words, a hand shotgun. Double-barreled perhaps, heavy enough to balance the recoil, so you'd have hand shotgun hunting just like they have handgun-pistol hunting.

The point is, they can sell all they make, so why should they change? It's like the internal combustion engine—so long as they can sell 'em they're not going to change the design.

R/S: *By the way, what was the Tucker car?*
WSB: It wasn't quite a turbine engine, but it had all sorts of improvements. It's so much better than any car on the market, there's just no comparison. It could stop on a dime, it could do all sorts of things. He only made two. He had about $20 million, but that's a drop in the bucket; when you're bucking General Motors, $20 million is chicken feed. And he *was* bucking General Motors. So

they put him out of business. He couldn't get materials. See, they can freeze the materials on anybody. I've seen this happen with a lot of things.

Another guy was going to make Lustron houses: this guy had a prefabricated house that was made of porcelain steel with the insulation in the middle. It was rustproof, termite-proof, it would last forever. They were supposed to come on the market at $5,000, then it was $9,000, then $12,000. He only made a few hundred before they went under.
R/S: *Do examples still exist?*
WSB: Oh, yeah, there must be, because they would never wear out! They were in different colors, you could add rooms to them, they could put this thing up in a couple of days. You got a lot, you could put up your house. And it could last forever. Well of course the real estate lobby really got into *him...*

Another guy had an aluminum house that was like an umbrella. It was shaped like that, the rooms were sort of pie-shaped. It had a big hole in the middle of it, so all you had to do was have a big hole, then you put this thing down. It could be installed in a matter of an hour. And it was supposed to cost $3,000. Now this was after the war, around 1947. So a friend of mine said he wanted to order one. And they said, "Well, we can't promise delivery." Finally, there was *one* made. I still have a picture of it. They couldn't get the aluminum!

A great necessity is low-priced housing—*well boy they just throw a block.* They want houses that'll fall apart in ten years so you gotta get a new one. Just like everything—cars, anything else. And you can't buck 'em.

There was this woman who went down to South America and found a birth control herb that'll last for *seven* years— and you could reverse it with another herb if you want to have children. So she came back thinking the chemical companies would jump all over it. They said: Wait a minute—we can sell a pill every day—what do we want to know about a seven-year pill for? So...they didn't want to know.
R/S: *Good grief! What happened to that?*
WSB: Nothing. Some friends of mine— the Eco-Technic Institute—they're going to the Amazon this summer and they're going to try to pick it up, do something with it. It would have to be a small firm, sort of *entrepreneurs.* But then you'd never get the OK from the DEA—no, I mean the FDA, the Food and Drug Administration. They'd never give you the

okay, 'cause they're sort of the company cops of the big drug companies. They get *their* shit through, no matter how dangerous it is, like Thalidomide and a lot of other compounds that turned out to be very dangerous, that have all sorts of side effects. But if some guy's making it in a basement laboratory—*he'll* never get the okay!

R/S: *Who are the Eco-Technic Institute?*
WSB: They are primarily an ecology organization...very successful. They have a big place in New Mexico; they have a beef ranch in Australia; they have a hotel in Katmandu. They own a huge... they seem to have the money... millions, 'cause that house they bought in the South of France with thirty acres—a house that could hold, house and feed seventy people at a conference—it's huge. That's about, I'd say, $6 million anyway. Thirty acres, man, twenty miles from Marseilles!

But at the conference—any of their conferences—they will not allow journalists. None! No matter how well-intentioned. And that's very sensible, 'cause you get scientists up there and they're going to be misquoted: "Scientist sees end of world in ten years" when he's saying that a certain situation will be *critical* in ten years—a water table or something like that. And then they won't come to the next conference. So the woman in charge just barred all journalists...

Heyerdahl was there, the Kon-Tiki man, the guy that sailed the papyrus boat...and doctors from the World Health...a lot of very interesting people. I was glad I went, but—god, the first night I got there, it was in the winter time, and these country houses—just a great big room with one tiny electric heater. I never took off my clothes throughout the conference! Just kept all my clothes on except my shoes and just heaped blankets on top of me. *Beware of country houses in the winter!*

R/S: *I'm interested in turning points in history—like, in* Cities Of The Red Night *there's that story of Captain Mission, which presented an entirely different possibility for the Americas which didn't happen...*
WSB: Well, there are lots of those turning points or dates; important, crucial dates. One of them is certainly (although it isn't a clear-cut date like a battle or something like that, but it's one of the great dates of history) *Systemic Antibiotics.* Because before that—boy, you got

an infection, you were dead! It's nothing now to have an infection. And pneumonia was a *big* killer. So, that's a very big date...
R/S: *I think the birth control herb you mentioned could be equally important—*
WSB: Absolutely. And, of course, August 6, 1945. Godalmighty, the Atom Bomb. Was that a date! (laughs)
[At this point, several people talk briefly to W.S.B. Biafra, lead singer for the *Dead Kennedys*, asks if William is familiar with the cancer cells of Henrietta Lacks, that keep re-appearing in laboratories around the world. S. Clay Wilson asks an unbelievably gauche question: "Bill, when you stared at your foot all that time when you were strung out in Morocco or wherever it was—did you have your shoe on or off?" WSB answers with matter-of-fact politeness: "Oh, no, I left my shoe on. I'd rather look at my foot with the shoe on rather than off..."]

R/S: *What magazines do you subscribe to?*
WSB: I subscribe to the *American Rifleman*. The others I can buy, but that's hard to buy and has the best information. There are a lot of interesting things in there, like the combustible cartridge. They've been working on that for years. It's the simple idea that the whole cartridge is made of gunpowder with some sort of glue or something, so there's no cartridge to eject. Well, in the early days there were a lot of inventions, a lot of very *strange* inventions, and they had a lot of attempts to do this. None of them quite worked. Well now they're coming back to the idea. There were a lot of little inventions that were dropped that they're now interested in again. Any way that you get rid of one step, like the ejection of the cartridge, you can get a whole new look.

And then there's something new called a rail gun. It's got two rails like this, a very strong magnetic field in there. A small explosive charge presses them together and shoots the pellet at ten times the velocity of any known rifle. Well there's an immediate problem there; at that velocity the pellet would disintegrate from air pressure as soon as it left the barrel. But all these things, like the sonic barrier, are technical details that can be ironed out in one way or another...

R/S: *What do you think about the recent assassination attempts on Reagan, the Pope—*
WSB: It looks like it's going to get very dangerous to be a pope or a president

W.S.B. and B.G., Basel, 1979.

ULRICH HILLEBRAND

or a prime minister. The time may come when they can't get anybody to take the job!

R/S: *It seems like they weren't totally serious. Using a .22...*

WSB: Well *he* was a nut, the other guy wasn't. The terrorist. I think he was really trying. If it had been a .45 I think it might have been *it*.

De Gaulle had real professionals after him for years and they didn't succeed, because his bodyguards knew what they were doing. That's the point—they would never have let anyone get *that* close to *Le General*. But here was this guy in the press circles, he had no press credentials. If they're going to let people come around the president without checking to see whether they're who they say they are, it's just ridiculous. Not only should they have checked the press credentials, but they should have put *all* the fucking reporters through one of those metal detectors. Because a nutty reporter could get the idea of assassinating the president—same thing would happen. They really should exercise some precautions—they always wait until it happens before they do anything.

A bodyguard has to be *telepathic*. Oh, absolutely! He's got to be able to see around corners. And another very important thing is—*looking up*. A lot of people don't do that. The American Secret Service—*they don't have it!* They're not alert like that.

R/S: *How can we improve our telepathic abilities? Are they genetically limited?*

WSB: No, I think everybody has them. It's just a question of *pressure*. Pressure! Those guys *had* to do that, or they'd find someone that would. In other words, if they were going to be bodyguards to De Gaulle, they had to be *intuitive*. Not just telepathic, but intuitive—know something's wrong: I don't like the looks of that guy...or that window...or, that's a bad place there...

R/S: *Why are bodyguards doing such a bad job these days?*

WSB: They're just not paying attention to what they're doing, that's all. They've never been up against real professionals. Well, they're not now—Hinckley's not a professional. But De Gaulle's bodyguards were up against army officers with money and weapons and knowing how to use them—not .22 pistols! And they tried and they tried but they never got him...

The week before President Kennedy was assassinated, he was in New York. He stopped at a red light and a girl rushed up and photographed him from a distance of three feet. Someone said, "She could have assassinated the President!" That was a week before Dallas! But that didn't seem to inspire them to tighten their security. Of course, the protection from a rifle with a telescopic sight is not so easy. But De Gaulle's men—they covered all the buildings on the route...

That Ruby and Oswald thing stunk to high heaven, the whole thing...

R/S: *What do you think of the theory that Jonestown was a CIA experiment in mass mind control—*

WSB: It's conceivable, conceivable. We *know* that they've performed such experiments in countries like Brazil... and Athens, the whole junta was CIA-inspired. In Brazil all these experiments in control and torture, etc, were definitely CIA-organized—we *know* that. They sent all these torture experts down to South and Central America. Did you see *City Under Siege*—I think that was the name of it. It was about... one of these CIA torture experts was kidnapped by the Tupamaros in Uruguay. He was sent down there as a police adviser. So they kidnapped him and they finally killed him. And then—at the end of the movie—you see another one getting out of the plane...

R/S: *Do you think they could take a disoriented person out of prison and program him to become an assassin and the person wouldn't really know exactly what he's doing?*

WSB: I think it's possible, but it seems to me it's more trouble than it's worth. If you really want the job done you don't want a disordered person—of course you've got an *alibi* there, no one can pin it on you, but...still, it's an around-the-world-oxcart way of doing it! But it's certainly within the range of possibility.

R/S: *What about telepathic suggestions to subjects while they're asleep?*

WSB: Well they wouldn't have to be telepathic—they could do that with microphones, sort of *subliminal* microphones. As to how effective the suggestions would be I just don't know. All these people are talking about hearing voices, telling them to do these things. Now where do the voices come from? Well this is one of the symptoms, of course, of schizophrenia, and we know now that the voices come from a non-dominant brain hemisphere, whichever that is. In fact you can *produce* voices by electrical stimulation of the non-dominant brain hemisphere in normal subjects. So that's the line to take—if you can get it into the non-dom-

inant brain hemisphere, then it has this terrific power: people can't disobey it. But only certain people would be subject to that sort of conditioning...

R/S: *How can we strengthen our psychic defenses?*

WSB: There are whole books on that. Dion Fortune wrote a fairly good book, *Psychic Self-Defense*. It's not a bad book—old fashioned—but there's some good tips in there. How to know when you're under psychic attack, what to do about it, and so on. That's a *fairly* good one.

There's something by David Conway called *Magic: An Occult Primer*—that's a very good book.

R/S: *Have you heard anything new in the field of biologic warfare?*

WSB: Well, we know that the English had what they called a doomsday bug in World War II—which was created by exposing viruses to radiation and producing mutated strains. That's more than *forty years ago*—they've come a long way since then! And also there are ethnic weapons that would attack only whites or blacks or Mongoloids or whatever because of racial enzyme differences. So they can devise a plague that would attack only one ethnic group. That also is pretty old; the first statement about that was about fifteen years ago. So they've come a long way on that one.

R/S: *What do you think of the hard-core survivalist movement in this country? Stockpiling dried food, weapons...*

WSB: It could be I suppose, a good idea, but then there's the question: You might not be able to get to your stash! [drily] And then you gotta be able to defend it and all that! I remember we had the bomb shelters, and then that sort of blew over. But I'm sure a lot of people are doing it...

You have several priorities: your first priority is weapons, second is drugs, third is tools. Antibiotics...

R/S: *When you say tools, do you mean like water purification devises—?*

WSB: No no no. I mean *tools!* Hammers, saws. If you don't have them, it's very bad!

R/S: *By the way, do you still record your dreams?*

WSB: Oh, *of course!* I'll write down a few notes, and then if it's worth bothering with, I'll write it out in a diary form...

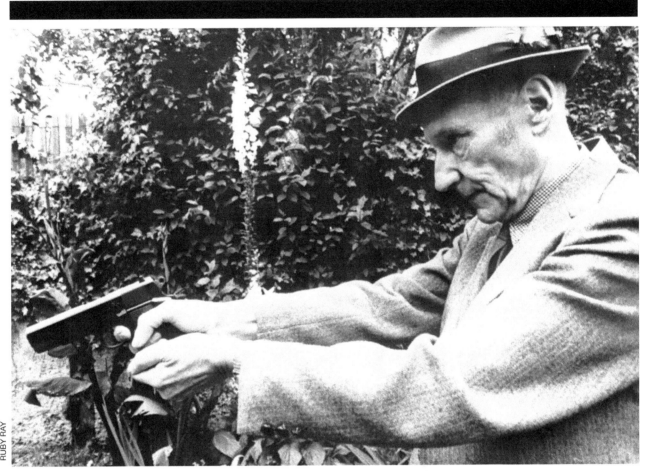

RUBY RAY

**William S. Burroughs with Colt Commander.**

# CITIES OF THE RED NIGHT

PAUL MAVRIDES

A chapter *not* included in *Cities of the Red Night*, published in 1981 by Holt, Rinehart and Winston. Copyright 1981 by William S. Burroughs. Our thanks to W.S.B. and James Grauerholz for their kind permission...

Murik is in IS, *Intelligence and Security*. His function is to know to watch and if necessary to intervene. In Futurwords he is a policeman... this term of the inferential future designating an agency which would become necessary to control the underprivileged in an emergent industrial society. It was in fact an important part of his job to see that such a society does not emerge... paradoxical position of *preventing himself from happening*. Within a well-run social group no such agency is needed.

IS is concerned with surveillance and control outside the A Units. The first thing a cadet learns at the academy is basic rules of study. Find out what others have done in your field then ask yourself what they were doing wrong. *What basic misconceptions limited their performance?* So Murik studied interrogation methods through the ages with ever-growing repugnance.

*Misconception 1: That interrogation*

necessarily involves torture. *Misconception 2: That interrogation is a battle of will between interrogator and subject in which the interrogator must establish absolute dominance. Misconception 3: That interrogation must be unpleasant and frightening to the subject.*

He concluded: "The natives on this planet always seem to do things in the most unpleasant and the stupidest way possible. They fear efficiency more than anything which means that their deepest fear is the revelation of certain basic discrepancies, certain innate genetic flaws that propel them on a course leading to such a horrible impasse that they cannot look at where they are going." Lie detectors and brain stimulation can lead to painless rapid and completely efficient interrogation techniques, involving no more coercion than strapping subject to a chair with electrodes in place. Another way of stating exercise: *Remove from process or artifact a component preconceived as basically essential...* Remove factor of torture or strong coercion from interrogation.

General procedure: Read and learn all you can about problem. Look at problem from a point of zero preconception. Devise variations and alternative solutions. Check back to see if your solution has workable advantage over solutions previously arrived at... To carry the method a step further than solution of purely technical problem where purpose is implicit in the artifact: devising more efficient gun, tool, boat, signal system, medical or interrogation procedure.

Consider a long range problem like relation of the many to the few. We are an elitist conspiracy. How has this problem of the relation between an elite and the general populace been solved in the past? The elite kept the populace down with physical and psychological coercion, held them in slavery, peonage, serfdom, kept them in ignorance, forbade them to carry weapons. This solution like all solutions that do not alter the basic problem led to further problems: *Eventual revolt.* The few are unable to contain the many. The few bring in mercenaries. Mercenaries become another problem known as protection from the protectors. No society has come up with a basically different solution in the past.

Consider the inferential future. Two developments are implicit in the weapons devised by the first revolutionaries. Weapons can be mass produced by machinery. Other commodities can be mass produced as well. This leads to societies based on money and factory workers who are not slaves or peons or serfs but who are as effectively forced to work for money to live on. They are in fact enslaved by poverty and the factory owners need assume no responsibility for them. Such a society is basically the same as older models. Power and money are now equivalent. The few enjoy elite status at the expense of the many. More and more efficient machine-made weapons put such an advantage in the hands of the moneyed elite that revolution from the bottom becomes impossible. However, such a society is also precarious because it depends on paid protectors who can take power at any time... The alternative of state owned factories leads to an elite of bureaucrats who manage the factories and supervise distribution of commodities. Workers are forced to work and paid in food coupons. All of these societies are variations on the theme of exploitation. All are precarious. The better and more specialized the weapons for enforcing conformity the more danger there is from the soldiers trained to use these weapons.

Elitism arises when a ruling class holds a basic commodity like land and others are forced to work for a fraction of the produce. It does not occur in hunting societies and other groups operating on subsistence level.

There is one notable elite in history that did not establish or attempt to establish territorial exploitation or expansion. This was the fortress of Alamout established by Hassan i Sabbah the Old Man of the Mountain. There were in fact several of these fortresses located in the mountains of Northern Persia. The fortresses received their provisions from adjacent agricultural villagers. It is to be assumed that they were paid a fair price and that cadet assassins were recruited from these villages. The Old Man's assassins spread terror through the orthodox Moslem world. Whenever a move was made to take Alamout, a general, a caliph, a sultan was struck down by assassins who made no attempt to escape and often died by torture. In military terms this was insane. Here is a general with a few hundred well trained soldiers who says to the enemy, "I can afford to lose a life for a life. My soldiers do not fear torture. Their barracks is not of this world. I will make no attempt to establish anything. This fortress will fall. I will leave no texts behind. Nothing is true. Everything is permitted."

This is the postulate underlying our system of education. Start from a point of zero preconception. A preconception is anything that is regarded as *a priori* true, right, real, permitted with regard to problem at hand. The church told people the earth was flat. What the church said was true. It was not permitted to see the tip of a mast on the horizon. In the same way any artifact may impose its reality. *This is a real cannonball. This is the way cannonballs are made. It is not permitted to make a cannonball any other way.*

At first the revolutionaries were too busy developing new weapons and tactics to question where they were going. Their efficiency was such that the struggle did not last long. The Spanish and later the English and the French were forced to capitulate leaving the A's in token possession of a vast territory stretching from the arctic to Tierra del Fuego and posing the victor's problem of occupation. Since the area was so large and the population relatively sparse this was not the urgent and absorbing problem it would have been under the usual circumstances of occupation where an army holds down conquered territory with terror and secret police. The problem was solved using Hassan i Sabbah and Alamout as a model... by occupying key areas, patrolling and keeping open the routes between occupied areas, and by constant surveillance of the unoccupied areas for dangerous foci of opposition. Surveillance of the unoccupied areas and intervention when danger signs appeared was Murik's job.

What constitutes danger is determined by position. The A's applied Hassan i Sabbah's model to the occupation of a much larger territory: Occupy, hold, do not expand, because there is no end to it. Fortified positions were to some extent rendered obsolete by the very weapons that had brought the revolutionaries to power: heavy artillery.

However, artillery must be brought within range. And since the A's occupy in each key area a series of fortified positions extending for twenty or more miles in all directions and intelligence networks far beyond that, it would not be easy to get in range with artillery. For adjacent to the fortified areas is a

potential citizens' army of farmers, villagers, hunters, fishermen all trained from childhood in the use of weapons, paid well for their produce in gold, tools and medicines, and motivated to attain cadet status. This citizen army loyal by interest formed a buffer and intelligence network. Beyond this zone bandits, warlords and pirates were occupied with feuds among themselves and had enough territory without undertaking a military campaign that would almost certainly end in disaster. There was also a buffer of disease, for the distribution of medicines and application of the measures needed to control malaria, yellow fever, dysentery, venereal afflictions, hepatitis was confined to the buffer areas. And the scientists in the fortified positions had also perfected a number of deadly biologic weapons, strains of bubonic plague and influenza, anthrax and animal fevers

that could decimate a potential enemy from a distance. It seemed to be a workable system and was not designed to last forever. Research was directed primarily towards space travel: *evacuation*. Alternatively into producing mutations on a mass scale that would eliminate enemies by turning them into biologic friends.

Murik had studied all previously existing intelligence systems, with particular attention to the Chinese. Intelligence in the past had been directed as much towards detecting potential enemies and rebels within, as towards gathering information on the military potential and intentions of enemies without. This whole aspect of intelligence was unnecessary… by a screening process and routine information. So IS could concentrate its entire attention on foreign enemies. Routine in-

formation regarding troops on borders could be handled by informants in the buffer areas.

Here the family system of the Chinese was used. The head man in a village was responsible for surveillance of his area. He was expected to know everybody and report any suspicious outsiders and rumors of troop movement outside the buffer areas. This network was limited in scope and did not tell him what was going on in Asia, Europe, Africa… what new weapons were being developed or what invasion plans hatched. For the territory occupied by the A's was the richest in the world and Europe was still smarting from the loss of their colonial possessions. Such information is of course usually supplied by agents living within a country and sending back reports. Most of this was handled by the A embassies in all major cities primarily concerned

with observing scientific and technical advances and persuading scientists and technicians to defect. Needless to say the embassies were *persona non grata* but few countries wished to go so far as severing diplomatic relations and risking a total trade boycott.

The diplomatic corps and foreign intelligence had been organized by Captain Strobe who like most of the heroes of the revolution had undergone rejuvenation with salamander tissue implants. It is reported that on one occasion when a move was under way to expel him from England where he was acting as ambassador, he invited the royal family and the Prime Minister to tea and served them teas with no sugar...

████████████████

Invasion plans are practically impossible to conceal if they involve the mass use of troops and ships. So IS is most concerned with monitoring scientific and technical advances which could obviate the need for conspicuous preparations. Top priority is assigned to three areas:

████████████████

1. Biologic and chemical weapons. Here the scientific superiority of the A labs had given us an overwhelming advantage. We invented these weapons we have used them sparingly and deviously so that the enemy does not known they are being used. Of course the germ theory is gaining ground in Europe but long before the idea of germs as a weapon occurs to them we will have nothing to fear from their clumsy cultures to which we can easily produce vaccines. So we do not fear or endeavor to block discoveries in this area. We are prepared to compete if necessary.

In areas 2 and 3, while we could compete we prefer not to do so owing to the overall changes in power balance and ecology involved in any use: competing would mean that irreparable damage had already been done and that rapid and *disastrous* proliferation was now unavoidable. These areas are:

2. Development of any motors, machines or conveyances using petroleum as fuel with especial emphasis on heavier-than-air airborne devices. Such blockage is difficult in that combustion engines are implicit in firearms, petroleum or equivalent substances have already been used in incendiary weapons, we have ourselves developed steam engines and it is a short step from the steam engine to the petroleum combustion engine. We know where the large deposits of petroleum are located and have occu-

pied these areas. Since many of them are outside the North American continent in these locations our embassies amount to armies of occupation. It is doubtful if such precautions can prevail over any period of time and the question is once again raised as to whether our movement is ultimately doomed by the very inventions that made it possible and by the machinery we have ourselves put in motion. A heavier than air aircraft propelled by petroleum engines could make fortified positions untenable. We have blueprints for such devices but would not produce them unless some enemy produced them first and we needed them for interception and retaliatory strikes. Perhaps not even then since retaliation in kind produces proliferation in kind.

3. Is most basic. No device based on nuclear fission can be allowed to develop. Noah Blake who foresaw this danger may be quoted here: "The development of an exploding nuclear device could render the planet untenable long before we are in position to leave it. Retaliation with a similar device or using a similar device as a preventative measure will only aggravate and solidify the danger." Needless to say, we have blueprints for a nuclear bomb which demonstrates the necessary steps and materials thus enabling our IS agents to know when such a device is under construction and how near to completion it is. As preventatives, biologic weapons are the most effective instruments though in some cases a few well-placed assassinations may be adequate.

████████████████

How far and how soon are we to go? Shall we murder some physicist in his cradle citing the Immortal Bard *only fools do those villains pity who are punished ere they have done their mischief?* As we know, the theoretical statement is the seed from which the solid artifact can grow in a few years. Once an artifact or procedure is theoretically possible it is just a question of time and technicians before a mushroom shaped cloud darkens the earth. Noah Blake saw the potential of projectiles that explode on contact. From grenade throw or shot from a bow it is a short step to long range artillery and rocket missiles. Even without heavier-than-air aircraft atomic missiles could destroy our stronghold from bases outside our control zones. We have already started to play God. Are we not falling into the same category as the Inquisition? Are we to deliberately block certain areas of investigation and knowledge? Is the principle of freedom

enunciated by the Articles so much hot air? These questions remained unanswered until the unthinkable happened. Word came through our agents that the Council of the Selected was working on an exploding nuclear device as a prelude to all-out attack on the Citadels of Satan. That means us. A general staff meeting was immediately convened and it was the Do of the Decade. My dear everybody was there, all the heroes of the revolution. Noah Blake is a 15-year-old boy, eyes cold unbluffed unreadable, with a bevy of giggling replicas. "I sounded a word of warning" they intone as one boy.

Captain Strobe was there with an entourage of the frivolous... Cardinal and Kelly the Priest, special envoy to the Vatican, suave and corrupt, his hemp marks a red frill around his clerical collar.

"Really these fire and brimstone fundamentalists."

"Why not dispatch a back-time hit man to do the job on Luther?"

It is the Vatican's contention that they allowed the Articles to take South America as a measure to institute reforms within the church and to clarify certain more basic issues. In any event partly owing to Kelly's able diplomacy there has been little trouble from the Catholics. In fact many priests now work in our laboratories and libraries and Father Dupre's brilliant pioneer work on the life cycle of malaria and yellow fever mosquitos has confirmed Benway's hypothesis and enabled us to virtually eliminate these illnesses from the occupied zones.

There had on the other hand been a great deal of trouble from the North American protestants who currently occupied a large territory in the Central and Southern areas of North America. It was here that the atomic installations were located.

████████████████

Jon, who had split himself into a male and female twin, was the expert on atomic weapons who had experimented with radium and drawn up the nuclear blueprints. She sat there with a supercilious and superior smile.

Bert Hanson, economics expert and businessman asked an abrupt question.

"Well Jon, how close are they?"

"A month to a low yield device."

"What do you mean by *low yield*?"

"It could take out this center."

"What is the range of their missiles?"

"About fifty miles. Within a year they will have bombs much more powerful and a three-hundred-mile missile range."

Murik gave a brief summary of the forces available on the borders of the

Bible Belt.

"We could probably invade successfully but they might escape with the plans. In any case considerable losses are to be expected."

"In the words of the Immortal Bard *We have soothed the snake not killed it*."

"The situation is little short of intolerable. We demand a final solution to the Bible Belt problem."

All eyes turn on Jon's clonic twin synthesized from salamander tissue. Like a machine that reproduces itself he had then developed the rejuvenation procedure with salamander transplants. He was also the admitted expert on biologic weapons and had isolated the venom of the Stone Fish, a sea wasp and the blue-ringed octopus.

Jon spoke briefly, if it could be called speech. He has no vocal cords and speaks with his whole body in hisses and gurgles and giggles and rumbles and heartbeats, in yellow liver language and red genital flashes. He finishes in a burst of rainbow colors that flushed through his translucent pink flesh.

His sister translated: "We have been working together on strains of radioactive virus, that is virus cultures subjected to various forms of radiation. We have a promising strain of Mudu the laughing sickness, and several hemorrhagic fevers. There is also a virus strain causing fatal erotic convulsions. He proposes that we blanket the area with a shotgun of all agents available."

The conferants nodded approvingly.

**WILLIAM ON MARS** Photocollage by J.P.A.

# W.S. BURROUGHS: SOURCES

ANTONY BALCH

**Other sources for writing by W. S. Burroughs:**

*Am Here Books, 2503 Medcliff Road, Santa Barbara CA 93109. Richard Aaron. $10 for catalog, $20 for catalog with W.S. Burroughs 7" record.*

*Atticus Books, PO Box 26668, San Diego CA 92126, Ralph Cook. $1 for catalog.*

*Pociao's Book Shop/Expanded Media Editions, Herwarthstrasse 27, 5300 Bonn, Germany. Tel. 02221/655887*

*S. Press Tonband Verlag Rochusstrasse, 56, Dusseldorf, W. Germany. Send for catalog of cassettes.*

**Books by W.S.Burroughs:**

Available from City Lights mail orders, 261 Columbus, San Francisco CA 94133

| | | | |
|---|---|---|---|
| *Ali's Smile + Naked Scientology* | $6.50 | *Nova Express/Soft Machine/The Wild Boys* | 6.50 |
| *The Blade Runner* | 4.50 | *Port of Saints* | 6.50 |
| *The Book of Breething* | 5.50 | *The Retreat Diaries* | 4.00 |
| *Cities of the Red Night* | 8.00 | *Roosevelt After Inauguration* | 3.50 |
| *Early Routines* | 10.50 | *Sidetripping* | 10.50 |
| *Electronic Revolution* | 4.50 | w/ photos of Charles Gatewood | |
| *Exterminator!* | 3.50 | *The Ticket That Exploded* | 3.50 |
| *The Job* | 6.50 | *W. Burroughs/J. Giorno Read* (2 LPs) | 11.50 |
| *Junky* | 3.50 | *William Burroughs: The Algebra of Need* | 8.50 |
| *The Last Words of Dutch Schultz* | 5.50 | by Eric Mottram | |
| *Letters to Allen Ginsberg, 1953-1957* | 8.50 | *With William Burroughs* | 8.50 |
| *Naked Lunch* | 4.50 | by Victor Bockris | |
| *Nothing Here Now But The Recordings,* | 12.50 | *The Yage Letters* (w/ Allen Ginsberg) | 3.50 |
| LP of experiments | | | |

# THE CUT-UP METHOD OF BRION GYSIN

CHARLES GATEWOOD

**WSB with E-meter.**

At a surrealist rally in the 1920s Tristan Tzara the man from nowhere proposed to create a poem on the spot by pulling words out of a hat. A riot ensued and wrecked the theatre. Andre Breton expelled Tristan Tzara from the movement and grounded the cut-ups on the Freudian couch.

In the summer of 1959 Brion Gysin painter and writer cut newspaper articles into sections and rearranged the sections *at random*. "Minutes to Go" resulted from this initial cut-up experiment. "Minutes to Go" contains unedited unchanged cut-ups emerging as quite coherent and meaningful prose.

The cut-up method brings to writers the collage, which has been used by painters for fifty years. And used by the moving and still camera. In fact all street shots from movie or still cameras are by the unpredictable factors of passersby and juxtaposition cut-ups. And photographers will tell you that often their best shots are accidents... writers will tell you the same. The best writing seems to be done almost by accident but writers until the cut-up method was made explicit—all writing is in fact cut-ups; I will return to this point—had no way to produce the accident of spontaneity. You cannot *will* spontaneity. But you can introduce the unpredictable spontaneous factor with a pair of scissors.

The method is simple. Here is one way to do it. Take a page. Like this page. Now cut down the middle and across the middle. You have four sections: 1 2 3 4... one two three four. Now rearrange the

35

sections placing section four with section one and section two with section three, And you have a new page. Sometimes it says much the same thing. Sometimes something quite different—cutting up political speeches is an interesting exercise—in any case you will find that it says something and something quite definite. Take any poet or writer you fancy. Here, say, or poems you have read over many times. The words have lost meaning and life through years of repetition. Now take the poem and type out selected passages. Fill a page with excerpts. Now cut the page. You have a new poem. As many poems as you like. As many Shakespeare Rimbaud poems as you like. Tristan Tzara said: "Poetry is for everyone." And Andre Breton called him a cop and expelled him from the movement. Say it again: "Poetry is for everyone." Poetry is a place and it is free to all cut up Rimbaud and you are in Rimbaud's place. Here is a Rimbaud poem cut up.

"Visit of memories. Only your dance and your voice house. On the suburban air improbable desertions... all harmonic pine for strife."

"The great skies are open. Candor of vapor and tent spitting blood laugh and drunken penance."

"Promenade of wine perfume opens slow bottle."

"The great skies are open. Supreme bugle burning flesh children to mist."

Cut-ups are for everyone. Anybody can make cut-ups. It is experimental in the sense of being *something to do*. Right here write now. Not something to talk and argue about. Greek philosophers assumed logically that an object twice as heavy as another object would fall twice as fast. It did not occur to them to push the two objects off the table and see how they fall. Cut the words and see how they fall. Shakespeare Rimbaud live in their words. Cut the word lines and you will hear their voices. Cut-ups often come through as code messages with special meaning for the cutter. Table tapping? Perhaps. Certainly an improvement on the usual deplorable performances of contacted poets through a medium. Rimbaud announces himself, to be followed

by some excruciatingly bad poetry. Cut Rimbaud's words and you are assured of good poetry at least if not personal appearance.

All writing is in fact cut-ups. A collage of words read heard overheard. What else? Use of scissors renders the process explicit and subject to extension and variation. Clear classical prose can be composed entirely of rearranged cut-ups. Cutting and rearranging a page of written words introduces a new dimension into writing enabling the writer to turn images in cinematic variation. Images shift sense under the scissors smell images to sound sight to sound sound to kinesthetic. This is where Rimbaud was going with his color of vowels. And his "systematic derangement of the senses." The place of mescaline hallucination: seeing colors tasting sounds smelling forms.

The cut-ups can be applied to other fields than writing. Dr Neumann in his *Theory of Games and Economic Behavior* introduces the cut-up method of random action into game and military strategy: assume that the worst has happened and act accordingly. If your strategy is at some point determined... by random factor your opponent will gain no advantage from knowing your strategy since he cannot predict the move. The cut-up method could be used to advantage in processing scientific data. How many discoveries have been made by accident? We cannot produce accidents to order. The cut-ups could add new dimension to films. Cut gambling scene in with a thousand gambling scenes all times and places. Cut back. Cut streets of the world. Cut and rearrange the word and image in films. There is no reason to accept a second-rate product when you can have the best. And the best is there for all. "Poetry is for everyone"...

Now here are the preceding two paragraphs cut into four sections and rearranged:

ALL WRITING IS IN FACT CUT-UPS OF GAMES AND ECONOMIC BEHAVIOR OVERHEARD? WHAT ELSE? ASSUME THAT THE WORST HAS HAPPENED EXPLICIT AND SUBJECT TO STRATEGY IS AT SOME POINT CLASSICAL PROSE. CUTTING AND REARRANGING FACTOR YOUR OPPONENT WILL GAIN INTRODUCES A NEW DIMENSION YOUR STRATEGY. HOW MANY DISCOVERIES SOUND TO KINESTHETIC? WE CAN NOW PRODUCE ACCIDENT TO HIS COLOR OF VOWELS. AND NEW DIMENSION TO FILMS CUT THE SENSES. THE PLACE OF SAND. GAMBLING SCENES ALL TIMES COLORS TASTING SOUNDS SMELL STREETS OF THE WORLD. WHEN YOU CAN HAVE THE BEST ALL: "POETRY IS FOR EVERYONE" DR NEUMANN IN A COLLAGE OF WORDS READ HEARD INTRODUCED THE CUT-UP SCISSORS RENDERS THE PROCESS GAME AND MILITARY STRATEGY, VARIATION CLEAR AND ACT ACCORDINGLY. IF YOU POSED ENTIRELY OF REARRANGED CUT DETERMINED BY RANDOM A PAGE OF WRITTEN WORDS NO ADVANTAGE FROM KNOWING INTO WRITER PREDICT THE MOVE. THE CUT VARIATION IMAGES SHIFT SENSE ADVANTAGE IN PROCESSING TO SOUND SIGHT TO SOUND. HAVE BEEN MADE BY ACCIDENT IS WHERE RIMBAUD WAS GOING WITH ORDER THE CUT-UP COULD "SYSTEMATIC DERANGEMENT" OF THE GAMBLING SCENE IN WITH A TEA HALLUCINATION: SEEING AND PLACES. CUT BACK. CUT FORMS. REARRANGE THE WORD AND IMAGE TO OTHER FIELDS THAN WRITING.

—William Burroughs

**Brion Gysin and William Burroughs (Dreamachine in mirror).**

A biography/appreciation by Terry Wilson…

## BRION GYSIN
(19 January 1916-  )

### SELECTED BOOKS

*Minutes to Go*, with William S. Burroughs, Gregory Corso, and Sinclair Beiles (Paris: Two Cities Editions, 1960; San Francisco: Beach Books, 1968);

*The Exterminator*, with William Burroughs (San Francisco: Auerhahn Press/Dave Haselwood Books, 1960, 1967);

*The Process*, (New York: Doubleday, 1969; London: Jonathan Cape, 1970);

*Oeuvre Croisee (The Third Mind)*, with William S. Burroughs (Paris: Flammarion, 1976; New York: Viking Press, 1978; London: John Calder, 1979).

Brion Gysin is regarded as one of the most influential and visionary of living poets and painters. In 1958, a chance encounter with William Burroughs on the Place St. Michel in Paris resulted in him moving into the famous Beat Hotel at no. 9 rue Git le Coeur in the Latin Quarter. He confided to Burroughs his inventions, the Cut-ups and Permutations, and thus began the most important collaboration in modern literature.

A naturalized US citizen of Swiss extraction, Gysin was born in Taplow House, Taplow, Bucks, UK. After the loss of his father when he was nine months old, his mother took him to New York to stay with one of her sisters and then to Kansas City, Mo., to stay with another. He finished high school at the age of fifteen in Edmonton, Alberta, and was sent for two years to the prestigious English public school, Downside. While there, Gysin began publishing his poetry before he went on to the Sorbonne. In Paris, he met everybody in the literature and artistic worlds. When he was nineteen, he exhibited his drawings with the Surrealist group, which included Picasso on that occasion.

Gysin is an entirely self-taught painter who acquired an enviable technique without putting foot in an art school or academy. At the age of twenty-three he had his first one-man show in a prestigious Paris gallery just off the Champs Elysees. It was a glittering social and financial (even a critical) success, with an article in *Poetry World* signed by Calas. But it was May, 1939. World War II caught Gysin in Switzerland with an overnight bag. When he got to New York, everybody asked: "How long you been back?"

He worked on seven big Broadway musicals as assistant to Irene Sharaff and then threw it all up to become a welder in Bayonne, NJ shipyards for eighteen months before he was drafted. In the army, he studied Japanese. "That was the most important thing," he says. "It had a great deal of influence on my attitude towards surfaces, attacks of ink onto the paper and brushwork, which has very much applied to my painting ever since." (*Performance Magazine* p.13)

New York was the hub of the free world during those years when French was spoken as much as English in any cultural or social gathering. Gysin went everywhere and met everybody except the Beatniks. For the second time, he just missed meeting William Burroughs. The first time had been in Athens where they knew the same expatriate troupe and went to the same bar every day at the same time. Burroughs moved in the crowd around the queer US consul who married him to a German lady to get her into the States. In New York, Gysin became close friends with the songwriter John Latouche who had a German secretary called Ilse Burroughs. Whenever she indulged in a private conversation on the phone, Latouche used to shout at her: "If that's your husband, don't let him up here. He's got a gun!"

He met the man, himself, one rainy day in Tangier in January, 1953. Gysin was exhibiting small pictures of the Sahara culled from a trip through the winter of 1951-52.

Burroughs "wheeled into the exhibition, arms and legs flailing, talking a mile a minute. We found he looked very Occidental, more Private Eye than Inspector Lee: he trailed long vines of *Bannisteria Caapi* from the Upper Amazon after him and old bullfight posters fluttered out from under his long trench coat instead of a shirt. An odd blue light often flashed around under the brim of his hat," Gysin recalls. (*Third Mind* p.49) "All he wanted to talk about was *his* trip to the Amazon in search of yage. It was said to make you telepathic. I felt right away that he didn't need too much of that stuff and I may well have tried to launch into my theory about how the *telephone arabe* works in Tangier but I'm sure he didn't want to listen at that time. Our exchange of ideas came many years later in Paris." (*Here To Go* p.159)

After the war, recognized for his studies of slavery, *To Master a Long Goodnight* and *The History of Slavery in Canada* (both 1946) and armed with one of the first Fulbright fellowships, Gysin studied for a year in France and Spain and then established permanent residence in Tangier. He opened his celebrated Moroccan restaurant The 1001 Nights of Tangier in order to hear the Master Musicians of Jajouka every day and through them he encountered "the magic and mystery of the Moors."

"Both extraordinary encounters and unusual experiences had led me to think about the world and my activity in it in a way that came to be termed psychedelic… I have spent more than a third of my life in Morocco where magic is or was a matter of daily occurrence, ranging from simple poisoning to mystical experience. I have tasted a pinch of both along with the other fruits of life and that changes one's outlook, at least somewhat. Anyone who manages to step out from his own culture into another one can stand there looking back at his own under another light… Magic calls itself

the Other Method... practiced more assiduously than hygiene in Morocco, though ecstatic dancing to music of the secret brotherhoods is, there, a form of psychic hygiene. You know your music when you hear it one day. You fall into line and dance until you pay the piper... Inevitably something of all this is evident in what I do in the arts I practice." (*Here To Go* p.2)

Gysin fell out of business, "not over money but magic." He found an amulet hidden in The 1001 Nights: seeds, pebbles, shards of broken mirror, seven of each, a small package in which there was a piece of writing. Written from right to left across the paper, then turned and written from top to bottom to form the cabalistic grid, it called on the devil of smoke to "make Massa Brahim leave this house as the smoke leaves the fire, never to return... "

A few days later, with the timely and overwhelming assistance of some American Scientologists, he indeed lost the restaurant and was "out with the shirt on my back." (*Third Mind* pp.48-49)

"I barely made it to London, where I sold my pictures of the Sahara and then crossed to Paris... Ran into grey-green Burroughs in the Place St Michel. 'Wanna score?' For the first time in all the years I had known him, I really scored with him... " Paul Bowles had always told Gysin he would one day.

"My intentions are in no way didactic," says Gysin. "I view life as a fortuitous collaboration ascribable to the fact that one finds oneself at the right place at the right time. For us, the 'right place' was the famous Beat Hotel..." (*Third Mind* p.148)

Burroughs was already holed up in the unnamed 'Beat' Hotel with his old suitcase full of moldy manuscripts when he and Gysin ran into each other. Gysin had lived in the rue Git le Coeur before the war in rather well-appointed circumstances overlooking the Quai. The Beat Hotel was not quite so salubrious. Allen Ginsberg had discovered the place and given out the word in the mid-50s and just about everybody on the road from California to Katmandu passed through the hotel in its heyday, roughly from 1958 to 1963. Gysin moved into Room 25.

Burroughs, attempting to get *Naked Lunch* and junk off of his back, was now only too willing to listen to Gysin's ideas on the magical-technological approach to writing and to try out the methods dis-

Brion Gysin, *Magic Mushrooms in Black and White*, 1961.

covered by Gysin which, as Burroughs immediately recognized, were specifically intended as ways *out* — out of identity habit, perhaps out of the human form itself.

Writing and painting were one in Gysin's art, especially since the intervention of the sorcerer in The 1001 Nights. If he had left Morocco with only the shirt on his back, he had quite a lot up his sleeves. The cabalistic grid was incorporated into his work and his paintings increasingly became formulae and spells intended to produce very specific effects in the viewer. In Islam, the world is a vast emptiness like the Sahara. Events are written: *Mektoub*. Likewise, Gysin's empty deserts became written deserts, written first from right to left, like Arabic, and then, after turning the page, from top to bottom, like Japanese, within the multidimensional grid. "The painting of Brion Gysin deals directly with magical roots of art," writes Burroughs. "His paintings may be called space art. Time is seen spatially, that is, as series of images or fragments of images past present and future... Here is a Gysin scene from Marrakesh — moving figures, phantom bicycles, cars... this is a literal representation of what actually happens in the human nervous system; a street reminds you of a car that went by yesterday, or a boy on a bicycle years ago, in fact everything that you have experienced on that street and

the other streets associated with it. The pictures constantly change because you are drawn into time travel on a network of associations. Brion Gysin paints from the viewpoint of timeless space." (*October Gallery Catalogue* p.1)

If events were written they can be rewritten: Operation Rewrite. Time itself was actually *pre-sent* and the only way to combat a pre-written pre-recorded universe was to cut up the writings and recordings. To make the words talk on their own. No one owns words; they were imposed from outside, the result of alien wills. Collage and montage were nothing new to painters:

"Writing is fifty years behind painting," Gysin declared. "I proposed to apply the painters' techniques to writing; things as simple and immediate as collage or montage. Cut right through the pages of any book or newsprint... lengthwise, for example, and shuffle the columns of text. Put them together at hazard and read the newly constituted message. Do it for yourself. Use any system which suggests itself to you. Take your own words or the words said to be 'the very own words' of anyone else living or dead. You'll soon see that words don't belong to anyone. Words have a vitality of their own and you or anybody can make them gush into action... 'Your very own words,' indeed! And who are you?" (*Third Mind* p.34)

"Cut up this page you are reading and see what happens," Gysin admonished time and time again. "*See* what I say as well as hear it."

"I can tell you nothing you do not know. I can show you nothing you have not seen. Anything I may say about Cut-Ups must sound like special pleading unless you try it for yourself. You cannot cut up in your head any more than I can paint in my head. Whatever you do in your head bears the prerecorded pattern of your head. Cut through that pattern and all patterns if you want something new... Cut through the word lines to hear a new voice off the page." (*Third Mind* p.44)

Events could be written and the message hidden in any piece of writing divined by the use of scissors.

*Minutes To Go* and *The Exterminator* (both 1960) detailed the theory and development of the Cut-Ups. Material was taken from newspapers, letters, The Bible, The Koran, *Naked Lunch* or anything — cut up and sprayed back in all

The Master Musicians of Jajouka.

directions. Many of the resulting texts referred to future events. Gysin introduced Burroughs to the possibilities opened up by tape recorders and permutated phrases like I AM THAT I AM, KICK THAT HABIT MAN and RUB OUT THE WORD through all their possible combinations, "spinning off on their own... into an expanding ripple of meanings which they did not seem to be capable of when they were struck and then stuck into that phrase" (*Third Mind* p.34)... I AM THAT AM I? THAT I AM I AM AM I THAT I AM?... Gysin explored projections, producing some of the first ever light shows, and with the young Cambridge mathematician Ian Sommerville invented the Dreamachine, regulated to produce light interruptions between eight and thirteen flashes a second, complementing the alpha rhythm in the brain, producing an elaborate infinite series of dream images in brilliant color — "painting pictures in the viewer's head."

Gysin and Burroughs intended to "blitzkrieg the citadels of enlighten-ment," whipping up the complete derangement of the senses as preached through the centuries by earlier hashishins like Rimbaud, Baudelaire and, most particularly, the legendary Old Man of the Mountain, Hassan i Sabbah, who terrorized Islam from his fortress of Alamout in the 11th century. Gysin's thought, as Burroughs has pointed out, is categorically divorced from any preconceived religious or philosophical system.

"... All the religions of the 'peoples of the Book,' that is, the Jews, the Christians, and the Moslems... are based on the idea that in the beginning was the Word," Gysin emphasizes. "Everything seems to be wrong with what was produced from those beginnings... [Our] methods were first of all a disruption of the Time sequence... produced by the Cut-Ups, and one had the idea of rubbing out the Word itself, not simply disrupting its sequential order, and finding out some other way. There are other ways of communication, so an attempt at finding them would begin by rubbing out the Word. If the whole thing began with the Word, well then, if we don't like what was produced—and we don't—let's get to the root of the matter and radically alter it.

"Painters and writers of the kind I respect want to be heroes, challenging fate in their lives and in their art... Fate is written... if you want to challenge and change fate... cut up the words. Make them make a new world." (*Rolling Stone* pp.51-53)

The important collaborations on this mission were Gysin, Burroughs, Sommerville and Antony Balch, who took the Cut-Ups and Permutations directly into the realm of film with *Towers Open Fire*, *The Cut-Ups*, *Guerilla Conditions*,... etc. Other white American compatriots residing in the Beat Hotel were, as Gysin says, just about ready to collapse with a whimper or run screaming for the police in the face of all this.

Immediately after the Cut-Up technique was demonstrated to him, Burroughs had taken it up with enormous enthusiasm and applied it to the monster manuscript from which he had already culled *Naked Lunch*. The Cut-Ups were "used in (on?) *Naked Lunch* without the

author's full awareness of the method he was using," Burroughs wrote later. "The final form of *Naked Lunch* and the juxtaposition of sections were determined by the order in which the material went—at random—to the printer." (*Third Mind* pp.42-43) Now, with full awareness of the method, he produced the famous trilogy—*Dead Fingers Talk, The Soft Machine, The Ticket That Exploded.*

"William used his own highly volatile material, his own inimitable texts which he submitted to cuts, unkind cuts," Gysin says. "He was always the toughest of the lot. Nothing ever fazed him..." (*Here To Go* p.185) Gregory Corso, on the other hand, was somewhat more than fazed. Corso collaborated, along with Gysin, Burroughs and Sinclair Beiles, on *Minutes To Go*, the first book of Cut-Ups, but for the final page contributed a "postscript" making it obvious that he was still completely staggered that anyone could possibly ask him to cut up his "very own words" — as if they were "no sacred texts at all," as Ginsberg said. (*Beat Book* pp.77-78)

"... the poetry I have written was from the soul and not from the dictionary," Corso protested. "Word poetry is for every man, but soul poetry — alas, is not so heavily distributed... my poetry is a natural cut-up, and need not be created by a pair of scissors... I have agreed to join Mr. Gysin, Mr. Beiles, and Mr. Burroughs in this venture, and so to the muse I say: 'Thank you for the poesy that cannot be destroyed that is in me'... " (*Minutes To Go* p.63)

Ginsberg acknowledged the "serious technical point" made by the Cut-Ups but admitted that he had also "resisted and resented" it, "since it threatened everything I depend on... the loss of Hope and Love; & could maybe even stand the loss of them, whatever they are, if Poesy were left, for me to go on being something I wanted, sacred poet however desolate; but Poesy itself became a block to further awareness. For further awareness lay in dropping every fixed concept of self, identity, role, ideal, habit and pleasure. It meant dropping language itself, *words*, as medium of consciousness. It meant literally altering consciousness outside of what was already the fixed habit of language-inner-thought-monologue-abstraction-mental-image-symbol-mathematical abstraction. It meant exercises, exercises in thinking in music, colors, no-thinks, entering and believing hallucinations, altering on neurologically fixated habit pattern Reality. But that's what I thought Poetry was doing all along! *But* the poetry I'd been practicing depended on living inside the structure of language, depended on words as the medium of consciousness and therefore the medium of conscious being. Since then I've been wandering in doldrums, still keeping habit up with literature... " (*Beat Book* p.78)

Ginsberg wrote to Burroughs from South America of the terrors of yage and of his resistance to and resentment of Cut-Ups. Burroughs' reply was firm:

> June 21, 1960
> Present Time Pre-Sent Time
> London England

*Dear Allen:*
*There is nothing to fear. Vaya adelante. Look. Listen. Hear. Your AYUASKA consciousness is more valid than 'Normal Consciousness.' Whose 'Normal Consciousness'? Why return to?... Tried more than once to tell you to communicate what I know. You did not or could not listen. 'You can not show to anyone what he has not seen.' Brion Gysin for Hassan Sabbah. Listen now? Take the enclosed copy of this letter. Cut along the lines. Rearrange putting section one by section three and section two by section four... Listen. Cut and rearrange in any combination. Dont think about it. Dont theorize. Try it. Do the same with your poems. With any poems any prose. Try it. You want 'Help.' Here it is... ACROSS ALL YOUR SKIES SEE THE SILENT WRITING OF BRION GYSIN HASSAN SABBAH. THE WRITING OF SPACE. THE WRITING OF SILENCE...*
> William Burroughs
> For Hassan Sabbah
> Fore! Hassan Sabbah

(*Yage Letters* pp.64-66)

While all this was going on, there were exhibitions, performances, animated readings with permutated recordings and projections throughout Europe and in England, a period Gysin remembers as "one enormous intellectual high." (*Rolling Stone* op cit)

In 1965, Gysin and Burroughs were in New York preparing text and illustrations for another joint work, *The Third Mind*, which was to be a complete statement in words and pictures of what the two had achieved, from the first Cut-Ups through to scrapbook texts and images culminating in "Hieroglyphic Silence." In fact, it would be another thirteen years before *The Third Mind* appeared in an English language edition. Publishers, like many others, appreciated the "serious technical point" all too well, while resisting and resenting it on every level. Gysin left for Tangier to start work on a novel, *The Process*.

"Few books have sold fewer copies and been more enthusiastically read," Burroughs wrote later of *The Process*. "Perhaps the basic message of the book is too disquieting to receive wide acceptance as yet... " (*Here To Go* p.188)

In *The Process* the Word *is* Female, the instrument of female illusion which must be rubbed out. The novel builds itself around a series of extraordinary encounters and experiences in Morocco involving Thay and Mya Himmer, a dauntless John and Mary-type couple, bigtime players. All of the sections of *The Process* are presented as transcripts of tapes made by the Himmers and the other characters. There is no omniscient author. Ulysses O. Hanson, sometimes known as Hassan, a traveller through a great desert where there are no brothers, nothing is true and everything is permitted, has possession of the tapes and thus is entitled to transcribe and present some form of continuity for those who require it.

"The sands of Present Time are running out from under our feet. And why not? The Great Conundrum: 'What are we here for?' is all that ever held us here in the first place. Fear. The answer to the Riddle of the Ages has actually been out on the street since the First Step in Space. Who runs may read but few people run fast enough. What are we here for? Does the great metaphysical nut revolve around that? Well, I'll crack it for you, right now. What are we here for? *We are here to go!*" (*The Process* p.325)

Such is *The Process*. The last section is called THEY. These Last Words are not spoken by a human voice. The words have been made to talk on their own. *The Process* is the beginning and end of Word.

From 1970 to 1973 Gysin moved between Tangier, London, Cannes, Venice and New York, working on a scenario of *Naked Lunch* to be filmed by Antony Balch, a still unfulfilled project (Balch died in 1980), and started work on a new novel, *Bardo Hotel*, which is still in progress. *The Third Mind* was published in France in 1976 and, finally, in America in 1978.

Brion Gysin with Dreamachines, NYC, Chelsea Hotel, 1965.

"The Dreamachine makes visible the fundamental dynamic order present in the physiology of the brain. Recent research into the structure of brain rhythms suggests that it is in a state of relaxation of thought that new relationships can be seen." —B.G.

A recent profile by Jon Savage in the London new wave magazine *The Face* concentrated on the younger artists inspired by Gysin's "lifetime of research predicated on the removal of false consciousness:" The Rolling Stones—Gysin took Brian Jones up to Jajouka in 1967, resulting in the posthumous LP *Brian Jones Presents the Pipes of Pan at Joujouka*; all the repetitive composers as well as David Bowie, Nick Roeg and Donald Cammell. "More recently Throbbing Gristle and Cabaret Voltaire have produced work that researches the Burroughs/Gysin discoveries further... Between them they've managed to take cut-ups out of the 60s." (*The Face* p.20)

In the 80s, the Dreamachine at last is being manufactured and seems set to be the drugless turn-on it should have been in the 60s. The long-awaited *Bardo Hotel* — the first chapter was published in Basel in 1977 as "Beat Museum—Bardo Hotel," dedicated to Ian Sommerville who died in 1976 — will undoubtedly be as much of a landmark in literature as *The Process* — and as uncompromising and disquieting. (Hopefully it will not be as unobtainable. Friends and even acquaintances of Gysin are regularly assailed by correspondents asking where they can possibly purchase a copy.) His tape experiments in 1960 have made him a "father" of Sound Poetry, with I AM THAT I AM a classic, broadcast by recordings, radio and telephone worldwide. He has never stopped experimenting and is unable to do so.

He and Burroughs are recognized by the young cultural underworld as *the* influential living Elders.

—*Terry Wilson*
June 1981

## References

William Burroughs, Allen Ginsberg, *The Yage Letters* (San Francisco: City Lights Books, 1963)

William S. Burroughs, Introduction to *Desert Devorant (The Process)* (Paris: Flammarion, 1975)

Arthur Winfield Knight, Glee Knight (editors), *The Beat Book* (p.o.b 439, California, Pennsylvania, 1974)

Terry Wilson, *Here To Go: R-101*. Brion Gysin interviewed by Terry Wilson, with texts by Brion Gysin and William S. Burroughs. A forthcoming *Rough Trade* book.

## Other

*Brion Gysin, To Master A Long Goodnight* (New York: Creative Age Press, 1946)

*The History of Slavery in Canada* (New York: Creative Age Press, 1946)

*Brion Gysin, Let the Mice In* (texts by Gysin, Burroughs and Sommerville) (West Glover, Vermont: Something Else Press, 1973)

*Beat Museum—Bardo Hotel*—Chapter One (Basel-Paris: *Soft Need Brion Gysin Special*, Expanded Media Editions, 1977)

William S. Burroughs, "Ports of Entry," October Gallery Catalogue (1981)

Nicolas Calas, *Poetry World*, Paris (1939)

Rob La Frenais, Graham Dawes, "The Deceptual Art of Brion Gysin," *Performance Magazine* #11, 1981

Robert Palmer, Interview with William Burroughs and Brion Gysin, *Rolling Stone* May 11, 1972

Jon Savage, "The Life of Brion," *The Face* 13, May 1981

Jason Weiss, "Gysin: Inventor, Painter, Poet," *International Herald-Tribune* (October 4-5, 1980)

Terry Wilson, "Planet R-101: Here To Go," *Soft Need Brion Gysin Special* (1977)

# HERE TO GO: PLANET R-101

An Excerpt from *Here To Go: Planet R-101*, by Terry Wilson…

T How did you get into tape recorders?

B I heard of them at the end of World War II, before I went to Morocco in 1950, but unfortunately I never got hold of good machines to record even a part of the musical marvels I heard in Morocco. I recorded the music in my own place, The 1001 Nights, only when it was fading and even in later years I never was able to lay my hands on truly worthwhile machines to record sounds that will never be heard again, anywhere.

I took Brian Jones up to the mountain to record with Uhers, and Ornette Coleman to spend $25,000 in a week to record next to nothing on Nagras and Stellavox, but I have to admit that the most adventurous sounds we ever made were done with old Reveres and hundred dollar Japanese boxes we fucked around with, William and I and Ian Sommerville. I got hold of the BBC facilities for the series of sound poems I did with them in 1960, technically still the best, naturally. I had originally been led to believe that I would have a week and it turned out to be only three days that we had, so in a very hurried way at the end I started cutting up a spoken text—I think the illustration of how the Cut-ups work, "Cut-ups Self Explained"—and put it several times through their electronic equipment, and arrived at brand new words that had never been said, by me or by anybody necessarily, onto the tape. William had pushed things that far through the typewriter. I pushed them that far through the tapeworld. But the experiment was withdrawn very quickly there, I mean, it was… *time* was up and they were made rather nervous by it, they were quite shocked by the results that were coming back out of the speakers and were only too glad to bring the experiment to an end.*

What we did on our own was to play around with the very limited technol-ogy and wattage we had in the old Beat Hotel, 40-watts a room was all we were allowed. There is something to be said for poverty, it makes you more inventive, it's more fun and you get more mileage out of what you've got plus your own ingenuity. When you handle the stuff yourself, you get the feel of it. William loved the idea of getting his hands on his own words, branding them and rustling anyone else's he wanted. It's a real treat for the ears, too, the first time you hear it. I started fiddling around with superspeeds and overlays as soon as I could. I've got a theory that this is one of the things Bebop sprang out of the first time Dizzy Gillespie and Thelonious Monk and them heard themselves at double speed and then at quadruple and on up to so many decibels you can't really hear it… made for dog whistles, after that. *Hey Rube!* — the old carny circus cry for men working the sideshows when they saw some ugly provincial customer coming up on them after they had rooked him… *Hey Rube!* —a cry to alert all the carny men to a possible rumble… *Hey-ba ba Rube-ba!* — *Salt Peanuts* and the rude sound coming back so insistent again and again that you know the first bar of Bebop when you hear it. Right or wrong, Burroughs was fascinated because he must have listened to plenty of bebop talk from Kerouac, whom I never met. He must have been a fascinating character, too bad to miss him like that, when I was thrown up against all the rest of this Beat Generation. Maybe I was lucky. I remember trying to avoid them all after Paul Bowles had written me: "I can't understand their interest in drugs and madness." Then, I dug that he meant just the contrary. Typical. He did also write me to get closer to Burroughs whom I had cold-shouldered… until he got off the junk in Paris.

T Who produced the "Poem of Poems" through the tape recorder? The text in *The Third Mind* is ambiguous.

B I did. I made it to show Burroughs how, possibly, to use it. William did not yet have a tape recorder. First, I had "*accidentally*" used "*pisspoor material*," fragments cut out of the press which I shored up to make new and original texts, unexpectedly. Then, William had used his own highly volatile material, his own inimitable texts which he submitted to the cuts, unkind cuts, of the sort that Gregory Corso felt unacceptable to his own delicate "poesy." William was always the toughest of the lot. Nothing ever fazed him. So I suggested to William that we should use only the best, only the high-charged material: King James' translation of the *Song of Songs* of Solomon, Eliot's translation of *Anabase* by St. John Perse, Shakespeare's sugar'd *Sonnets* and a few lines from *The Doors of Perception* by Aldous Huxley about his mescaline experiences.

Very soon after that, Burroughs was busy punching to death a series of cheap Japanese plastic tape recorders, to which he applied himself with such force that he could punch one of them to death inside a matter of weeks, days even. At the same time he was punching his way through a number of equally cheap plastic typewriters, using two very stiff forefingers… with enormous force. He could punch a machine into oblivion. That period in the Beat Hotel is best illustrated by that photo of William, wearing a suit and tie as always, sitting back at this table in a very dingy room. On the wall hangs a nest of three wire trays for correspondence which I gave him to sort out his cut-up pages. Later, this proliferated into a maze of filing cases filling a room with manuscripts cross-referenced in a way only Burroughs could work his way through, more by magic dowsing than by any logical system. How could there be any? This was a magic practice he was up to, surprising the very springs of creative imagination at their source.

44

I remember him muttering that his manuscripts were multiplying and reproducing themselves like virus at work. It was all he could do to keep up with them. Those years sloughed off one whole Burroughs archive whose catalogue alone is a volume of 350 pages. Since then several tons of Burroughs papers have been moved to the Burroughs Communication Centre in Lawrence, Kansas. And he is still at it.

From the archives of
## William S. Burroughs
"Nothing Here Now, but the Recordings"

T The cut-up techniques made very explicit preoccupation with exorcism — William's texts became spells, for instance. How effective are methods such as street playback of tapes for dispersing parasites?

B *We-e-ell*, you'd have to ask William about that, but I do seem to remember at least two occasions on which he *claimed* success…

Uh, the first was in the Beat Hotel still, therefore about 1961 or '2, and William decided (laughing) to "take care" of an old lady who sold newspapers in a kiosk, and this kiosk was rather dramatically and strategically placed at the end of the street leading out of the rue Git le Coeur toward the Place Saint Michel, and, uh, you went up a flight of steps and then under an archway and as you came out you were *spang*! in front of this little old French lady who looked as if she'd been there since—at *least* since the French Revolution—when she had been knitting at the foot of the guillotine, and she lived in a *layer* of thickly matted, padded newspapers hanging around her piled very sloppily, and, uh, she was of absolutely *incredible* malevolence, and the only kiosk around there at that time that sold the *Herald-Tribune*, so that William (chuckling) found that he was having to deal with her every day, and every day she would find some new way to aggravate him, some slight new improvement on her malevolent insolence and her disagreeable lack of… uh (chuckling) collaboration with William in the buying of his newspaper (laughter)…

So… one day the little old lady burnt up inside her kiosk. And we came out to find that there was just the pile of ashes on the ground. William was… slightly conscience-stricken, but nevertheless *rather satisfied* with the result (laughter) as it proved the efficacy of his methods, but a little taken aback, he didn't necessarily mean the old lady to burn up inside there… And we often talked about this as we sat in a café looking at the spot where the ashes still were, for many months later… and to our great surprise and chagrin one day we saw a very delighted Oriental boy—I think probably Vietnamese—digging in these ashes with his hands and pulling out a whole hatful of money, of slightly blackened coins but a considerable sum, and (laughing) we would have been very glad to have it too — just hadn't *thought* about digging in the thing, so I said: "William, I don't think that your operation was a complete success." And he said: "I am very glad that that beautiful young Oriental boy made this happy find at the end of the rainbow… "

T She consummated her swell purpose…

B (Laughing) Exactly… exactly… (chuckling)

Now the other case was some years later in London when he had perfected the method and, uh, went about with at least one I think sometimes two tape recorders, one in each hand, with prerecorded um—runes—what did you call them? You said Williams' things—

T Spells.

B Spells, okay, spells.

T Like—

B (chanting)

*Lock them out and bar the door,*
*Lock them out for e-v-e-rmore.*
*Nook and cranny window door*
*Seal them out for e-v-e-rmore*
*Lock them out and block the rout*
*Shut them scan them flack them out.*
*Lock is mine and door is mine*
*Three times three to make up nine…*
*Curse go back curse go back*
*Back with double pain and lack*
*Curse go back — back*

Et cetera… yeah… *pow*… "Shift, cut, tangle word lines"… sure…

*Well*, that was for the Virus Board, wasn't it, that he was gonna destroy the Virus Board…

*("Well, what did they expect? A chorus of angels with tips on the stock market?"—William Burroughs) "The Permutated Poems of Brion Gysin" (as put through a computer by Ian Sommerville) was broadcast by the BBC, produced by Douglas Cleverdon. ("Achieving the second lowest rating of audience approval registered by their poll of listeners"—BG) Some of the early cut-up tape experiments are now available: *Nothing Here Now But The Recordings* (1959-1980) LP (IR 0016) available on the Industrial Records label from Rough Trade, 137 Blenheim Crescent, London W11, England.

An Excerpt from *Here To Go: Planet R-101*, Brion Gysin interviewed by Terry Wilson (with original writing and an introduction by W.S. Burroughs), available July 1982 from Re/Search Publications...

# HERE TO GO: PLANET R-101

*— Who Runs May Read*

"May Massa Brahim leave this house as the smoke leaves this fire, never to return..."

... Never went back to live, and I've only been back there even to visit only very briefly...

And then it was back to Paris for a year or so, 1949-50, and then in 1950 I went to Morocco with Paul Bowles, who had taken, bought a little house there, and I stayed there really, or felt that I was domiciled there, uh, although I was really only a sort of terminal tourist, from 1950 till 1973...

"Magic, practiced more assiduously than hygiene in Morocco, through ecstatic dancing to the music of the secret brotherhoods, is, there, a form of psychic hygiene. You know your music when you hear it, one day. You fall into line and dance until you pay the piper."

BG "CUT-UPS:
A Project for Disastrous Success"
in *Brion Gysin Let The Mice In*

B Yeah... what a tale... what a tale... yeah, I met John Cooke in Morocco uuummm but, uh... I don't know what to say about all that, really...

T He designed tarot cards?

B Yeah...

T A new set of tarot cards...

B Yeah, so he did. How did you even know that?

T I saw them the other day.

B Oh really?... No kidding? They're still around eh? Well well...

T Is he still alive?

B Yes, I imagine he's still alive. I think living in Mexico*... and he comes from one of those very rich and powerful families who were the Five Founding Families of Hawaii... who own the island, did own the island of Molokai... and, uh, many people in his family have been interested in mystic things, and he was particularly interested in magic all his life... early connection with... what do they call it, kaluhas or something, the Hawaiian shamanistic magic men?... Kahunas, yeah...

T Yeah. So tell me about Morocco... you got more and more immersed into Islam, or, uh—

B Not really, no, I never was much immersed truly into Islam, or I would've become a Moslem, and probably still be there... uh, it was most particularly the music that interested me. I went with Paul Bowles, who was a composer long before he was a writer, and, uh, he has perfect pitch, an unusual thing even among composers, and he taught me how to use my ears a great deal during the years we'd known each other in New York, but when he'd taken this house, bought this house in Tangier, he suggested that I go and spend a summer there living in the house and he was on his way to America, he was just going to leave me in the house... but it turned out rather differently... he was going to New York to write the music for his wife's play, Jane Bowles' *In The Summerhouse*, and he had written a great deal of theatrical music for Broadway, all the Tennessee Williams plays, all of the plays by Saroyan, and many other productions of that time... and was a great expert on that... but he also had very very extraordinary ears, and, uh, he taught me a lot of things, I owe him a tremendous amount, I owe him my years in Morocco really because I wouldn't't've gone there if he hadn't suggested it at that particular time... I might have gone back to Algeria, which isn't nearly as interesting a country, never was...

But, uh, in 1950 we went to a festival outside of Tangier on the beach, on the Atlantic shore, at a spot which was

---

* John Cooke died sometime after this was recorded.

previously a small harbor, 2000 years ago in Phoenician times, and must've marked one of the first landfalls that any boat coming out of the Mediterranean via the Straits of Gibraltar would make as soon as the boat entered the Atlantic, the first landfall would be at this little place not very far from Cape Spartel... and, uh, the Phoenician habit was always to establish a center of religion, I mean a thanks offering for getting them safely over the dangerous sea, one supposes, and a marking of the spot which eventually became a center of their religious cult, presumably a college of priestesses... two or three more landfalls further down the Atlantic coast is what used to be the great harbor of Larache...

All these harbors are now silted up completely... Larache was the site of the Golden Apples of the Hesperides, where Hercules went to get away from the demonic... the orgiastic priestesses, who were guardians in a sacred grove surrounded by a serpent if you remember, a dragon — well the dragon is the river, in each case there are these winding rivers that go back up into the country; only one of them still exists, the Lixos. Well the Lixos was presumably the dragon in the mythological tale and there was an island in the harbor, and this spot that we went to had been on the same geographic and even religious plan, as it were, and the festival was given there, which doesn't correspond to the Lunar Calendar but to the Solar Calendar, and has to do with the harvest and actual cycle of agricultural life of the people there... And I heard some music at that festival about which I said: "I just want to hear that music for the rest of my life. I wanna hear it everyday all day." And, uh, there were a great many other kinds of extraordinary music offered to one, mostly of the Ecstatic Brotherhood who enter into trance, so that in itself—it was the first time I'd seen large groups of people going into trance—was enough to have kept my attention, but be-

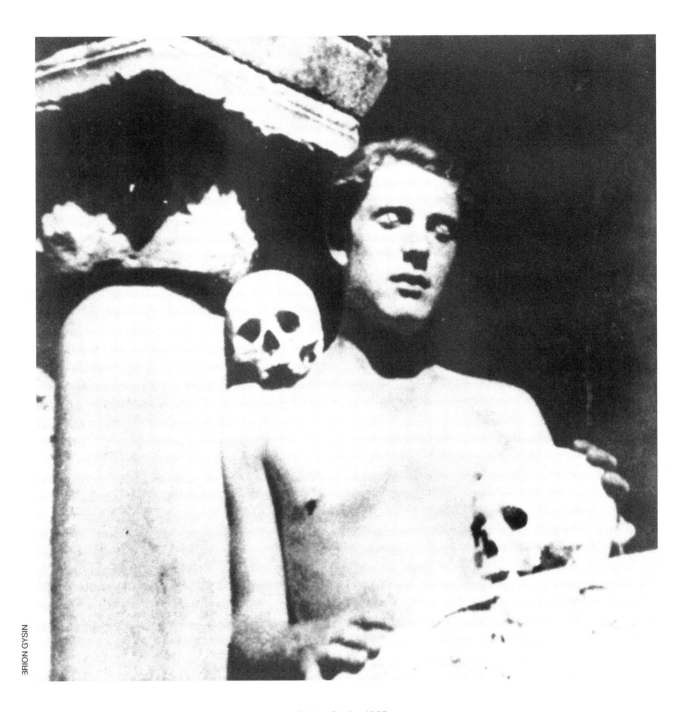

**Brion Gysin, 1935.**

yond and above all of that somewhere I heard this funny little music, and I said: "Ah! That's my music! And I must find out where it comes from." So I stayed and within a year I found that it came from Jajouka…

(LOUD CRASHES, TAPE STOPS)

B Your question… ?!

T You found that your music was at Jajouka… The purpose of the Rites of Jajouka is to preserve the balance of Male-Female forces, is that correct?

B Yes, in a very strange way I think it's a very pertinent question that you ask. Uh, when I met them finally, it took about a year to find them, and went up to the mountain village, I recognized very quickly that what they were performing was the Roman Lupercal, and the Roman *Lupercalia* was a race run

from one part of Rome, a cave under the Capitoline Hill, which Mussolini claimed to have discovered, but is now generally conceded to be some 10 or 15 meters further down… and in this cave goats were killed and skinned and a young man of a certain tribe was sewn up in them, and one of these young men was Mark Antony, and when in the beginning of *Julius Caesar*, when they meet, he was actually running this race of *Lupercalia* through Rome

on the 15.March, the Ides of March… and the point was to go out to the gates of Rome and contact Pan, the God of the Forests, the little Goat God, who was Sexuality itself, and to run back through the streets with the news that Pan was still out there fucking as he flailed the women in the crowds, which is why Julius Caesar asked him to be sure to hit Calpurnia, because his wife Calpurnia was barren… *Forget not in thy haste, Antonius, to touch Calpurnia, for the Ancients say that in this holy course the barren are rendered fruitful*, or something like that, are the lines from Shakespeare on the subject… Shakespeare dug right away that's what it was, the point of the sexual balance of nature which was in question… And up there on the mountain another element is added, inasmuch as the women, who live apart from the men, whose private lives are apart from the men, whose private lives are apart from the men's lives to a point where even women's language isn't immediately understood by men— women can say things to each other in front of men that men don't even understand, or care to be *bothered* with, it's just women's nonsense, y'see… and they sing sort of secret little songs enticing Bou Jeloud the Father of Skins, who is Pan, to come to the hills, saying that… We will give you the prettiest girls in the village, we will give you Crosseyed Aisha, we will give you Humpbacked—… naming the names of the different types of undesirable non-beauties in the village, like that, and, uh, Pan is supposed to be so dumb that he falls for this, because he will fuck anything, and he comes up to the village where he meets the Woman-Force of the village who is called Crazy Aisha—Aisha Homolka… well Aisha is of course an Arab name, but it's derived from an earlier original, which would be Asherat, the name of Astarte or any one of these Venus-type lady sex-goddesses like that… And, uh, Bou Jeloud, the leader of the festival, his role is to marry Aisha, but in actual fact women do not dance in front of any but their own husbands, the women in Arab life, all belly-dancing movies to the contrary, do not dance in public, or never did, and most certainly don't in villages, ever dance where they're seen by men any more than men dance in front of women… so that Crazy Aisha is danced by little boys who are dressed as girls, and because her spirit is so powerful—

(TAPE STOPS)

"… a faint breath of panic borne on the wind. Below the rough palisade of giant blue cactus surrounding the village on its hilltop, the music flows in streams to nourish and fructify the terraced fields below.

"Inside the village the thatched houses crouch low in their gardens to hide in the deep cactus-lined lanes. You come through their maze to the broad village green where the pipers are piping; fifty *raitas* banked against a crumbling wall blow sheet lightning to shatter the sky. Fifty wild flutes blow up a storm in front of them, while a platoon of small boys in long belted white robes and brown wool turbans drum like young thunder. All the villagers, dressed in best white, swirl in great circles and coil around one Wild-man in skins.

"Bou Jeloud leaps high in the air on the music, races after the women again and again, lashing at them fiercely with his flails—'Forget not in your speed, Antonius, to touch Calpurnia'—He is wild. He is mad. Sowing panic. Lashing at anyone; striking real terror into the crowd. Women scatter like white marabout birds all aflutter and settle on one little hillock for safety, all huddled in one quivering lump. They throw back their heads to the moon and scream with throats open to the gullet, lolling their tongues around in their heads like the clapper in a bell. Every mouth is wide open, frozen into an O. Head back and hot narrow eyes brimming with dangerous baby.

"Bou Jeloud is after you. Running. Over-run. Laughter and someone is crying. Wild dogs at your heels. Swirling around in one ring-a-rosy, around and around and around. Go! Forever! Stop! Never! More and No More and No! More! Pipes crack in your head. Ears popped away at barrier sound and you deaf. Or dead! Swirling around in cold moonlight, surrounded by wild-men or ghosts. Bou Jeloud is on you, butting you, beating you, taking you, leaving you. Gone! The great wind drops out of your head and you hear the heavenly music again. You feel sorry and loving and tender to that poor animal whimpering, grizzling, laughing and sobbing there beside you like somebody out of ether. Who is that? That is you.

"Who is Bou Jeloud? Who is he? The shivering boy who was chosen to be stripped naked in a cave and sewn into the bloody warm skins and masked with an old straw hat tied over his face, HE is Bou Jeloud when he dances and runs. Not Ali, not Mohamed, then he *is* Bou Jeloud. He will be somewhat *taboo* in his village the rest of his life.

"When he dances alone, his musicians blow a sound like the earth sloughing off its skin. He is the Father of Fear. He is, too, the Father of Flocks. The Good Shepherd works for him. When the goats, gently grazing, brusquely frisk and skitter away, he is counting his flock. When you shiver like someone just walked on your grave—that's him; that's Pan, the Father of Skins. Have you jumped out of your skin lately? *I've got you under my skin…*

"Blue kif smoke drops in veils from Jajouka at nightfall. The music picks up like a current turned on… On the third night he meets Aisha Homolka who drifts around after dark, cool and casual, near springs and running water. She unveils her beautiful blue-glittering face and breasts and coos.

"And he who stammers out an answer is lost. He is lost unless he touches the blade of his knife or, better still, plucks it out and plunges the blade of it into the ground between her goatish legs and forked hooves. Then Aisha Homolka, Aisha Kandisha, alias Asherat, Astarte, Diana in the Leaves Greene, Blest Virgin Miriam bar Levy, the White Goddess, in short, will be his. She must be a heavy Stone Age Matriarch whose power he cuts off with his Iron Age knife-magic.

"The music grooves into hysteria, fear and fornication. A ball of laughter and tears in the throat gristle. Tickle of panic between the legs. Gripe of slapstick cuts loose in the bowels. The Three Hadji. Man with Monkey. More characters coming on stage. The Hadji joggle around under their crowns like Three Wise Kings. Monkey Man comes on hugely pregnant with a live boy in his baggy pants. Monkey Man goes into birth pangs, and the Hadji deliver him of a naked boy with an umbilical halter around his neck. Man leads Monkey around, beating him and screwing him for hours to the music. Monkey jumps on Man's back and screws him to the music for hours. Pipers pipe higher into the air and panic screams off like the wind into the woods of silver olive and black oak, on into the Rif mountains swimming up under the moonlight.

"Pan leaps back on the gaggle of women with his flails. The women

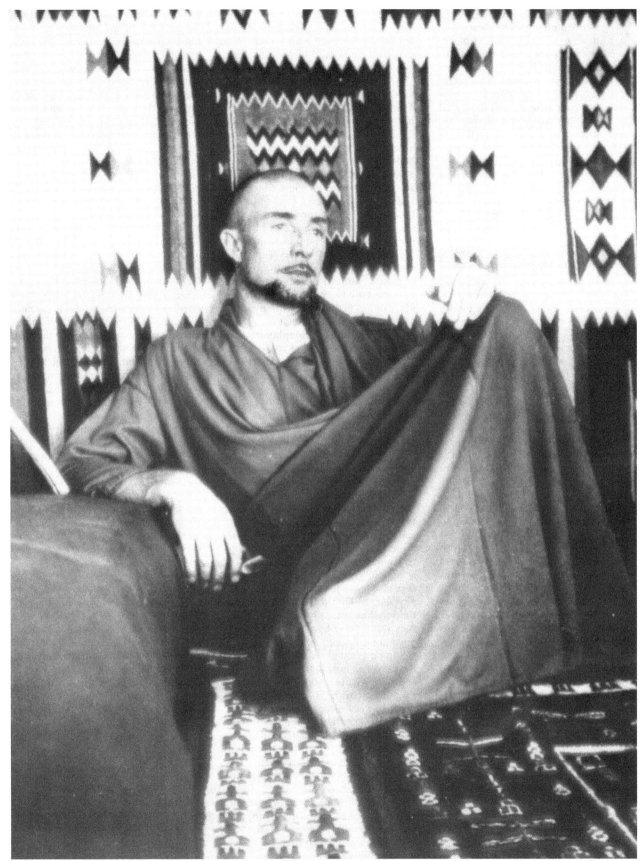

**Brion Gysin, Algiers 1956.**

scream and deliver one tiny boy, wriggling and stumbling as he dances out in white drag and veil. Another blood-curdling birth-yodel and they throw up another small boy. Pan flails them as they push out another and another until there are ten or more little boy-girls out there with Pan, shaking that thing in the moonlight. Bigger village drag-stars slither out on the village green and shake it up night after night. Pan kings them all until dawn. He is the God Pan. They are, all of them, Aisha Homolka."

BG "The Pipes of Pan"
*Gnaoua* 1, 1964

... It would be very difficult to say just what they are aware of and what they are not aware of. I have known them for more than 30 years now, 20, more than 20 of them in very intimate daily contact, with some of them at any rate, and for the period that I knew them the most...

... Obviously they know so much more than I ever thought in the beginning; I think of course they realize that their name has to do with the whole history of Sufi thought, because the family name of the musicians is Attar... uh, it was after knowing them well for 20 years and then getting into some kind of legal difficulty and attempting to help them with their documents that I found this out... uummm really the longer I knew them the less I knew about them, is almost a way of phrasing it... they, uh, know a great deal more than they let on, of course... I don't know how much, how much do *you* want to know, because I could go on for booklength about whatever I have learned about them which is curious...

"I kept some notes and drawings, meaning to write a recipe book of magic. My Pan people were furious when they found this out. They poisoned my food twice and then, apparently, resorted to more efficacious means to get rid of me..."

*BG Let the Mice in*

T Your restaurant...
B Oh the restaurant came about entirely because of them...
(CHANT BECOMING OBVIOUS ON TAPE)
I said, "I would like to hear your music

every day" and, uh, they said, "Well, why don't you just stick around and live in the village?" And I said, "No, that isn't possible, I have to go back and earn my living"... and they said, "Well, then why don't you open a little cafe, a little joint, some place in Tangier, and we'll come down and make the music, and, uh, we'll split the money?" And, uh, their idea was a very simple one, I think, which got blown up into... palatial size, because of the fact that I found a wing of a palace that belonged to some Moroccan friends of mine, where I set up a restaurant and, uh, it turned out to be a very expensive and very... as I had no previous experience in such matters, it turned out to be a very expensive venture (laughing)... I'd always been at most a customer in such places, and to learn how to run it... I had many other things to do which kept my mind off the musicians, although the rest of the staff were always complaining that the musicians were being favored, and I said yes, the restaurant existed entirely for the music, and it was literally true...

A group of them came down from the mountain and stayed a period of time, living in the house with me, and so I heard them practising, I heard them teaching the younger children how to play, and learned more and more about the intricacies of the music... I found out various interesting things about them, first of all that they had a secret language, that they can talk through the music, they can direct a dancing boy, for example, to go from... they can give him all his instructions simply musically... but that they also had a language of which I really learned nothing, I didn't have the time to, but I think that at that point they would have been willing to teach me a great deal about it, even to start writing a vocabulary to find out what it was, which language it was that they speak in private... but, uh, the restaurant folded with Moroccan Independence, a very difficult moment, when all of my clientele disappeared overnight, inasmuch as Tangier had been a small country of its own, with embassies, and ambassadors and their staffs and their visitors and everything connected with them, which was the backbone of my clientele... and they all left, and Tangier lost its independence and became part of Morocco... so the restaurant folded up and they went back to their hills...

And then I saw them later as friends,

went back to the village several times for the festival, and, uh, then the Rolling Stones came to stay in Morocco, brought along Robert Frazer, who was an art dealer in London at that time, and he knew them and brought them to visit me and we made trips together through Morocco, and Brian Jones later came back, he wanted very much to go up to the mountain, and although he never got there during the festival time he did bring a sound engineer with him and recorded the music which appears on that record*, which is now out of print I'm sure... about which there was an enormous amount of legal difficulties over trying to get money to the musicians, for all of the usual recording company reasons, and naturally complicated by the fact that Brian had died and that the other Stones were not terribly interested in the record, probably because it reminded them too much of things that they preferred to leave in the past, partly on the musical level, because Brian had wanted to take the Stones' music rather more toward the openings that Moroccan music made possible, and, uh, which have appealed to other musicians since and I think will have even more and more effect in the future... but Mick was very determined to keep it right down to that R&B which they had ripped off the American Black music, which he found a perfectly good product to last for the next 20 years, and has lasted 10, at any rate...

T So a different type of relationship with the Jajouka musicians after the restaurant folded?

B Well, I might say about it, from the beginning, uh, that I got to know them much better than most people ever would because of the fact that we were in business together, whether we were first in business around the restaurant, or later around one or other records that they'd made, uh, you really get to know people only when you do business with them, and we got to know each other very well, for good and for ill, for reasons of business...

T There was some difficulty, wasn't there...

B Plenty...

T Involved you losing the restaurant...?

B Plenty, yeah, plenty... hhmmm...
(TAPE STOPS)

---

* *Brian Jones Presents The Pipes of Pan at Joujouka*, Rolling Stones Records, 1971.

"Bou Jeloud is on you, butting you, beating you, taking you ..."

51

From a forthcoming book of interviews with Brion Gysin, edited by Genesis O-Orridge. In Paris, Jon Savage asked the questions...

**R/S:** *You said it was worth surviving the whole cancer operation because there were some things you wanted to do—*
**BRION:** Oh, you make that sound *much* too optimistic—too positive! No no... the only *reason* for surviving was to wrap up some odds and ends, and some of them are already wound up. I mean like getting *The Third Mind* published. Less satisfactory — getting Dreamachines into production, which they are, only partially. And getting some shape to my life as a painter—and that hasn't really happened yet—I mean, some successes along the way like this show at the museum... but this will take more work.
**R/S:** *Do you mean wrapping things up, or just sort of putting things in perspective, or continuing—*
**BRION:** Mostly wrapping them up. Because I have plenty of things to *continue*. Let's say—the songs that I've written with Steve Lacy*—I want to get that all onto a record... if that's the ideal receptacle for it, whatever. I have a long manuscript that I would like to finish, but I found I'm not the activist I once thought I was. It's very difficult to do too many things at once—in fact I can't really ever do *two* things at once.
**R/S:** *Is the manuscript* The Beat Hotel?
**BRION:** Yeah.
**R/S:** *The bit that was published in* Soft Need—*was that the beginning or—*
**BRION:** That was just a small piece in the middle.
**R/S:** *Ideally, would it be a book like* The Process?
**BRION:** It would have a form, yes, and I have found a form — it took me many years to find the exact form. Yes, I do now have the exact form. And I really have wanted to fill the form that I now can see ahead of me.
*The Process* certainly is a very *formed* book — the whole idea actually end-to-end. So in that same way—Yes, I do now have an exact receptacle of the form into which I would pour all this.
**R/S:** *Is that how you worked with* The Process *as well?*
**BRION:** Yes. I only was able to work when I had found the form... it filled itself in, sort of inevitably. Once the form was *recognized*, then the material slipped into its proper place quite easily.
**R/S:** *Because—in* The Process... *there's an enormous mixture. On one level there were all sorts of allusions to* Othello *and* Homer, *and then... there seemed to be people like* Mya *who were definitely sort of creations that you'd actually known. Also, there was lots of ethnic stuff about* Morocco... *there seemed to be a lot of different things—*
**BRION:** Well, I had decided very definitely to put into it practically everything that I know about Morocco, because it would be impossible for me to write any more, inasmuch as it's rather the stomping ground of Paul Bowles, who has invented his own mysterious, murderous Morocco which is not mine. But, it's his territory as much as Malaysia was the territory of Maugham... My good friend Sanche de Gramont has written a very successful book about him (*Maugham*).
**R/S:** *To a lot of people you're only known as a writer — is painting actually harder to organize?*
**BRION:** They're both very hard to organize. There are definite forms for getting a book published or not published, and getting some money or not getting any money from it... Whereas painting is much more formless, much more mysterious... As to how a piece of spoiled canvas or scribbled-on paper suddenly becomes worth an enormous amount of money... has nothing to do with the case of literature and life and a career.
**R/S:** *In all the books you put out you're actually communicating to a large number of people instantly, because—let's say the book has a run of two thousand—there'll probably be about ten thousand*

*people who read it—and that's a lot of people. That's more than will probably ever see a picture of yours...*

**BRION:** Yeah, that's true... And certainly more people can read a book than can "read" a picture, in any case. The level of *pictorial* education is not the same as just the ordinary literacy level of people who can read a book and get one kind of sense out of it, at any rate. Pictures *reverberate* much longer than a book does, because of the fact that they exist in a very different *time* from the time of a book. The time of a book is the imagined time in which the book is written (which it is meant to represent)... and the time that it takes to read it. The time in music is the time that it takes to play it from the beginning to the end. Whereas a picture changes with every second of the day because of the changing light... all of what I do changes that dramatically, even. And many people that I have known who own pictures of mine have said, "You know, I owned that picture for several years before *one day*, I happened to look at it and *then* I saw it. I had already bought it because I liked it, but I hadn't *really* seen it until several years after I had owned it." Well — that's not the same time that a book exists in.

**R/S:** *Do you actually prefer either medium, or is that irrelevant — or do you just like them both for different reasons?*
**BRION:** Yes, apparently. It's rather troublesome to me as a matter of fact — to like them equally well.
**R/S:** *Do you think the course of your career would have been different if... I think people find it very hard to cope with the fact that one does two different things at once.*
**BRION:** I certainly do, and I don't do

Brion Gysin at the October Gallery, London, 1981.

tising or public relations or god knows what, and you really get only your advance. I personally have never seen any royalties, except some so ludicrous that they're not even worth mentioning.

In regard to pictures, they are sold by a gallery which takes a percentage according to whether you have made an agreement for just that one show, or—if you are going to work a number of years with that gallery, they will then pay you a monthly stipend, and they take a much greater percentage of the price for which the picture is sold at that time. And if the picture is re-sold after that, you have no lien at all on that money. As in the case of the Jasper Johns that he sold for nine hundred dollars eleven or twelve years ago... and has now been sold for the ludicrous sum of a million dollars.

R/S: *I bet he's pissed off—*

BRION: Not really—he said he just doesn't understand it. He was brought up during the years of the Depression, and such sums are really quite unreal to him...

R/S: *What's happening with the Dreamachine? At one point... you said it could have been the drugless turn-on of the 60s. Why didn't it happen?*

BRION: One of the reasons is that... I think it *scares* people... Because of the fact that it deals with that area of *interior* vision which has never been tapped before. Except in history, one knows of cases—in French history, Catherine de Medici for example, had Nostradamus sitting up on the top of a tower (which is now just being restored, at the present time, over there). And there was no pollution in those days... one didn't have any screen between the man on top of the tower and the sun. And he used to sit up there and with the fingers of his hand spread like this would flicker his fingers over his closed eyes, and would interpret his visions in a way which were of influence to her in regard to her political powers... they were like instructions from a higher power.

R/S: *But they were good visions—*

BRION: They could also foretell bad things too. Peter the Great also had somebody who sat on the top of a tower and flickered his fingers like that across his closed eyelids... And any of us today can go and look out the window or lie on a field and do it, and you get a great deal of the *type* of visions—in fact, it's the same area in the alpha bands of excitation of the brain—within the alpha band between eight and thirteen flickers a second. And the Dreamachine produces this

just two. I do more than two. Yes—as you understand the word "career"—it's certainly a mistake to do more than one thing. In fact, even if it's only in sports or in a physical skill of some kind, you are better off to do just one thing... Not everybody can be a decathalon hero...

R/S: *How do your paintings get out? Do they all go through galleries, or—*

BRION: No, *exhibitions.* I've never had a gallery that really occupied itself with my career at all, and that's a very considerable lack. As I was saying to you, it's insane that my work should be in all the museums in France and all the important museums in America, and not in any

gallery. But that's obviously my fault... more my fault than theirs, at any rate.

R/S: *Presumably, painting is actually also different from a business point of view, in that you presumably (if you have an exhibition, sell paintings) make a fair amount of money every few years. Whereas with a book, you may not make any money at all, but they might come out more frequently—*

BRION: No, it doesn't really work that way. If you make a book which is a hit book, you make quite a good deal of money. If you make anything less than a hit, you make nothing at all. Because they find ways of charging it off to adver-

continuously, without interruption, unless you yourself interrupt it by opening your eyes like that.

So, the experience can be pushed a great deal further—into an area which is like real dreams. For example, very often people compare it to films. Well, who can say who is projecting these films—where do these films come from? If you look at it as I am rather inclined to now—like being the *source of all vision*—inasmuch as within my experience of many hundreds of hours of looking at the Dreamachine, I have seen in it practically everything that I have ever seen—that is, *all imagery*. All the images of established religions, for example, appear—crosses appear, to begin with; eyes of Isis float by, and many of the other symbols like that appear as if they were the Jungian symbols that he considered were common to all mankind.

And then one goes very much further—one gets flashes of memory, one gets these little films that are apparently being projected into one's head... one then gets into an area where all vision is as in a complete circle of 360 degrees, and one is plunged into a dream situation that's occurring all around one. And it may be true that this is *all* that one can see... that indeed the alpha rhythm contains the whole human program of vision. Well—that is a big package to deal with—and I don't think anybody particularly wants... *amateurs* sitting in front of Dreamachines fiddling with it, perhaps...

R/S: *Are you paranoid or realistic (depending on your definition of that). Do you think that part of the fact that the Dreamachines haven't turned out is deliberate?*
BRION: Somebody said that the lesson of the 60s was the fact that all the paranoids turned out to be right!
R/S: *I think William Burroughs said that: a paranoid is somebody who knows what's going on—*
BRION: Who sees what's happening. And it's a very easy package of *dismissal* into which to dump every kind of objection to what *is* going on. Who can say? I don't really know—it seems to me much more random than that. I don't feel paranoid in that—I don't think there's some sort of *agency* after me—or if they are, they're doing it with kid gloves...

R/S: *Talking about dream-like states... is there any sort of Surrealist source in that? Because they were trying... they made*

*some attempts to merge the two states... Has the Dreamachine and even cut-ups taken it a whole stage further?*
BRION: Oh, but quite a *different* stage. It's actually dealing with the material involved—I mean, cut-ups are taking the actual matter of writing as if it were the same as the matter involved in sculpting or in painting... and handling it with a plastic manner. The Dreamachine is something else again, as it gives an extended vision of one's own interior capacities, which could also be overwhelming. After all, people could think that these were being *imposed* upon them—before they were capable of realizing that they were a part of all human experience. And from there—say they *did* realize that— well, a great deal of what they see in life would be changed, it's true.

In some people's lives, they say, "Oh, yes, I've had visions like that when I rubbed my thumbs in my eyes," or, "Yes, I remember one time I was going past a row of trees" or something or another like that. It would become more general knowledge that this is part of one's interior vision, and I think that—I would even go as far as saying that this particular century in which we live has given a great importance to painting, and this knowledge of one's own interior possibilities would rather lessen its importance—as there have been other centuries which have given greater importance to say, *architecture* or *music*. Painting itself looks to me like it's on its way out—as though it were dying on the vine. And this recognition of one's own interior possibilities might very well supplant that.
R/S: *Why would you say painting is dying on the vine? Is it because of the gallery system... is it because of the social and cultural place it has?*
BRION: No, it really began with the Einstein apprehension of the physical quality of the world, where the energy of the world (which is supposed to be represented in the arts, after all) is declared to equal *m*, which is the mass of the earth times the speed of light squared. And anybody who realizes that you can change the force in an equation—you can change the elements from one side to the other of the equation—in the same way people realized that the *matter* of painting (which for the last few centuries has been considered to be colors, ground colors floated in oil and laid onto a surface and dried, producing an effect of luminosity and transparency) could be changed by adding pieces of cut-up newspaper as the Cubists did, or throwing sand into the mixture to produce

exploding kind of matter itself. So, matter was being played with very early in painting... by the beginning of the twentieth century, at any rate...

Here's the *energy*—which is sort of the talent or the genius of the artist—represented by the speed of light squared which is a flash vision forward. And the *m* is the oil and vinegar mixture—like I always said—like you're making a salad... here was oil and linseed oil and lengtheners like turpentine and whatnot were used as a medium in which to float colors and produce an *image of the world*. But then one saw that that *image* was not sufficient. By the time that photography had jumped into its place in the middle of the nineteenth century, people had announced it: "As of today, painting is dead!" That was the announcement with which photography was hailed, at the time, and there was such a grain of truth in this, that one thought that obviously pursuing the exact representation and the way of... hyperrealism was no longer interesting—so let's try and change the nature of the *matter*. And so—sand was thrown into the canvas... collages were invented, and that's why I thought that all of those techniques which had entered into the arts in the beginning of the nineteenth century hadn't even touched the realm of literature yet.

R/S: *I think you'd be surprised to see how much cut-ups have actually been assimilated and taken for granted—*
BRION: That's true—even in France, where it doesn't work nearly as well because of the nature of the language... Almost immediately, within the very first few months, there was a group of American poets that brought out a two-volume book of their 'genius' work called *Locus Solus*, which was *all* cut-ups. But they never acknowledged it—it happened within six months of the publication of *Minutes To Go*, in January 1960.
R/S: *How did you work with the cut-ups— was it an accident which you then observed and then built upon systematically?*
BRION: Yes—that's what it was, an accident... but which I *recognized* immediately as it happened, because of knowing of all the other past things—I knew about the history of the arts, let's say. And it seemed like a marvelous thing to give to William, who had a huge body of work to which it could immediately be applied. It wasn't applicable to my condition because I didn't have that body of work just to take and cut up and produce something new with. I would have to produce new work which then I would

cut up—it seemed like a contradiction in terms. And William was doing so well with the marvelous subjects that he had, which were drugs, sex and rock'n'roll—he was doing *good* with it. So—let him have it!

R/S: *And indeed* The Process *is cut-up—*

BRION: No, there are lots of cut-ups in it and lots of things that came out of using cut-ups, but very thoroughly assimilated.

R/S: *It's more stylized, I think, and the temporal cut-ups are very clear... they're mated, actually. A lot of William's books are quite hard to read all the way through because you just sort of jump and pick bits out... I just like savoring bits, all the gamey bits, or whatever. But* The Process *is much more like a proper novel... it would seem to be scripted.*

BRION: It's *tooled*, actually... The general all-over picture is that there's no voice of an omniscient author, and that these are a series of voices which are the different presences of speech. There's *I, thou, he, she, it,* and *you-they,* etc... As I said, they were tooled down until they fitted like that, and lots of the pieces going through the information was cut-up and echoes of Herodotus, echoes of T. E. Lawrence—echoes of all kinds of people are cut right into it to give it that sort of particular timeless flavor.

## THE BURROUGHS ARCHIVES

BRION: ... I was always telling William—in fact it's the thing that did pull us *out of the hole*—was my insisting on this with William, who had always just thrown, practically abandoned, his manuscripts everywhere. Lots of manuscripts have disappeared and god knows if they'll ever see the light of day. The suitcase full of material that never went into *Naked Lunch* was left behind in Tangier and the street boys were selling it for a dollar a page!

R/S: *So somebody somewhere has got them—*

BRION: A few pages here and there... But there is a huge amount of material in Lichtenstein... you've seen the William Burroughs Archive [catalogue]? All of that stuff hasn't been seen by anybody. One hopes... very soon it will be sold to somebody else or sold to a university who will know how to catalog it and put it at the disposal of people who want to consult it. But as it is now, it's just wrapped up in boxes in Lichtenstein.

R/S: *Why is it there?*

BRION: It was bought by somebody in Lichtenstein.

R/S: *Are they doing any research on it?*

BRION: No. Nobody's allowed to look at it at all... The man who owns it has a very good reason—that he knows nothing about how to catalogue it, and as it has once been catalogued as it appears in that printed book, he wants the material to remain just in that order, in order to be able to hand it on *intact* to somebody else. Because he made a poor investment for reasons which had to do with the enormous money gap that occurred between the dollar and the Swiss franc. Like, if he sold it today for a sum which is offered, he would make a profit of forty-five percent on his dollars, but he'd be *losing* money on his Swiss francs...

R/S: *When did you first start thinking about making films?*

BRION: Right then at that time, particularly saying to William that... we should get hold of somebody that could help us—that was in the business already. And right in that same short street which is only one block long, somebody that I knew just as a neighbor invited me to a party, and that's where we met Antony Balch.

Antony had been intent on making films since he'd been twelve years old... Our plans didn't work out—I mean, we made only those two short films, after all, and we had meant to make at least *Naked Lunch*—that's never been made yet, although I wrote *two* scripts for it at different times. A lot of money was spent...

R/S: *I've seen the storyboard for one of those... that Genesis P-Orridge has.*

BRION: We saw it when Antony died—it was very nearly thrown away, all of that material—his mother didn't know anything about him, and none of his business associates did, because they were really quite on a different beam with him. And it seemed the best idea [was] for Gen to have it — which is why I sort of shoved it off in that direction. He has the storyboard and a whole layout of the pictures... of camera angles and shots and stuff like that.

R/S: *Cans of film—*

BRION: Which he hasn't seen yet.

R/S: *I'm dying to see that stuff—*

BRION: So are we all.

R/S: *Was it all on 16mm?*

BRION: Thirty-five. There may be some 16mm in there, but everything they shot was always in 35mm... and in 70mm.

R/S: *Did you actually find it difficult to do at the time?*

BRION: Of course! The money's always enormous! It's always very expensive. Antony was a very successful distributor of films, and made a good deal of money. He also spent a good deal of money, as one does in that movie world. You have

to spend that sort of money in order to be able to get to the people who will put up a good deal *more* money. You have to travel around as we did and see them and meet them and whatnot, and none of those things worked out. Antony spent a really... I have no idea of how much, but, say—fifty or a hundred thousand pounds, perhaps already was spent on those film projects...

R/S: *William also did a book recently called* The Blade Runner—*do you know if that's to be made into a film?*

BRION: No, nothing's been made into a film and put on the screen—nothing except the two that we did together, *Towers Open Fire* and the *Cut-ups,* and then Antony and he did *Bill and Tony* on 70mm. And then the material that Genesis now has which has never been seen by anybody...

R/S: *Where were those films done?*

BRION: They were done in Paris, London, New York, and Tangier.

R/S: *Over a period of years?*

BRION: No, not all that long.

R/S: *When they came out, were they actually shown?*

BRION: Sure they were shown. And even now they're still shockers when they're shown. People yell and scream and jump up in their seats and are very affected by them, still. They still look very, very new to people.

R/S: *I'd agree with that. I saw them... when Throbbing Gristle was playing... people were actually completely flipped out, and the whole concert ended up in a huge fight. The whole evening was very, very charged... I felt, not as a result (but pretty damn nearly) of seeing those two films first, in combination with all of that.*

BRION: Sure. Well, the same thing happened in New York, where you would think the audience might be more *blasé,* but they were not people were also jumping up and down there too. Almost everything that we've done still has that kind of charge in it...

R/S: *In a way that's wonderful—*

BRION: Well, it's also difficult to live with, because people—as recently as this week, where I've been frequenting all the art dealers that I know who are now sitting there ensconced in their art fairs dealing in million dollar, half million dollar pictures that they have hung around the walls of their stalls—are just sitting there on their balls saying, "You know that's what we're doing, and *you,* dear Brion, as much as we appreciate you, you're still very *avantgarde...* We're tired old gentlemen, you know—if

Brion Gysin with Dreamachine, Basel 1979.

you'd only come to us twenty years ago when we were full of enthusiasm... " Of course, twenty—

I *did*... I've known them that long, and they gave the same answer then. They were all after *ten minute masterpieces* by Andy Warhol or Frank Stella or any of those stars that they've *invented*, who sell for huge sums of money...

R/S: *Were those two films originally part of larger things?*

BRION: No, they were meant to be what they are. For the *Cut-ups*, a great deal more film was exposed than that, and that's presumably what Genesis has there now—the stuff that one didn't use... more than that, even. I'm not even quite sure myself—Antony was always fairly vague about it, even...

We were always going to see that old stuff again, but there was always new stuff to see—we'd be *visioning* that, and I'd say, "When are we going to vision all the rest of the stuff that you have there?"—"Well, it's at, you know, the B.F.I. in cans... " So, I'm not sure what Genesis has. A good deal of it is photographs of me working in Paris, and working... painting a huge great big paper in New York that William just—left the studio and left the paper behind. It was shoved up into a space where you could easily have forgotten it, but he's always been a great one for just picking up his hat and what he can hold in one hand and—a portable typewriter in the left hand—he leaves his *own* manuscripts behind, so I can't really complain too much when he's left a great deal of *my* work behind. He has—he's destroyed

an enormous amount of my work—but he's destroyed a great deal of his own by just *letting go*...

R/S: *I suppose at the time it didn't seem to matter.*

BRION: Well, one was just so busy and, having all these tons of paper to move around and—where were you going to put them—and, where one was going one wasn't quite sure—it wasn't as if one was going *home*... we were just settling some place else for awhile...

* *Steve Lacy and Brion Gysin Songs* (12" LP + 7" 45), Hat Hut Records, Box 127, West Park, NYC, NY 12493, or, Box 461, 4106 Therwil, Switzerland.

*"Romance is about losing, essentially. Delights are about control… "*

**JOHN GACY AND
ROSALYNN CARTER**

BRION: The American scene is certainly full of death. Full of it, my god. The Monster of Augsburg—in my childhood there was a horrible cat who, at the end of the war, 1919, had eaten some thirty-two boys. He made them into *patés* and sold them to his friends and stuff like that. Well, this was considered *very* extraordinary: a case for Krafft-Ebing. But now, here's Rosalynn Constable Carter, whatever her name is, in a photograph with—
SLEAZY: Yeah, but the fact that Gacy was around just meant that he was a little bit more—
BRION: You're absolutely mad, man, he was a *community leader*. He dressed up as Santa Claus and he gave Santa Claus performances; he wasn't disguised at all. That's who he *really* was, he was Santa Claus.

He was a pillar of society, like a Norman robber baron. You got all these people buried under you, you put them through the dungeons—you got them like that, and you explain the thing to yourself and to society like that. Why

*shouldn't* you go up and shake the President's wife's hand and get your picture taken? …

We've arrived back where we've always been. Now things are getting back to normal when *this* is happening. Who did Eleanor of Aquitaine have for dinner? She had Gilles de Rais, who had eaten one-hundred-and-thirty-five boys, or something like that—*that's* who came to dinner in those times. Little Mrs. Carter from the South—she's getting right up there in history! She's in there with the Empress Theodora and Messalina. She's rubbing elbows with good company like that. She's got the Monster of Augsburg right there, turned into a fat Kiwanian. I think that's the way it's going…
SLEAZY: I don't think any of that stuff actually happens in New York. It always happens in the suburbs, doesn't it?
BRION: Oh no, it happens on the West Side…
SLEAZY: You don't get mass murderers in New York. You get murderers, obviously. You get muggings, you get stuff like that, but you don't get people that are really specialized.
BRION: You kidding yourself? You just haven't been frequenting the *specialists*…

**ON PAPER**

BRION: Paper was invented by the Chinese, and got to the Arabs about the eighth century. Before then, there'd been papyrus paper from Egypt, which was older, of course. But the sort of paper as we know it appears in Europe only about the twelfth century, and came from Arab sources through Sicily, through the German kings—the Hohenstauffen. Kings of Sicily imported paper first of all, because they had large schools set up of people, copying manuscripts for the first time onto paper. And so paper making made its way in Europe connected with good water, which is very important—the water source. All the paper mills were set up along rivers that were then still very clear. The Rhine was clear until my day; I saw the Rhine clear in 1930. Now it's a great big sewer… dangerous sewer.

My first cousins had a paper factory on the Rhine from about 1500, maybe

earlier, and made paper from reclaimed linen sheets and things like that; made that fantastic handmade linen paper that's so tough you can barely tear it. And they made money for bank notes too, for a long time—centuries.

As a child, I made paper there too, where there was this big mess like porridge—Genesis P-Orridge!—and you'd grab a dollop of it in a big wooden spoon and throw it into a box that had a net at the bottom like a sieve, and you'd dump it up and down in a mortar like that until a sort of drool was distributed evenly all over the surface of your mesh. Then you'd turn it out on a marble slab and roll it either cold or hot… and that was handmade paper.

In the S_____ Museum they still have those things shown, materials that they used and the machines that they had, stuff like that. Their paper went up and down the Rhine. And of course, from the Rhine—from Amsterdam—it went quickly and easily to London; that was the nearest port. So they and people from Basel used to go back and forth from London from Elizabethan times regularly. Well, the Holbein, who was the principal painter at the court of Henry VIII, came from Basel, and worked on paper. And this woman that I know has this collection of papers that are of such value that she's always been afraid to distribute them in any way, because of the fact that they could fall so easily into the hands of forgers. And she should worry.

*All* collections are full of fakes and forgeries, in any case. I spent a whole winter working and going through the archives that the Louvre has here in Paris. You have to get special permission and a letter from your embassy and all kinds of stuff to get in—I did that. And I was particularly interested in the German and Basel painters and graphistes like Durer and Holbein and Urs Graf and Nikolaus Manuel Deutsch, of which they have a big collection. And half of their Durers are fakes! At least half. Obvious fakes. And they say, "Yes, yes, we know they're fakes, but you know, they've been here so long—they were given by somebody in the eighteenth century, so they have *some* kind of historical value, and we're not saving them simply because

they are real or are very good, but... "—You know, those kind of museum-ology-type stories that they tell; I guess they're reasonable enough. But this woman has given me quite a lot of these different papers. I have still big wads of them in there that I haven't used. And I have used them on some very interesting projects, but I don't have enough to... a book of this size, for example. I wouldn't even be able to make a single copy.

GEN: That's a nice sort of connection, timewise, isn't it?

BRION: As I said, it was studying Japanese—the Japanese language school—that got me so interested in paper and ink, really. It's a whole study and it's the basis of their aesthetic. As a matter of fact it's based on the two—

GEN: Actually coming *from* the materials rather than imposing them.

BRION: Right.

GEN: Strange coincidence that there is a family connection... *Can't escape your roots, boy!*—What is it he says in *Towers Open Fire*? "You can't deny your blood."

BRION: I deny that statement!

GEN: I got a horrible sensation the other day watching myself on a video. I suddenly looked and—I did an expression identical to my father. It was horrible, I thought, "Oh shit!" ... That always worries me a bit—being trapped.

BRION: "Somber moor, looking like Othello."

(tape ends)

## A ROOM OF ONE'S OWN

BRION: ... We live in a period, I think, unique in all history. No house has an attic anymore, there's no granny to put in the attic—granny's gone away to Florida to an old age home in St. Petersburg. Nobody even knows her maiden name. You ask any American the maiden name of either one of his grandmothers and he hasn't got any idea. So there's no connection anymore—most of them don't *want* any connection. They've decided that they're going to be just *Americans*, for one reason or another.

More than that, we have this enormous privilege which I think is unique and comes about for the first time in any society—of it being possible *to have a room of one's own*. Nobody had a room of his or her own ever in all of history. Everybody lived with... dogs... and camels...

GEN: You mean, even within somebody's family you have your own room—

BRION: Yeah, it was never possible. You always slept with brothers and sisters, and mothers and fathers and grandparents and all sorts of people; maids living in the house, sleeping behind the kitchen door. Do you know how much the idea of having a room to yourself has changed the whole sexual scene? In fact, I think that really the basis of the sexual scene is the fact that it's been possible to be able to be alone to *do* these fancy things that you've thought up. It was never possible if you lived in the bosom of a family, how can you possibly? People do get up in some really kinky situations but not like *that*.

Peter Christopherson and Brion Gysin, Paris 1980.

And I think of a society like Muslim society where all sexuality occurs with your clothes on! I was once sitting with a man who had four wives and I suggested that any one of his wives might have seen him with his clothes off and he was shocked at the idea. And sex is very quick, and religious law demands immediate washing after it so it's all bangbangbang and *shoo... zoot* to wash yourself! None of this languorous lying around and this luxury situation that everybody's thought about; for our ancestors that never really existed at all. Maybe sometimes for a sultan and his harem, yes. But even so, just think of that: all of

them tattling on each other and jealous of each other and poisoning each other's children—all that happened regularly, and still does.

GEN: The only way to change a society properly is to break down the family units and the atomic structure or whatever they call it. 'Til you break it down you can't break any other system of control. At the moment most societies still are based on the assumption of families, so it's one of the key areas to fight if you want to change things.

BRION: Yeah, but do you? Does one? Are you going to change it into *what*?

GEN: Change it into what? Why do people always have to change things into something else?

BRION: William changes it into a *Wild Boys* scene—you and I know that William himself wouldn't survive a wild boys scene! (laughs)

GEN: ... I think... loose alliances you choose, not a family in the normal sense, but people you find you relate to more naturally than you do people who are related by blood. Whom you tend to associate with more often than you do with (what do you call them?) *filial* family. I've never understand the logic of the filial family—why just because somebody came out of the same fanny you should like them, or because somebody was your mother's sister you should like them.

BRION: Well, it hardly ever happens, does it?

GEN: No, but it's traditional that you keep in touch with aunts and uncles and cousins and all this shit, you know. And it's very unlikely you even like your own family. But it's still suggested to you from an early age that it's quite natural and reasonable to like relatives. And to dislike relatives is *unnatural*...

BRION: Not in my family...

██████████████████████

## DEAD FINGERS TALK

GEN: How did William lose part of his finger?

BRION: The most commonly told story is that he cut it off himself and threw it into the face of a psychoanalyst who was questioning him in an army examination...

GEN: And that's the story he tells?

BRION: No, he doesn't tell it, *other* people tell it. He's never told it to anybody. He doesn't say anything—

GEN: As usual. I guess that's a good technique sometimes: to clam up. I do remember it now.

BRION: He's not the only one. Partly the legend may be due to Maraini, who was an Italian who wrote a very admirable book called *Secret Tibet* twenty years ago, and more recently a monograph that was written also twenty years ago (it has come out only now) about Japan. And he and his wife and three daughters were taken prisoner by the Japanese at the time when he had come as a diplomatic-cultural expert from Italy to Japan, and then Mussolini joined with the Axis and all the Italians were demanded—*obliged*—to take their fascist oath. And they refused and so they were thrown out to the Japanese prisoner camp where they were very badly treated.

Maraini demanded an interview with the general and—here's this Japanese general sitting with his regimental sword in front of him like that, and Maraini... took his sword, and cut off his own finger and threw it into the man's face. And that had absolutely *the* desired effect—it was the thing that really impressed the Japanese more than anything else that he could have done. Everybody got more food, and lives were saved by this gesture. So maybe it's partly that true story that's been *loaned* to William as part of his legend. But that didn't happen quite that way.

GEN: So you've lost a toe, and he's lost some of a finger—

BRION: Everybody loses a little something here and there on the way through this rat race...

██████████████████████

This excerpt is from a forthcoming book of interviews with Brion Gysin, edited by Genesis P-Orridge. Genesis and Peter (Sleazy) Christopherson asked the questions...

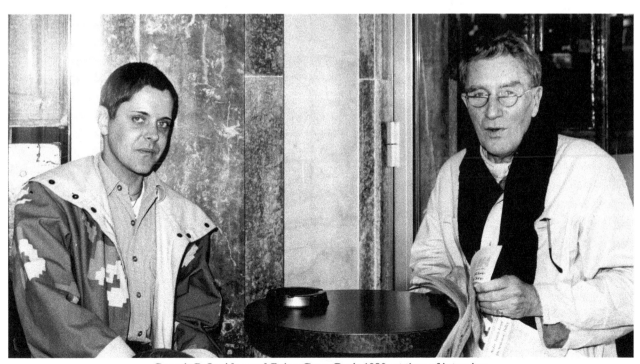

Genesis P-Orridge and Brion Gysn, Paris 1980, at time of interview.

"Real total war has become information war, it is being fought now... "

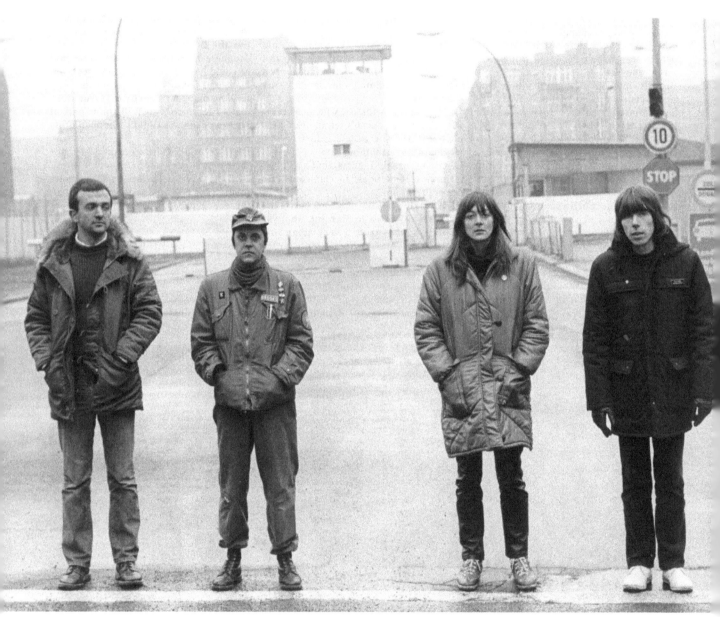

**THROBBING GRISTLE** at the Berlin Wall.

*... E am not especially clever, just basically very average, E merely try to maximise thee effectiveness of whatever gifts or abilities E have by focusing them towards what E want to happen. And understanding structures like making love and what they REALLY are, not just three words butter thee fact, that builds one's energy, protective and power which maximises thee chances of what you want to happen happening and that's all magick is. We all know what making love is, a ritual fusion, UNITEE to maximise power & purity of purpose, self-negation in pleasure, a focus, its like a snowball once you get thee system that works, that makes things happen, it just gets easier because it just grows as you roll it. Butter you need discipline to increase focus to push harder to get it bigger you MUST concentrate. Its a matter of observation not learning. One observes oneself and thee world & analyses how people who maximise their effectiveness seem to achieve it & then you apply those observations to oneself, adding personal variations & presto. Triumph of thee will. Thats what they meant. And thats what Love Under Will means. LOVE is crucial. Uncorrupt, unselfish love is thee focusing agent...*

excerpt from a letter from
Genesis P-Orridge
July 9th, 1981
T.G.H.Q.G.B

# THROBBING GRISTLE BIOGRAPHY

*"Everywhere, all over the world were millions of people just like this, ignorant of one another's existence, held apart by walls of hatred and lies... In the end their awakening would come. You were the dead, their's was the future... "*

George Orwell *1984* (1949)

## THE INSTITUTE OF CONTINUING EDUCATION

Industrial records (IR) HQ, tucked away up an anonymous East End sidestreet. Genesis P-Orridge sits surveying his little bunker. cluttered as it is with model skulls, videos, books, cassettes, decorated with stark posters and tasteful displays of meatrack pornography, furnished with low level couches of camouflaged foam. It's an unusual home, full of vague, sinister connotations. It's a home bursting with ideas.

He shows me a book on guard dog training sent by IR stablemate Monte Cazazza from San Francisco. There's a chapter on how to avoid legal difficulties should your dog kill someone. I stroke the Alsatian-Doberman crossbreed nuzzling at my feet. Genesis is a small, lean man of thirty-one, his nails are long and clean, his fingers glow with gaudy silver rings and his crisp combat jacket rasps somehow *authoritatively* when he moves, which is often. It bears a neatly-sewn TG insignia over his heart. He talks with a fragile Mancunian accent in soft, controlled tones. When you glance at him, you know his face belongs to a girl, but when he says that Americans are the weird ones, you look at the book and know he's right.

I'd never been *sure* of Throbbing Gristle, been too aware of the climate against artyness, always suspicious of people that throw a wall of publicity and fractured innuendo around their work and personality. I wondered if GPO's shock tactics and well-known peculiarities were cultivated to mask a distinct vortex of "meaning" and "talent," however hip and financially viable that vortex had become... consumer art or Art Con?

COUM Transmissions performance.

"What's with this serum?"
"I don't know, but it sounds ominous. The man's not to be trusted. Might do almost anything... Turn a massacre into a sex orgy."
"Or a joke."
"Precisely. Arty type — No principles."

William Burroughs
*Naked Lunch* (1959)

## A LITTLE KNOWLEDGE...

TG have existed for many years, fermenting in thought if not deed from when Genesis was a pop art exponent—rooted in avantgarde outrage and C.N.D., listening to the Velvets and corresponding with William Burroughs—to IR's current adventures into videology and hi-tech camp. Young Orridge was hanging out with a gang of Hell's Angels when he stumbled across a young musician's co-operative in Hull (one member being Dead Fingers Talk frontman Bobo Phoenix — draw your own connections) and found his Nico in the fine lines of Cosey Fanni Tutti. Forming the performance art troupe COUM, they dutifully grinded around Europe's cramped, cliquey (and usually crappy) arts centers, produced the infamous 'Prostitutes' exhibition at the ICA (a show which included used tampons, nude photos of Cosey and an unreported bulk of painting and sculpture), before realizing the repetitive folly of their art context limitations and opting for the mainstream communications network of record production. COUM components Orridge, Cosey, Chris Carter and Peter 'Sleazy' Christopherson transformed into TG, formed Industrial Records on borrowed money and entered the twilight market in 1977—to raves of encouragement from Mark Perry and Sandy Robertson—with *Second Annual Report*, a bleak abstract landscape of synthetic dirges and continuing ideas from the days of COUM. More recently, TG handed the publishing rights of *Report*, free of charge, to two enthusiasts who re-pressed it and utilized its selling power as the spiritual and financial foundation for Fetish and Red Records.

Along with *D.o.A.*, *20 Jazz Funk Greats*, *Heathen Earth* and a few singles, Throbbing Gristle have sold records to nearly one-hundred-and-fifty thousand people. Genesis and Carter work full-time for IR, Sleazy directs videos for supergroups (today it's Peter Frampton), and Cosey poses nude in mild-relief mags like *Whitehouse* and *Sadie Stern*, jumps out of cakes with no clothes on, and recently scooped the cover of *The Sunday Times* color supplement due to an article on her "earning power" (tee

hee). She earns a lot more from stripping than making records.

TG have just finished recording the soundtrack to Derek Jarman's new film *In the Shadow of The Sun*, recently shown at the Berlin Film Festival and London's ICA.

Genesis was once fined two hundred pounds for sending an obscene postcard through the post. The offending object bearing a picture of Buckingham Palace with (gasp) a bum on it.

The rest is draped in rumor and myth, shreds of information, misunderstanding and lies. Mock horror headlines!

## SEX AND CENSORHIP

Genesis has analyzed TG's misinterpretation — Genesis analyzes everything. It all stems from his fact-finding holiday to Auschwitz, his fascinated flirtations with the ornaments of power, images of sex and death. "A lot of people hate us. The *NME* hate us, they were outraged that I went to Poland and saw the death camps. They just decided that we must be awful people because we weren't budding socialist workers, Victorian puritans or Moonies or whatever it is they are. They decided that young people should not be encouraged to listen to us, that was their policy and I have proof of that. They pretended we didn't exist."

Some people think TG irresponsible, a view I once shared. In fact, they are probably the most carefully conceived amalgam of ideas and ideals that I have encountered. They are aware of what they do and how they do it, and are responsible, ultimately, to themselves. Behind Throbbing Gristle's mottled sheet of experimental sound is a labyrinth of minor projects, a constant re-evaluation of standards and avoidance of obvious procedure. It's all there, available to those who want to bother to look, in their newsletters and record covers, their videos and recordings, and, most obviously, in their deviant string of gigs.

But because TG refuses to be pigeonholed into categories of big-pricked rockists or austere social democrats, they tend to get ignored in preference to the worthy TG children—be they Cabaret Voltaire or Clock DVA—bands that they have actively inspired and fostered. Gen's mind flicks back a moment: "People think that we're worse than irresponsible, they think we're downright subversive and immoral... they've got this puritan Mary Whitehouse-view of sex, some people can only deal with it in basic situations: archetypes. Like the media

says, 'Chrissie Hynde is okay' y'know. *But...* well, they thought the cover of *D.o.A.* was disgusting, pornographic."

Extra facts of that cover: "That girl was the daughter of the woman I was staying with in Poland. She asked me to take some photos of her little girl 'cause she didn't have any... her mother was in the room all the time, and she thought it was really cute y'know, which it was. She was just posing around as little girls do, standing on her head and stuff, so when the pictures were taken it was a totally innocent situation." When we pick up that cover, it's solely down to us what interpretation we put on it.

"*I see England. I see France. I see a little girl's underpants.* Who is the sinister party?" Genesis is now in his element. "I'm glad those pictures had that extra quality, stressing the ambiguity of little girls' unintentional sexuality. When I took them that wasn't the intention though, and that interests me. We're interested in information, and the fact that your view of things can totally alter depending on how you're looking at it, or by what people tell you about it afterwards."

Like the IR 'Death Factory' logo, used acceptably for two years before Genesis' revelation that the picture wasn't one of a factory after all, but of the ovens at Auschwitz, apparently chosen to remind Genesis of the horror—and danger—of man's "stupidity."

"When I told them about Auschwitz, the picture was suddenly outrageous, so it actually changed physically before their eyes by them being fed that one extra line of information. I find that disturbing."

## POWER AND PROCEDURE

Disturbing because it illustrates the power of suggestion and manipulation. The power in the hands of those who write the caption under the photograph, the voice-over to the TV news. Art, newspapers, radio, the camera—all can be made to lie, even if they're telling the truth: by *omission, deception, misinformation*. "That interests us, and we tend to play on that as a group."

Another experiment unfolds, in the shape of TG's most recent record release, two singles brought out on the same day, four A-sides in 24 hours coming in separate covers and camouflaged plastic bags. He slides them down from the shelf, ready to reveal all. "The picture on 'Adrenalin' is of The Ministry of Defense building, and it's illegal to pho-

tograph it, so that's naughty. On 'Distant Dreams' it's got what looks like a country lane, but in fact that's taken inside Auschwitz—it's the first thing people saw, so they didn't panic. On 'Subhuman' (the term Hitler used to describe the Jews and the gypsies) there's a pile of Jewish people's skulls taken at a camp, and inset is a caravan. And on 'Something Came Over Me' (he flips it over and delicately traces a shape on the card with his fingernail)... that's Sleazy's spunk in water, but nobody realized. It shows that it can work both ways if you want it to. Those holiday snaps on *D.o.A.* were the opposite. This is an example of how you can do things with design and so on, this whole area of suggestion is very potent and complex, people could have really gone to town on these covers. 'Racist!' 'Fascist!' 'Sexist!' All the things they called us we decided to put out, but they didn't even notice..."

In a state of constant flux and experimentation, TG prompt you out of automatic acceptance and routine, *they test what is conditioned and what is desired.* When IR released both singles simultaneously they learnt some odd truths. Some papers only reviewed one song, not realizing they'd received two different records. Many shops only ordered one disc, unable to cope with the apparent mental strain of having such an unusual—through hardly earth-shattering—occurrence on their hands. The double release was designed to test the record industry's dull, conditioned response. TG can be very trying.

## PSYCHIC YOUTH CLUB

Is there anybody here? Yeah!
Round the corner
Here's the psykick dancehall
Here they have no records
They know your questions
about no words...

The Fall "Psykick Dancehall" (1979)

Throbbing Gristle play (with) sound, they rarely produce muzak. The images conjured hardly being conducive to ambient coffee table lounging: it's repulsive, funny and harrowing. Moody, but not without focus. Their records are rapid *communiques* of specific messages or overall intent. Their rare gigs seventy-five percent spontaneous statements of that intent. Improvised, subtle, sometimes boring, TG give them the grandiose title of "psychic youth rallies," believing that by being there at the same

time, both group and audience are showing a mutual empathy with that intent. They'd have to, it's hardly entertainment, or even supposed to be.

"Our gigs are about the brain and perception. It's an instinctive thing, people feel an empathy with the attitude, it doesn't have to be obvious, it's left unsaid. We don't want people to follow us just because they *like* us, we want them to think, and follow us only if they feel they can identify with that attitude... feel an empathy with what we're doing, it's hard to express... It's always been true with music though, different people just want different kinds of empathy. Some just want foot empathy, where they can tap their foot to something; some want wet-your-knickers empathy, little girls who like Adam Ant at the moment; then some people have got a much more basic psychological or philosophical emotion or desire, they want more from music than just that. They're the people who tend to come and at least check us out, people who aren't intimidated by people being arty, and it's all kinds of people, not just 'intellectuals,' but fourteen-year-old kids from council estates. Some of them get very, very angry when we are inconsistent, and the press miss the point entirely in their reviews of our gigs. They forget: we're not entertainers. We're not uniform or consistent deliberately, we're varied on purpose. We *do* try to make it difficult for them to check they're really there, that they haven't just come from force of habit. We don't want them there if they come thinking they know what to expect, we want them to come because they *don't* know what to expect."

I ask Genesis why, which seems the question most inspired by the riddles of Throbbing Gristle... "That's the way life is, things change. The human being is taking in new input every single day of its life. If we didn't take that into account we'd be cheating on the people who watch" (the way lots of bands do). "But the basic attitudes don't change, and that, ultimately, is what people can suss, y'know?"

## SUBVERSION

*"The surest way to corrupt a youth is to instruct him to hold in higher esteem those who think alike than those who think differently."*

Nietzsche *The Dawn* (1881)

Steeped as it is in the aforementioned ignorance and rumor, presented cryptically and splattered with Genesis' art-conscious pranks and morbid humor, the TG 'attitude' is sometimes hard to follow. But there are no secrets at IR, and your instinct is usually correct. TG is an exhibition of lifestyle, a constant re-evaluation of all values and thoughts, an organic example of progression and self-expression. To put it simply, they are an 80s refinement of rock's old (and only) message: To conform or not to conform, to stay in line or to ask questions, to die on your feet or live on your knees. "To always be awake and ready to alter, to be aware that you're mortal and that life isn't about formulas, and that expressions of life (art or music) shouldn't be about formulas either. To be aware, not lazy. We're just showing people they can live this way too, showing them that they're not crazy or alone in wanting different things. We want to make people happy, and one of the ways we can do that is by helping to remove guilt, that's the main thing."

Using records as propaganda, corresponding regularly with sixteen hundred other musicians—lost souls and kindred spirits—by providing a contact base between bedroom-bound cassette makers and producing a news magazine (*Industrial News*) that throws up more questions than answers, TG are subverting now

for the future. They experiment with the lure and potency of power, with uniforms (Genesis owns a growing camouflage collection from around the globe), terminology and regalia.

TG don't get involved with the causes and clichés of The Great White Liberal consciousness, the dogmas and demonstrations of emotional hang-ups and guilt complexes (sexism, racism, no nukism, thisism, thatism) thinking them red herrings introduced to divert people from The Horrible Truth—into useless, fruitless 'activism.'

"There are a lot of side issues, but the only real revolution takes place inside people's heads, so it's a very slow, organic process, and that's not a defeatist attitude, it's just realizing that what you have to work on is people, not politics, getting more and more people to move across and perceive the world in what I would consider a more realistic way, and that makes politicians totally redundant."

Genesis is an anarchist with a little 'a' and a long wait. "I'm not interested in changing politics because I don't accept politics as even necessary, I think it's just a bluff. You keep telling people to vote and vote and vote, and they'll then have a say in what happens, but in fact they don't. They don't get a say in what hap-

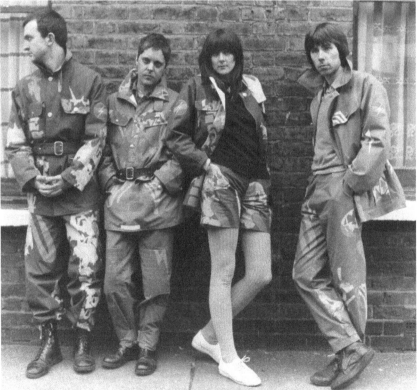

TG in clothes by Lawrence Dupre.

pens between elections, on specific issues. What they're told they're voting for isn't what happens afterwards, it's just a complete sham. So if you get a change in decades from subverting youth now, or standing as an example to youth, or giving more information to youth to help them to see through it, then it's still a far quicker change than voting for one politician or another. That's not real change, it's just twiddling with the details and altering the balance a bit. So we're not ignoring it, we're just recognizing things that are important and the things which aren't; we're just going about it in the way we believe is right." Less and less people vote at each election…

"Basically half the country do not participate already. If three-quarters stopped then they'd be in a real crisis. There's going to be a battlefield, 'cause the ones in the minority are still going to say that they're the government, knowing they're not, and the only way they could stay in power would be to form some kind of dictatorship. As always, the people who run the military have the real power."

Genesis is full of dangerous visions, I think he revels in them. He could be crazy or stupid, or very aware and very honest. Who's to say?... and that's half the problem.

"The dangerous thing is, most of those in power don't even realize it, its stupidity. They're quite convinced that they're Right and Normal, and they're moral upright citizens speaking for the Silent Majority, and they know what's good for us and what's bad for us and know what we should or shouldn't want. *That's* crazy!"

And that's why information is important.

*Throbbing Gristle:*
*The Mission is Terminated*

## VISIONS OF THE FUTURE

*"You know how you could smuggle microdots into a country without them knowing? You smuggle them in with a shipment of dope. Like with heroin. The microdots are down inside the packets. Nobody'd notice, they're so small."*

*"But then some junkie'd shoot up a hit of half smack half microdots."*

*"Well, then, he'd be the fuckingest educated junkie you ever did see."*

Philip K. Dick *A Scanner Darkly* (1977)

Yes, Industrial is a company of the weird, wacky future. Their products are available in several different mediums, all over the world; they may be difficult to swallow, but at least they're fun and

modern. IR was the first major independent to release music on cassettes only— by Leather Nun, the Cabs, Richard Kirk, Clock DVA and themselves. They've also released an interview tape, and, being interested in products and packaging, put out the *24 hours* cassette set of all their live performances in a suitcase. The tapes being available as a single package for (cough) eighty-eight pounds, or, individually for four pounds. Audacious, laughable, TG have sold over one hundred complete cases, seventy going to the land of the rising suicide rate, Japan (where, perhaps not surprisingly, TG are a big cult group).

Besides being a gimmick and experiment, these tapes—totally unedited— make TG the most accessible group of all, charting their growth and variety, making the whole thing somehow *honest* and available. No matter where or when you've seen them play, you can get the gig on tape, be it good, bad or indifferent. Genesis even says that they encourage people to record the gigs themselves, thereby totally destroying the concept of bootlegs, and what Genesis describes as "the ridiculous *professional* industry of vinyl dreams and record junkie youth."

They are currently editing IR's third video release, the first live compilation video, a tape of The Fetish Night Out gig at the Lyceum a few months ago. Pretentious? Elitist? "Well, where does it end? People could say that by putting out records we're being elitist. What about people without a record player? What about deaf people? Everything's got some form of elitism in it. In fact, it's the opposite really, us doing video now is opening up new avenues for other people to use, and TV and video are huge mountains that've hardly been chipped at. Now they're becoming cheaper and more available, they should be used."

IR hire a video camera and recorder from a company for under eight hundred pounds a year. "Make your own TV, do your own video, your own image.

It's a quick new form of communication, that's all. It can reach a lot of people in their homes, or in clubs or in shops all over the world.

"Y'see, records are losing a lot of their effectiveness as propaganda and demonstration, most battles have been fought with records for the time being, but we'll still be releasing things when we feel there's a need to."

The newest, and probably most exciting release is an LP of William Burroughs' previously private tape experiments, much referred to in his books, but never before heard: *Nothing Here Now But The Recordings* (IR0016). "We've been friends with him for a long time, seven or eight years, and he just agreed to us taking the tapes away, fifteen hours of them, and editing them down to an LP. It's a good job we got them, 'cause they were recorded over twenty years ago and the oxide was actually crumbling off the tapes as we held them."

The tapes, experiments with the Cutups of Brion Gysin and Burroughs himself (a process borrowed many years later by Bowie to write *Diamond Dogs*) find WB sitting in a room unearthing random thoughts from the dark recesses of his junk-celled soul. and capturing them with throat mikes, assumed voices and tape loops. To allow their release at all is a brave move on Burroughs' part; they're so personal and unpolished it's obvious they were never intended for public consumption. They seem to have lost none of their relevance and humor through the passage of time, and they're helped along by Burroughs' incredibly dry rhythmic waver. He comes up with some beautiful one-liners, so apparently ridiculous as to mean anything you want them to mean, much like TG.

Needless to say, *Nothing Here Now But The Recordings* fits neatly into the IR catalogue, next to the random, rambling visions of Genesis P-Orridge, a man destined for Mental Home, Mortuary or Prison because he's crazy or he knows *too* much. Hate, mistrust or love him. He is a man to be watched.

*"We are the dead," he said.*
*"We are the dead," echoed Julie dutifully.*
*"You are the dead," said an iron voice behind them.*

—*Simon Dwyer,* London 1981

# THROBBING GRISTLE ON KPFA

This is Throbbing Gristle...

R/S: *In your first US concert in Los Angeles, they didn't even put your name on the marquee, just "Modern Concert." You've always functioned at the borders of tolerances... How has censorship changed your life?*

GEN: It's not really changed our lives at all. I've always found that if you really think about the way things are structured, you can usually find the freedom you really desire within what's already going on. And you just tend to irritate people who aren't quite sure what you are. In other words, if you don't let them focus on exactly what you are—if you seem to be several things simultaneously to which they object, then they tend to ignore it and try not to think about it. Whereas if you're just one thing—if you're, say, somebody who is into perverted sex, then they can say, "That is a sex pervert" and try and deal with it... Or, if they think you have dubious political ideas, they can deal with *that*. Or any ONE thing. But when you're several things, or seem to be possibly those several things—then it's like a friend of ours in France says, "It's the theory of transparency." And you become invisible.

I'm sure everybody understood *every* word of that!

R/S: *Still, you have had your problems with the law in times past... How do you account for the fact that you have successfully deflected a lot of people's expectations with each new record?*

GEN: We just have a very simple philosophy, which is that we always think what *we* want to do next... We look at our record collection, or whatever's going on, and we decide what we personally would like to have or possess as a record, or a magazine, and then, if nobody else is doing it, then we'll do it. And with the records that we do, usually we tend to—if we're not sure—contradict whatever we did last time, and it seems to work quite well.

Most of us are quite good at predicting what people will expect, and then the four of us, between us, can usually confuse that expectation, with a little discussion. We do a lot of talking first.

COSEY: Besides that, there's no point in repeating yourself either. If you've got one thing on record, there's no point in recording the same kind of thing again!

SLEAZY: That goes for other people too... If someone else is doing a thing, it's really pointless wasting time repeating *their* formula. We've always believed in doing things for ourselves.

CHRIS: I think that's where punk's biggest downfall came... Everything in punk began to sound exactly like everything else that was before it... which we try to avoid.

GEN: People are trained through the mass media like TV and newspapers to expect things to always be the same. They expect washing powder to always be the same, or they expect a particular rock band to always give them the same response or style. You get a very famous group—everybody knows that most groups tend to, if they get a hit record, they repeat that formula over and over, like the Bee Gees did, until finally it becomes totally uninteresting. But until that point, everybody knows what to expect and they go along wanting that. And it's an unusual approach for a group to actually, deliberately try and *not* do that. And that's why when we play live... we always try and play live *differently* to anything on record or tape, 'cause we don't see the point of people coming up and knowing what they're going to get. Why bother to go out of the house if you know what you're going to get?

SLEAYZ: The reason that a lot of people bother to do that is because they prefer not to have to think about anything! But we've always liked to try and encourage people to think about what we do on a small scale, and hopefully (this sounds pretentious, doesn't it?) but hopefully, think a little bit more about some other things as well.

GEN: People are trained to be comfortable, because comfortable people who aren't thinking are easier to keep under control. Nobody who wants to run a country wants a lot of people who are individuals thinking for themselves, because they're all going to cause trouble at some point. So it's as obvious as that. And that's probably why occasionally we get problems with authority or organizations, because we don't make anybody feel comfortable.

R/S: *Chris, you've recently released a cassette which is actually quite comfortable... or, how would you assess it?*

CHRIS: Originally the takes on that tape weren't made for release, they were just me doodling at Industrial Records' studio. That's why a lot of them sound a bit lacking in sort of certain parts, 'cause they're sort of... some of them were done as backing tracks for other TG things that never sort of came around. And I didn't really mean to release them, but...

SLEAZY: One of the things about Industrial Records, which is our own label, is that we've always had a policy of releasing more or less *everything* because, in contrast to most large groups which try very hard to *manicure* their image and only release live tapes when they're absolutely perfect, and overdub on top of the live recordings, and so on like that—we've actually released *every* concert we've ever done on cassette! Simply because we think that it should be available.

GEN: There's thirty-five one-hour cassettes, most of which are live TG. Every TG concert is available on cassette, and the new ones in America will be too. I mean, if you're going to play for people in public, you're saying that they're entitled to share in the experience. So how can you suddenly say they're not allowed

to have the music more than once? So even if people come along with cassette recorders, we always say they can record it too. Because it's for *them*! A live concert is for the people who come—you can't suddenly turn around and say, "Yes, you can have it! No, you can't!" Then you're doing the same *control tricks* all over again, trying to stay in a power position, which isn't what we're after at all.

R/S: *Is it true that none of you depend on paying the rent from your projects?*
GEN: Not at the moment. It was until about a year ago, and then it became impossible to be part-time record executives. And so Chris and I both get one very minimal weekly wage, and work full time for Industrial Records. Otherwise nothing would have continued.
SLEAZY: But by the same token, we don't ever allow a temporary need for money to have any control over the actual product that we produce. As soon as you *have* to play a gig on Saturday, or you *have* to sell x-thousand records in order to pay the mortgage, you might as well forget it!
GEN: The fact that we get a wage at the moment at all is just expediency to make

more projects happen. It's not because we don't have any other way to survive.

R/S: *I think a lot of people are surprised at your next album being William Burroughs. How did that come about?*
COSEY: We are a record label, not just Throbbing Gristle... We bring out records by other people selectively, and the next one is William Burroughs.
GEN: Through various acts of faith we've ended up acquaintances of Burroughs, and we've also applied some of his ideas and Brion Gysin's ideas—about cut-up collage techniques with tape—to the sounds that we use. And it seemed very logical that we should actually try and make his original experiments with cut-up tapes available to the public, so that instead of just reading about them you could actually hear the results. And as most young people are more record-oriented, it would maybe have more effect on them to get hold of a record of it, when they may never read the book. They may then be inspired to experiment themselves and find out how much of the future you can reveal...
SLEAZY: We've always done things because they're the things that we like,

and not for any other collateral reasons. We like William Burroughs and we very much like the tapes on this album, and so that's why we're doing it.

R/S: *Sleazy and Genesis are branching into video?*
GEN: Trying very hard—it's expensive, though.
R/S: *"Psychic Television"?*
GEN: That's right. But we've done videos already as TG on Industrial, so it's already begun, in that sense. And we'd like to continue experimenting with image and sound combined... which seems to be the modern equivalent of cut-up techniques.
SLEAZY: We were the first independent record company in England to actually release proper video cassettes, professionally-made video cassettes. We have two: one of the album *Heathen Earth*, and one from a live concert that we did in England.
GEN: Basically, everything that we do is just aimed at trying to find out how people's minds are manipulated... and then short-circuit that.

END OF KPFA INTERVIEW BY VALE 5/26/81 11 PM

AUTOMATIC SET BY PETER CHRISTOPHERSON

TG with Jon Savage.

# GENESIS P-ORRIDGE INTERVIEW

During their week in Los Angeles, Throbbing Gristle visited some *noir* landmarks: 10050 Cielo Drive, where Sharon Tate *et al* were sacrificed; the Spahn Ranch where Manson's family once idylled; a Mexican magic shop for *curanderos*, and Tijuana, where Genesis and Paula P-Orridge were married (by Mr. Bradly Martin, according to the marriage certificate).

In San Francisco, they visited Alcatraz, the Creature Exchange, the Chabot Range, surplus stores and the U.S. Government Bookstore, where Genesis ordered the report on Jonestown. This interview with Genesis P-Orridge was done by Vale at a Civic Center cafeteria just before TG's return to England...

**R/S:** *Why is (Charles) Manson still interesting?*

**GEN:** The *philosophy* is what's interesting—the view of the world of anybody is interesting. And even to the level of what actually happened you can see—visiting LA... seeing the Spahn Ranch and the way it was like a fairy tale place where people could get into a very private fantasy trip without anything to break it— cowboys and Indians and mercenaries— it's really like that in LA, isn't it? The little canyon with the little ranch house and horses, and it was kind of a movie set...

**R/S:** *The rock formations themselves are extraordinary.*

**GEN:** You could see how people could really get into a trip that became more and more kind of a fantasy life. I cannot honestly condemn exactly, condemn completely even what happened at the end— although obviously I wouldn't have been very pleased if it was me! I think there was an argument for that kind of activity to become inevitable by *somebody*... they were an instrument of fate, in that sense. But they became that because of the way they chose to try and live and evolve.

But really, it's not that interesting to discuss the events of 1969 anymore. It's just part of America...

**R/S:** *Books are still coming out, though. The Manson Women—*

**GEN:** Which is terrible—

**R/S:** *And self-indulgent. It's just an advertisement for the writer—*

**GEN:** Who's an idiot. That was obviously only published because they knew they could sell a certain number just because it had the name "Manson" on the

Genesis with Iggy the Iguana at the Creature Exchange, SF.

front. There's no publisher of even hack books at Safeways that could possibly be convinced that it was a well-written or well-ordered *or* intelligent book—it was just absolute rubbish. It didn't even have the interviews in. It kept going on and on about *I interviewed this girl, I interviewed that girl,* but it never let them say anything. She just kept saying *they seemed like spoiled brats.* So what? So what if they were or are or are not—she should just let them speak. She should just be a very passive catalyst to letting them speak, and let everybody have the intelligence to make their *own* decisions about the book. She spent most of the book trying to make sure that you thought about it the same way that she did—she was trying to prime you in advance to only see one possible interpretation of every sentence that she actually printed.

R/S: *Do you have that pamphlet that Manson wrote?*

GEN: "Your Children." It's just a transcript of his speech to the judge when they entered the courtroom, basically. It's very good, though…

R/S: *Could you give us a little history of your encounters with William S. Burroughs. Didn't he testify for you a long time ago? Was that through the mail?*

GEN: Through the mail, because he was back in New York. But he sent a letter to the court. And he tried to get me legal aid and everything, and he wrote to Lord Goodman and tried to get him to be my lawyer but he was ill. And his own lawyer was busy on another case that kind of clashed with my case.

R/S: *That was for sending collaged postcards through the mail?*

GEN: In '76—"Sending indecent mail."

R/S: *Didn't they attempt to try you on each postcard separately?*

GEN: They did. They tried me on five separate cards. They were all hand-collaged. And as soon as they'd got me guilty, they walked up and they had an envelope with about another twenty in it, and they said, "We can get you on each one of these, any time we want. And you get twelve months inside then. So, watch your step!" It was like blackmail, basically.

I was found guilty on every charge. They fined me on each separate postcard—the maximum. So instead of paying one fine, which is the normal procedure for the offense, they made me pay five separate fines for the same offense.

R/S: *How much?*

GEN: It was three hundred and something pounds, including costs, which at

Cosey Fanni Tutti.

the time was a lot of money. And they refused me legal aid and refused me time to get the money… when they were told I had about four pounds in my bank, and I was on unemployment benefits.

R/S: *How did you raise it?*

GEN: I borrowed it. I had no choice—I would have got twelve months in prison if I hadn't borrowed it within twenty days.

R/S: *So… how did William get involved?*

GEN: Well, I had already met him and was in correspondence with him.

R/S: *You met him in person when?*

GEN: 1973, on Duke Street, where he used to live in London.

R/S: *That was when he did that David Bowie interview.*

GEN: I complained about it. I said to him, "Why did you do that ridiculous interview with David Bowie?" He said, "Advertising!"

R/S: *Did you initially just call him up?*

GEN: I found his address, or an address for him, in the back of *File* in the Mail Art section—remember the directory of all the addresses, the yellow pages? And he had down that his request for images was *Camouflage For 1984* (Remember the image request list?) And I just thought, "Oh, he's probably not at that address anymore, but I'll write him

anyway." So, I sent him a letter… complaining that he and Allen Ginsberg were trying to exploit the fact that they knew me by telling everybody that they knew me just so they could get into parties for free, and things like that. That was the first letter he ever got from me.

R/S: *Of course he'd never heard of you.*

GEN: No. But he was quite intrigued. And then I sent him a book that I'd done, called *To Do With Smooth Paper,* which was all hand-drawn pages, sort of telegraphic pages. Every page was hand-done, and I used to send them out to people… and I never kept anything. And I got a postcard through the door, and it said, "Thanks for the smooth paper—William S. Burroughs." I was really shocked. I thought, "Well, he *does* live there."

So then I sent him a shoe box filled with expanded polystyrene, with a wax cast of Donovan's left hand that somebody had given me—the thumb was broken off. And I just wrote on the outside, on the lid, "Dead Finger's Thumb." And he liked that, too.

Then we were just about to try and move to London. We had these stickers for this friend of ours… his address was 10 Martello Street, and he had a studio upstairs, and he was trying to get us a place there too, so it had his phone number on it and his address. I came down to see him one weekend, and he said, "Some idiot rang me up today and said he was William Burroughs, and that he wanted to talk to you and meet you, and I told him to fuck off!" And he said, "Somebody must have been messing around, and *I didn't fall for it!*" And I said, "Well it probably *was* him, because I've been writing to him and given him this phone number." And then he was really upset, because he'd always wanted to talk to William Burroughs and meet him—and he'd told him to fuck off!

So then I wrote to William and said, "Could I have your phone number?" I can't remember—anyway, I got his phone number, one way or another. And he said, "Next time you come to London, just ring me up and then get in a taxi and come straight around and visit me, and I'll pay for the taxi." So I did. I came down to Victoria Station and got in a phone box and rang him up and he said, "Hi-i-i, get in a taxi, and this is the address, and tell the guy that I'll pay at the other end." That's how I got to meet him.

R/S: *What was his apartment like? You*

Stan, Sleazy, Genesis and Boyd Rice (NON) at the Spahn Ranch.

*had to go up some stairs…*
GEN: I can't remember if it was two flights or… Really small, a living room which was very small, and a bedroom which was even smaller, and then a bathroom that was even smaller. He had that photograph of Allen Ginsberg with the top hat on (with the stars-and-stripes) in the bathroom. And he had a pen drawing that I'd done, based on one of his short stories, over his bed, with a little Moroccan hand-woven ribbon around it—nice touch. And that was the first time I'd seen any Brion Gysin paintings. And he had a color TV under the window, and he just kept changing the channels all the time, and recording little bits on a Sony tape recorder. It was him who recommended Sony cassettes for doing cut-up's in live work… of which the one we're using now is, like, the descendant. And he had a lot of whiskey, and we drank a lot of whiskey. His Irish friend John Brady was there but he went out and left us alone, and we just talked and talked and drank and drank and watched *The Man From U.N.C.L.E.* cut up with other things. He found *The Man From U.N.C.L.E.* really funny—he liked it, was laughing a lot at it. And then he took me out for a meal.

We did a couple of photographs. He went through my suitcase—he said *could he see what I had in my suitcase*? I had a ferret as a scarf—a ferret skin. And he said how he used to have ferrets, *live* ones… and then he put it on, and asked me to do a photograph of him wearing this ferret in his lap. I did one of him with John, the Irish bloke, and then John did one of me and William together.

That was how we met. And I used to write to him. He was the one who helped us get money from the Arts Council—he wrote to Lord Goodman who was then involved with the Arts Council and recommended we should get some money. As *COUM Transmissions*, as an art group in general—mail art, performance art, music, etc… *communication*.
R/S: *But that was before you did music—*
GEN: No, I've always done music, ever since I was at school. Always. I made my first LP when I was at school and got one copy pressed.
R/S: *Really? What instrumentation was on it?*
GEN: God, all sorts. Table knives, all kinds of Brazilian instruments that somebody lent me, half-broken acoustic guitars with amplifiers inside them—

hundreds of instruments. It was kind of a joke/psychedelic record, but not many people understood that. It was a very sarcastic LP.

And it's strange, 'cause I got that made at a place called D-Roy Sound in Stockport, in Cheshire, England. It wasn't till a couple of years later, when I read *Beyond Belief* about Ian Brady and Myra Hindley—that he used to tape Hitler's speeches off war documentaries, and get them made into LP records at the same place—which I thought was a nice little connection, He lived in Manchester.

The symbol of *COUM* was always a cock—a prick, a penis, slightly drooping, but with one drop of sperm coming out of the end—just post orgasm, you know. The moment just after. We used to have a sticker that said "we guarantee disappointment." And we all had embroidered patches with that on—Cosey used to embroider them; we all had them on somewhere on our clothes. And William said he thought it was the best symbol for communication he'd ever seen…

He really helped us a lot. He helped us get our first grants to do more things—which is how we managed to be able to afford to move to London. And then he helped us when we got all the legal action

against us, with a lot of recommendations and advice, of what to do and what not to do, and to be polite, and not try and turn it into a big battle, and just take the minimum punishment they gave me and not complain too much, or they just get heavier, you know.

He's always helped. Whenever I've had a lot of trouble about anything, he always comes through and does try and help or advise, which I think is really nice, because he has no kind of obligation to do that at all. And he does it just very quietly and very discreetly. I just write ad tell him what's happening or what's going on, like I write to anybody…

R/S: *When did you meet Brion Gysin?*
GEN: Well, I knew about him through the books and through William, and when we were doing *Contemporary Artists*—you know—the huge encyclopaedia that I wrote with Colin Naylor—
R/S: *Are you listed as an author in* Books In Print?
GEN: "Editor." It's a huge book. Nearly two-thirds was typed with this one finger,' cause I can only type with one finger. In that, I insisted on having Brion Gysin in the book—I said I wouldn't do the job unless he was in. Because I knew he'd done a lot of stuff that *should* be in it, but that most people never thought of him as an artist. Then I wrote to William and asked for Brion's address, so that I could get the information for the book, and then corresponded a couple of times because of that. And then it kind of stopped—I heard he was very ill, so I didn't want to irritate him with lots of correspondence.

And then… it was only about a year or so ago, I just suddenly decided to start again, get in touch with him again, in a more sort of serious manner.
R/S: *Well, you met Terry Wilson somewhere along the line—*
GEN: Oh, that's right, at the ICA, the Prostitution Show, in 1976. Just before that Terry Wilson turned up, introduced himself, and said he was writing a book about Brion… and that he had a big manuscript, and he thought I would be interested in reading it, the transcripts of the interviews. And I said yes. But then at the ICA, on the first opening night, there was a great big fight, and I got hit over the head with a beer glass, and Terry was talking to me when that happened and he's very sensitive and nervous and he just, *v*anished, you know, feeling somewhat freaked out. I didn't see him for about two or three years. I just reactivated contact again…

R/S: *When did you meet Brion in the flesh, so to speak?*
GEN: I don't remember—guess it was last year. Seems like I've always known him, though. I know one reason—it's because Monte (Cazazza) wanted to do *Kick That Habit Man* and I wanted to make sure that Brion knew and approved and got paid something for it.
R/S: *Brion had already recorded it—*
GEN: Yeah. So I wanted to make sure it was all done properly, 'cause I knew he'd been ripped off before, and I didn't want it to look like we were just exploiting him, so I wanted him to know all about it. So William gave me his new address and phone number… and then I went over and visited him, two or three times. And he came to England and visited a couple of times, came around to our house.
R/S: *What was his apartment in Paris like?*
GEN: Small, two rooms, tiny, tiny kitchen. Right opposite the Pompidou Center, that great big weird looking art gallery—literally directly opposite—out of his window that's the view. And he's done a whole load of drawings based on it, too. From when it was started right through to when it was finished… which are really nice, 'cause they've all got little tiny photographs collaged in of the actual thing, you know—people who worked on it and all that.

And he's got two Dreamachines there too. The one he's got, which was made in Switzerland, is about four feet high, in steel; it's about ten inches across (a tube) with a particular pattern of holes cut in at particular intervals, mathematically, and it spins with a silent motor. And the inside of the tube has one of his ink drawings inside, and then there's a light bulb in the center that doesn't move, so you get this flicker. And you close your eyes and you sit or stand about six to eight inches from it, and it gives you a flicker pattern that tends to induce alpha waves, alpha rhythms. You basically just trip out.
R/S: *What did you experience?*
GEN: Oh, I just got this very basic stuff. I'm very slow to relax with machines like that… very suspicious of allowing too much control to slip from me too quickly. Plus, Brion was watching me and I was very aware of the fact that he was at the table staring at me waiting to see what responses I got, what I did and what my face looked like, and everything—which made me much more inhibited anyway. So you feel like, "Oh wow, I really want to see fantastic things so that Brion's im-

pressed," and then you think, "Oh, but I don't want to do that 'cause it's pointless." And so you kind of need to be able to use it a lot of times before you just got used to the machine and didn't worry about that, you know. Ideally you should have it at home in your private place.
R/S: *Are you going to get one?*
GEN: What! At ten thousand dollars? I'd love one but I can't afford it. The guy who made them for Brion made twenty as a limited edition fine art sculpture—not as a thing to be accessible to people who might find it more *useful*. And Brion just had to be expedient and think, "Well, at least twenty will exist, as opposed to none." And he got one made very well, exactly as it was always meant to be—he got two free by doing that as well. So at least people who visit him can have access to it. It's the whole thing of being pragmatic, you know, *flexible*.

But really, they should be on sale in supermarkets for like fifty dollars each—plastic version of it would work just as well. Because it really is a psychedelic drug with no drug. No addiction problems, nobody's ever had any bad experiences with it, and all this stuff about epileptic fits is bullshit, and if you're really, really epileptic—what percentage of the population is it that you're excluding? Very tiny. And the rest of the penal population can have an endless psychedelic drug, without any physical, metabolic danger or effects. And they don't have to keep buying them every week when you've swallowed it, you know—it's there forever. Unless the light bulb goes—then you buy a new bulb. It's the ultimate drug experience; it really is, and that's probably why he's had so much problem trying to market it.

He has tried lighting manufacturers and… they kind of were interested, and then chickened out. It's a very, very marvelous *anti-control device*, as well as being a beautiful thing to look at. The worst you get is like the ultimate psychedelic patterns with your eyes closed—that's the *least* you get. The most you get is, you start to see actually recognizable visions of people and characters—you can go back through time, go back into your previous existences, go into the future… It's like a psychedelic drug—you can take it as far as you wish to go.

And the great thing—that was one of the happiest things that ever happened to me—was when we released *Heathen Earth* I sent him a copy. For years he's been obsessed with Moroccan music, and he stayed in Morocco because of the

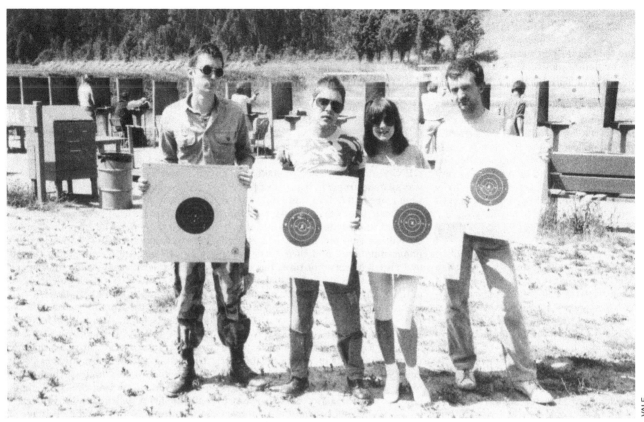

Stan Bingo, Genesis, Paula and Sleazy at Chabot Range, Oakland.

music, 'cause that was the closest to the Dreamachine parallel that he could get with *sound*. And he said that side one of *Heathen Earth* was the best music he'd ever played with the Dreamachine. It intensified it for him—after like twenty years he got a much more intense thing from it with that... and he said other people have said the same thing. He said it's the best music he's ever found for the Dreamachine, and that we kind of picked instinctively the pulses and effects and moves of the whole thing... which is like the biggest compliment he could ever have given me...

The whole concept of *Heathen Earth* was—it was more like a kind of seance, where we went *up* and we just let something *through*, with no control—the four of us just made up the whole thing in real time, and the LP lasted exactly as long as we played. I still don't know any groups that have had the nerve to go up and make an LP in less than an hour and say that it's going out unedited regardless of what's on the tape—I mean we've never been credited for that achievement! And, to do it in front of other people so they could see we didn't cheat.

R/S: *That's the "theory of transparency" in action—*
GEN: And that's also the theory of *COUM Transmissions*, which is: if you're opened up and you're aware of all possibilities and don't try and shut off anything, or repress anything, then things are transmitted through you just like they are through shamans (or anything else). Not all the time, but it means it's possible that it will happen. And sometimes it does. Just like when we play *live*, sometimes it can be technically perfect but it doesn't have that extra something, and another time—

See, like to me, LA was like, *proper* TG. The music in San Francisco was *good*, but I preferred LA because the sort of wound-up energy in it. It was total chaos musically, but the *effect* was true TG.

We've always said to people that we can't play very often, because it takes a certain amount of time for that psychic energy to come back. And even in a week, it can't. I mean, there's just no way that in San Francisco I could possibly pump out that much energy again so quickly. I'm like the transmitter,

whatever. The others are all pumping it through too, but it ultimately comes out of my mouth or head—the kind of final scream or whatever it is, *message*. They focus it all through. That's why we started calling them *psychic rallies* instead of concerts—because they *are*. That's why on *Discipline* it says *Marching Music for Psychic Youth*. Psychic youth are a more exact version of *The Wild Boys*—they're like the contemporary update of *The Wild Boys* to me, the psychic youth.

R/S: *How did you determine the content of Burroughs' LP? You went to the archives, listened to everything and made selections—*
GEN: Yes, except that I knew very specifically I wanted the tape recorder experiments, *not* readings. I refused to listen to any readings at all—I said, "I am not interested in that." *The experiments alone.* And that's what I suggested to him in 1973.
R/S: *And it took this long for it to materialize? In 1973 you weren't even putting out records then—*
GEN: No, but I knew we would; people just don't always believe me at the time. But... I kept reminding him. Whenever I

72

asked him direct questions about it and suggested it, he never mentioned it when he wrote back—it was like I never said it. He didn't say no or yes, he just didn't reply to it at all, like he hadn't read it. Which is a trick I've learned off him. If somebody writes you a letter and you don't want to have to offend them, or you don't want to actually make a decision, you write back a completely normal letter—you just *omit* any reference to that particular topic. It's very useful to do!

R/S: *Did you write the sleeve notes on the Burroughs LP?*

GEN: Every word. It took a long time, 'cause… I had to try and encapsulate my emphasis of what I thought was important about him, without it being arrogant or patronizing or rude. That's why it says that he did the books but these may not seem to be the most important things in the end. Because quite honestly I don't think they are.

R/S: *I've always thought* The Job *was very important—*

GEN: Which is an *ideas* book. His short essays, his ideas and his philosophy—*triggers to thought*—those are what really matter. I said to James (Grauerholz), "I don't care if I never read a William Burroughs novel again… what I like about William's got nothing to do with that—that just happens to be the way I bumped into him—through a couple of novels. But even in the novels what I got off on most was the ideas. Probably partly because I'm not gay, you know, so that all that gay stuff was lost on me. I used to get off on that whole thing of the tape recorder experiments and the political structures and the agents."

R/S: *He made the scientology center in London move three times, didn't he?*

GEN: Yes, that's one of the things we talked about when I first visited him. And he showed me his notebooks which are incredible.

R/S: *What about releasing an LP by Brion?*

GEN: All I can say is, I would like to find a project or a way to release something by Brion, but neither of us have really come up with a way to do it… or what it should be, really.

We've got this Apple computer and what we want to do is, we want to get Brion's voice on a cassette and then program the computer to do cut-ups with his actual voice, because it can do that. And get permutations—not typed out—but on tape. You know how he used to do it in print—we can now do that with his real voice… and cut it all up on the computer into all the possible variations of his voice.

R/S: *With a limited number of words?*

GEN: Yeah, like *Kick That Habit Man*—he just says it once onto a tape, and our computer will do the permutations with *his* voice. We have a tape of him doing it, but an atonal one.

R/S: *Atonal?*

GEN: Well, in the sense that—when he does it live, he stresses things in a more dramatic or theatrical manner, which he does really well—I mean he makes it really sound like sense, you know. Whereas typed out, often you can't see the flow. If we put it in a computer it'll be *between* the two, because the words won't run tonally, the stress will always be the same on each word regardless of the order. It'll give a very strange quality which may or may not be interesting, but it's worth doing it just to see.

We've got one phrase, *Poets Do Not Own Words*, which he said for us and we're going to do. Also, it would be possibly interesting to do something with him and Monte, where Monte did backings like he did for *Kick That Habit Man* but Brion did the vocals… in a similar manner. Some kind of collaboration like that. He said he's very interested, because he always saw them as songs, and he always wanted them on jukeboxes and on the radio. That's another reason he was so pleased with Monte's record, because it actually did get played on the radio, and it was even on a jukebox in London. Monte completely worked that one out on his own—I mean, Chris gave him a little technical advice on how to operate the machines, but Monte came up with it, and even the way to do the voices. It's one of Brion's favorite ever things…

So it's weird that after all these years it's finally flowed together, you know. A lot of people think, "Oh, they've just done a William Burroughs LP" but they forget that it's taken eight or nine years. And it took me the years before I even met him and all the years since I've known him, for the trust and for it to come to fruition as an idea and kind of be refined down to what it ought to be. But I'm not in a rush; I never try and rush things like that because they always happen in the right way at the right time. For some reason it feels like this is a really good time for it to appear. It makes a lot of sense for *Industrial* to release a *non-musical* LP now.

R/S: *You're starting video productions—*

GEN: That's the idea, but it hasn't happened yet. *I believe everything when I see it and not before.* I'm not worried about it, but—

R/S: *Throbbing Gristle broke up on the threshold of commercial success—*

GEN: For the purity of what my fantasies and dreams are, that had to happen. I don't see why I should keep trimming 25 percent of every fantasy off, just because other people can't handle it or think it's silly. That's just like a *bad situation*, and once you're aware of it, you're *condoning* it if you allow it to continue, which is not good for anybody.

Discipline! We need some discipline! Me too, you know. I'm toughening up now, as far as things like that go. I feel no obligation to talk to or see or be visited by anybody that I don't have a particular interest in. Because I don't see why I should *act*—nobody has *any obligation* on this planet. Everything's *voluntary*—what obligations you decide to have are the ones you *choose* to have. And I've chosen to have certain ones, but that doesn't mean I have to have any that are put onto me by other people. And often I am very soft about it and I'm *overpolite*, and I waste a lot of time being very polite to people who ultimately I'm not interested in, never will be. If I find I'm disinterested in somebody or suspicious of somebody, even if they seem to be very nice, well I'm just going to have to say, "I'm sorry, but NO" or "Too bad… " And if it's somebody that I do like or I have some commitment to, then it'll be "Yes, of course." But even within that, you can know somebody and not like somebody else that they hang out with. There's no reason why just 'cause they hang out with somebody that you're not interested in, you have to be friends with both! It's very difficult to keep that discipline. But I think, ultimately it's a better way to work. Because everybody knows where they stand. And the people who are your friends should know that *they're* your friends, not everyone they know.

I think ultimately now, the time is such that things are so scary—you've got to be *really tough*. And if somebody is really your friend, they should understand. And if they take offense… too bad! I think everybody's got a bit too saggy and soft, including me, and it's unhealthy for everybody, and it makes everything suffer. It wouldn't matter, except that it does actually affect everything. And if you're *here to do* (I actually do not agree with *here to go*—it's a trigger to a way of thinking, but I think as a sort of slogan in itself I don't agree with it, I think you're *here to do*), I don't think it matters why or what the results are, as long as you

feel comfortable with your motivation. But you've got to be really sort of *aware* of yourself and your inner workings to be sure that you're comfortable with your motivation, obviously. And that's not something you can teach anybody, or prove. So you have to be very very sure of yourself in that sense... and that takes years. And it often gets misconstrued as being *egoism* or arrogance or whatever, when it isn't at all. It's just like—you've worked efficiently on yourself so you know what you're doing.

People don't question a mechanic often when he says he's going to fix the car—they assume he knows what to do already (they don't always, but often they do!). And it's the same with somebody who's more of a creative person—they should know themselves well enough to know what they're doing... shouldn't need to keep disbelieving it. Because it'll become self-evident quickly enough if they're making mistakes.

That's just more *camouflage* for people who are insecure—when they start attacking other people as being *egotistical*. One of the worst phrases that happened in the psychedelic era was "ego trip." I think that was really destructive. I think it's one of the keys to what destroyed the whole thing—because it made out as a symbol that anybody who was interested in themselves, or was prepared to go out in front and do something first, was an ego tripper. It inhibited people. Anyone who was prepared to push, or do, and ask questions later, and just keep moving regardless and say to people who didn't like it, "Well fuck you!" was an ego tripper. And a lot of people were just too afraid to handle that criticism... especially when they were softened up with drugs.

R/S: *What would differentiate "psychic television" from the other kind?*
GEN: Well, it would be *non-programmed.* There won't be any programming, so you won't ever know what's going to be on when you turn it on. That's the *first* obvious thing to do. The second is that entertainment is the *least important* of the criteria! The content in itself is the content. You know, television today is like a thirty second orgasmic thing—you've got to keep the viewer's attention by an orgasm every thirty seconds or forty seconds—you know what I mean, *attention orgasm.* And I just think that's *bullshit.* People don't need orgasms all night if it's *interesting.* Starting in the opposite direction—it would be far more healthy to make it as entertaining as possible; it

TG in L.A.

would be far more *effective.* And if you start off thinking that the most minimal is still better as an alternative, then you can't fail but increase that to become much more entertaining, in the true sense—that it stimulates, and confuses, and surprises, and sometimes bores too. It's like an actual television in the sense that it's all the states of real life, with *no guarantees...*

But it doesn't mean that, if we got hold of a really good 'B' movie from 1955 which would in itself be entertaining, that couldn't be slammed on. But in the context of all of psychic television, it would actually gain more significance, too. Because you would think it's counterpoint to something else that might have seemed incredibly minimal. Plus, it's not meant to be used as a TV channel in the normal way—you can turn it on and leave the sound down. It's only going to be on between one and six in the morning—that's the best time to absorb things anyway. That's the time when there's the

least to watch, the time when you need it the most, and when you're prepared to take almost anything that happens as an alternative to boredom. And you can turn it on and have it turned down and be having coffee and rapping after you've got back from somewhere, and be laughing and playing records, and there's just these pictures on and you're treating it as a moving picture. And every now and then you see an image that you like, "Oh, look at that there!" And it might be a building blowing up on a loop for ten minutes... and then suddenly the building will stop and somebody will be on—it might be William Burroughs' face appears talking and you go, "Oh, what's this?" and you turn it up and hear him saying something; if you're not interested you turn it back down again. *And all the time you're giving them the choices,* you see. You're giving people control of whether they watch it or treat it as a picture, of whether they have the sound up and are turned the other way reading a

74

book. And the sound won't necessarily always go with the picture. It has no *need* to—who said it has to? Who said you've got to feel *gripped* by it, or that you've got to look at it or not look at it? I often have my TV on with the sound down all day, even when I'm not in!

Television thinks that anything that doesn't grip and excite and please people is a failure—which is not necessarily true.

R/S: *You would use it in a documentary fashion as well?*

GEN: Oh yes, it's going to have *every-thing*. If there was a concert you were interested in, you could go out with a couple of hand-held cameras and just film it, pump it on one night for two hours. And people could listen or not listen or go, Well I'm glad I never went to see *that*.

I'm going to try and experiment with effects like metabolic or psychic effects, too. We've done one experimental film of a Dreamachine already. And I want to see if you can make TV programs where you watch them with your eyes closed... and the flicker has the same effect as the Dreamachine. So you can tune in for Dreamachine. *That* one you could have programmed on every day, say three in

the morning for half an hour of Dreama-chine time.

R/S: *Have you ever experimented with those white noise recordings advertised in "New Age" magazines?*

GEN: It seems like that could be the soundtrack too, right? There's no limits once you start thinking... and it doesn't have to be the same all the time. No reason why if you get bored with one thing you don't change it—if somebody comes up and says, "Why haven't you done *this*?"—"Oh yeah, we'll do that!" It's totally flexible. You don't think, "Well, we've got an eight-week season booked already, we can't do that now." And, you can guarantee that once people know it exists in any form at all, they're going to start sending things, suggesting things.

But initially it will be cassette television, 'cause we can't get our own channel and so on at this stage. We're going to have to start off by doing long vid-eocassettes that you put in for at least four hours, preferably longer. They're going to come out with eight-hour ones soon. And it will say, "This is meant to be watched continuously" (or at least be in the TV continuously). You're not meant to stop it—even if you go to bed you can leave it on. But the sound can be turned up and down at random, and

you don't have to sit and stare at the TV. It's meant to be played from midnight on and *seen as a channel*, as an alternative transport...

We're planning to have the East Berlin news on once a week, every week, with English subtitles. So that you hear *their* version of everything... which would be a very interesting discipline for people.

The possibilities alone are endless. And even if we never managed to get our own channel, we could still have an effect. We can alter the way it's seen. Even if they never admit it, we can make bigger TV stations start to rethink the way they operate, just like independent labels have done to record companies. I mean, I don't see any particular level as being where I'm aiming to get *to,* we're just going to do what we can, and the effect it has is what it has. At least we tried and we did something we *thought* should happen. And hopefully it will inspire other people to do sort of parallel projects to gradually break the whole monopoly.

R/S: *That cultural monopoly's the biggest—*

GEN: That's why it's the one to attack next!

**Chris Carter.**

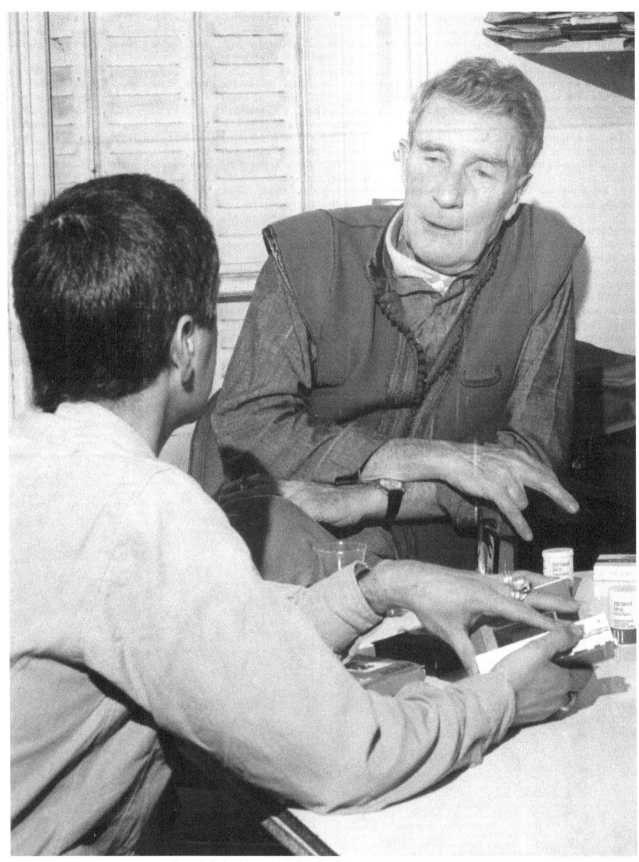

Genesis P-Orridge and Brion Gysin at Brion's flat, Paris 1980.

# ON BRION GYSIN'S PAINTINGS

Brion Gysin, *Midnight and More Marrakesh*, 1967.
Watercolor on paper 20 x 17.9 cm

A lot of them are black and white and grey—most of them are eighteen percent grey. The colored ones are incredible—from a long distance they just look like a vague Jackson Pollock texture, but when you get to about here [*gestures about six feet away*] you realize that it really is hundreds and hundreds of tiny little people. Some of them are at night and some of them are at dusk. There's nothing that's actually photo-realism, but they're more real than anything. They contain the true light of what things look like... And it's grown on me—gradually it's dawned on me how strong it is. And you see the most unbelievable things and it's better than LSD or anything—you see real pictures you see people from the past and the future. And anyone can see this—if you buy one you can do that forever. Whenever you want—just go on a trip...

—*Genesis P-Orridge*

Brion Gysin, *Devil Dance Marrakesh*, 1967.
Watercolor on paper 22.5 x 18.5 cm

**TG in L.A.**

# THROBBING GRISTLE INTERVIEW

London. April 23, 1981
Interview with Throbbing Gristle by Rieko (and friend) from Japan...

**GENESIS: Word associations?**

R/S: *Death.*
GEN: *Nature's trick*, I think it is. It's the big trick that you can't avoid, that makes everything rotten—that's what it is.
SLEAZY: It makes everything good!
CHRIS: After life?

R/S: *Flowers?*
GEN: I don't think about flowers very much. I like flowers. Makes me think of hippies giving people flowers, and demonstrations in Washington putting flowers down, right? And suburban gardens and very, very boring people, but occasionally they're romantic. People that are in hospitals. Flowers are always supposed to be nice, but they're usually associated with bad news like deaths and illnesses and people having arguments and trying to make people like them again!
R/S: *Do you have any specific flowers you like?*
GEN: No, the only plant that I really like is one called *honesty*. And it's not got any flowers—you get these leaves and you rub the leaves and the covering drops away and then they're almost transparent, they're very silver. They're very nice—you've seen honesty? And I always liked that best cause it's dead before it looks pretty. When it dies in the winter is when it actually looks good—up 'til then it's just green, and boring. Then you rub the leaves, and it looks like very, very thin paper, like rice paper. That's my favorite plant. It's not really a flower. I like that best... very mysterious plant, and I like the name as well: *Honesty*—in England, anyway.
R/S: And how about you?
SLEAZY: The best thing to do to flowers is hang them upside down. If you hang them upside down then they dry in the condition that they were when you hung them, so they remain preserved, even though they're dead.
GEN: That's a very similar sort of concept. That's interesting—we both like things that are dead but look more alive.

SLEAZY: The same with some people, of course.
GEN: They won't be preserved...

R/S: *Family kinship?*
GEN: Is it *families*? The trouble with all of these is they're really big subjects, aren't they? The sort of thing that you can dedicate your entire life to—the one word. It's a subject I'm very interested in—that's why I'm interested in things like Jim Jones and Charles Manson and different religious philosophies. I don't believe in families in the sense that you have to like people that you're related to by blood. I think you should *choose* your own family, the people that you actually feel close to, or related to in the way you think. Soon as you get old enough! I don't even *see* my cousins, aunts and uncles and all those relatives and I'm not interested in them. I don't see why I should be—just because my mother's father fucked the same woman, you know? I don't see what that's got to do with *my* life. But you're expected in most countries to like people just because of sex relations of people you never met! It seems a bit crazy. So I'd like to evolve a lifestyle (or I've tried to) where it's a very flexible or fluid grouping of people that's more like a family should be. With no obligations at any given moment to stay a part of that—you know, you're a family as long as everybody feels the same and then you're not when they don't, 'cause otherwise it just becomes a way to *control* people and stop them feeling free. So I think it's an interesting subject: to find some system of grouping together with people which doesn't destroy anybody's liberty, and where they can still be quite honest with each other.

And I spent most of my life involved in exploring that, living in communes, in different groups, and working in different groups. That's why I never work on my own—I never do anything on my own, because it seems pointless. It's more difficult to work with other people in a lot of ways, but more rewarding. And also often the work that you do is consistently more interesting because you

have more people's brains to suggest things. And I'm very dubious that one person can always come up with lots of great ideas all the time. If you've got six people who are pretty good—six average intelligent people can come up with a lot more good ideas than one very intelligent person quite often. So everybody gets a better chance.
R/S: *Also, more accidents with more people—*
GEN: Yes, lots of random chance.

R/S: *Fog?*
GEN: I like fog a lot. I used to go out in the fog when I was a teenager with my penis hanging out of my trousers! Including my friend, the two of us used to walk along in the fog, and then if we wanted to have a piss we'd just stand wherever we were and piss, even in the middle of a main road. Nobody could see, and it was really good fun to do naughty thigs like that. I liked it for that reason. You could be doing something that was unacceptable in the daylight, ten yards from somebody's house, but nobody would know, so therefore it was all right to do it.

I like it just because it is mysterious and has all those memories of old movies and so on. And there is something very strange and spiritual about it, because the *sound* is different. All the sounds in the air are actually different—muffled, and you can't tell how far things are away. And you can imagine or fantasize all kinds of things around you and you can't be proved wrong, because you can't see what's really happening.

It doesn't frighten me—it's never frightened me. A lot of people find it frightening—I don't. I like the light as well, where it's dark it's not dark—it actually kind of generates more light, but you can't see—so you have the effect of darkness without it being completely dark... I associate it with feeling mysterious and alone, but being able to imagine being able to do anything...
R/S: *But in a state of chaos you can—*
GEN: I don't know. I have no ideas about chaos. The only thing I can say is I don't think there's any such thing

as chaos, because in terms of time—if time is eternal, then ultimately everything has order. Everything is bound to somehow have a pattern, in infinity. You can't make a random noise, for example, not in infinity. Therefore you can't have any real chaos. You can have states of flux or flexibility—fluid situations which some people would say were chaos—but they're not, they're just something happening now, but the order isn't apparent at the time it's happening Everything's part of something else that's happening, therefore it can't be chaos.

R/S: *How about you? The question was fog.*

SLEAZY: You used to be able to get these cans of London fog in the shops, for tourists, in the shops that sell Union Jacks. But you can't get them anymore—I think it's because there haven't been so many fogs. I don't know why that is.

GEN: Because of the smokeless zones. But that's smog, that's not real fog. Fog is mist, rain...

R/S: *Inflatables?*

GEN: Inflatables? What about them? We've got a friend who makes inflatables, Jules Baker. He just went to Japan with his inflatable dinosaurs to do something for Japanese television, about two weeks ago. I helped him with his show a couple of times in Northampton. He's made inflatable giant footballs, UFOs, huge boulders and other objects for years. That makes me think of the pig that Sleazy used on the LP for Pink Floyd. That was an inflatable, and it got away! The road buoy snapped and it floated off. It makes me think of hippies—that's when it started, in the 60s. Arts festivals, community arts festivals. Oh! Do you mean inflatable women?

R/S: *Any inflatable. Inflatable to me could mean sexual stuff, it could be anything. Somebody I met (described) to me this inflatable tubing which he walked on water with...*

GEN: That reminds me of a guy called Scotty. He used to have a portable vacuum cleaner on his back, and a bag hanging over his crotch, and then he could just switch it on and it would inflate this, like, forty-foot long penis! *Huge* one. He made one that was about ninety-feet long, really big backdrop by the Thames, and he stood there like this with his ninety-foot-long prick. And he used to go to arts festivals and openings of art galleries where everything was being very trendy and polite and then suddenly just switch on this vacuum cleaner. This huge prick would just shove through everybody! He

made a snakeskin one as well. Then he became a teacher... settled down.

He used to work with Hermine who was Chaos in *Jubilee*. His full name is Anthony Scott. And he also made the longest, most meaningless movie in the world.

R/S: *How long was it?*

GEN: What— The whole film? Well, it's playing in everybody's local cinema now! That was one version of it—it was everything on in every cinema all the time. But then the other version of it actually was in Cannes—about one-hundred-and-forty cans of film. And it was just all the footage he used to get free from Soho and Wardoff Street joined together, everybody's thrown out bits of film. Sometimes he showed it like twelve hours at a time. It never finished, you see...

R/S: *Things like that are much better in video, I think—*

GEN: But there wasn't any video then, not that people could get hold of. That was in '69. But ultimately, of course, his idea was that everybody alive was the longest and most meaningless movie in the world—that was kind of the concept...

...So you want to know about the meaning of the universe and life?

R/S: *How to get to heaven?* (laughs) *What did you want to become when you were a child?*

GEN: Exactly what I am. I can remember very distinctly that I wanted to be some form of bohemian creative wanderer, trying to understand what was happening. And writers and artists and musicians were the only people that seemed to have any kind of romantic, desirable edge to them. I always had this conviction that I would be like the people who wrote the books that I liked to read. I didn't think that I'd settle down in a normal way, at twenty or something like that. No, it's amazing, but everything that's happened to me was just how I always imagined it would be... in a perfect world.

But I think also it meant I was so fixed on the idea—I wanted it so strongly and it was so clear—that it was far more likely that it would actually happen. I think that's how you can actually make things happen. So, I always *knew*, quite strongly. But I didn't dare tell anybody, I didn't tell my parents or friends, because they'd probably try and stop me. And I had the instinct to know to keep quiet about it, and act as normal as possible; while doing research; while reading lots of books and so on, and trying things out

quietly, without anybody realizing. Because I knew that they'd get disturbed if they knew what I wanted to do. And then I just waited until I left school... and immediately started doing things. I was away from home then, so it was okay. That's the only reason I went to a university—to get away from home so I could start doing what I really wanted.

R/S: *What did you do when you started?*

GEN: I did performances, happenings. And I did a lot of writing, collaging, and started experimenting with musical instruments. Well, I'd already been doing it a bit. But I just did it more and more. I started a magazine that had *no* editors. Everybody who sent anything to the magazine—every single word was printed, even their name and address. (laughs)

I don't know, I think I was influenced by reading Kerouac's books about the Beat Generation, and books about Dada and Surrealism. The thing that I was always interested in was their actual *lifestyle*—not so much the work that they produced, but the way they lived, and the fact that they did live out their lives like an art work or like in a creative manner, so that reading about their lives was as exciting as reading a good book, or seeing a painting. And that's why I liked Aleister Crowley as well—for the same reason—he lived his entire life around his idea or philosophy, and everything he did was part of that. And that's what I decided I should do—that's what I decided everybody should do—but it's not up to me to make people do what I think they should do... And if you meet other people who have a similar kind of idea, then that's great! Of course, it's true that there are not as many people who are genuinely active as everybody thinks. And you end up with a very high chance of meeting a large number of the people who *are* doing interesting things if you keep on—just by the law of averages, you know. And it's funny, 'cause you often meet somebody like—when I met Derek (Jarman), it's like I always knew I would end up meeting him. I knew about him for years, and I never bothered to find out where he was. And he said the same; he said, "I always knew I'd meet you one day. I've heard about you." That happens all the time with people.

R/S: *What was your impression after you met him?*

GEN: The thing I remember the most was having a really long conversation

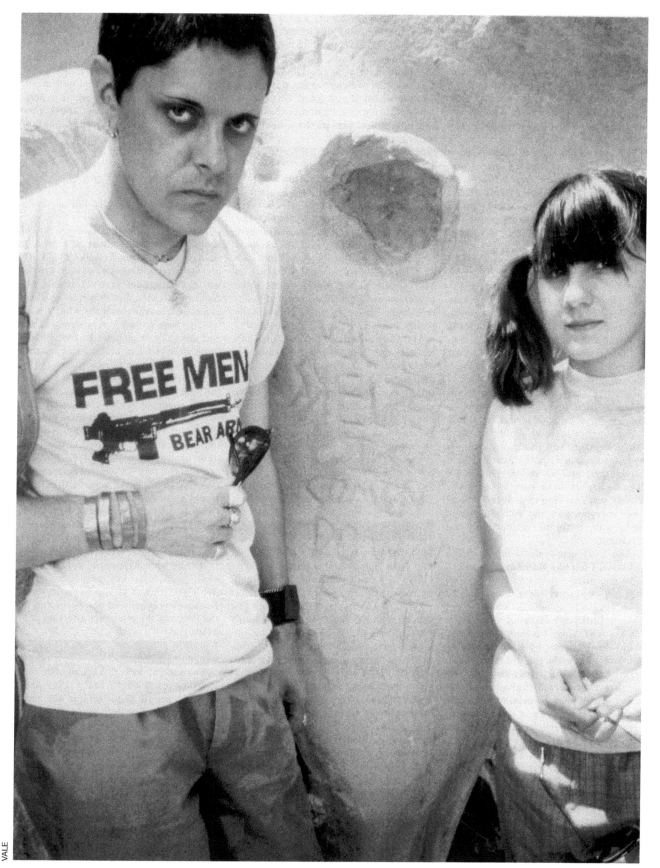

**Genesis & Paula P-Orridge at the Spahn Ranch.**

with him in his flat about magick and the Rosicrucians. It started in the afternoon and then it gradually went dark outside while we were talking—we just talked and talked. And he didn't put the light on. And that silver globe gradually got stronger—as the light went down it kind of stood out more and more—you know the one I mean? Near the window—the one for seeing the future.

R/S: *I noticed that—I was near his place and I didn't know where he lived. I just saw that and thought it must be his place. You can see it from Charing Cross Road.*

GEN: And that witches' gazing globe seemed to be getting stronger all the time. They're mercury glass and you use them for looking into.

R/S: *I thought it was kind of a mirror—*

GEN: Well, it's not intended to be a mirror, it's intended to go *through*. I mean, all those things are just systems to focus your will and your attention, and also to get the brain into a state where *things come through*. That's why I don't think there's any difference between lots of different philosophies. The pure forms of most disciplines are very similar—they're ways to achieve mental states, to maximize your own ability to make things happen. And that's just one system; meditation's another, drugs could be another, and so on. Jogging could even be one! It doesn't matter what you *use*, all you're trying to do is to focus all your energies, and also activate certain paths in the brain that are normally just left to rot.

And I just got really... into a different state. I felt like I'd been... just very, very energized—that my mind was really full of positive ideas. I was excited that there was somebody who I didn't have to justify my existence to; he knew the kinds of things I meant, he didn't go What do you mean by such-and-such a word? He knew the general things I was trying to say. And I was very pleased, because I discovered that what he was doing wasn't as superficial as some of it looked. Like *Jubilee* and so on could be seen as quite superficial. But the reasons he was doing it were far more interesting than the actual film. That's why I like his new films better, because the films are actually like what he's trying to do now, whereas before, it was hidden inside it. And he's kind of stripped away the camouflage and got back to the actual essence of what he's really trying to do. Which is probably why he's getting bad reviews in all the papers, because they can't handle anything that's too pure. They keep saying What does it mean? and it doesn't mean anything. It's not *meant* to mean anything. He never said it meant anything, he said it's just like a dream, it's not about anything at all. It has no focus, it has no start or finish; again, it is a mental state which, if you accept or use, you can get into a nice state of mind yourself, and then things just start happening in the brain.

The same way as Brion Gysin's Dreamachine makes things happen in your brain, too, by a trick, a flicker. It's a thing that goes around with holes and there's light in it, and you close your eyes and look at it. Like he said, it's the only art work he knows of where you look at it with closed eyes. And it flashes on your eyelids at the same rate as alpha rhythms, and you just...see really incredible... the *least* you see is like really strong LSD. And also, if you keep using it, you start to actually see complete hallucinations of people and landscapes. So it's like a really, really strong psychedelic drug, but it's not a drug, therefore it's totally safe. It costs nothing once you've got the Dreamachine—you just plug it in and switch it on. It's like—when you've got one, you've got a lifetime supply of an ultimate psychedelic drug. Which is just, again, useful for reminding the brain what's possible. It doesn't tell you any answers, it doesn't take you anywhere and leave you there, it reminds you of your *potential*.

R/S: *When you met Derek at his place, was that when you decided to work together?*

GEN: ... I can't remember now—yeah, he was just very open, he talked about what he was doing, sort of, What do you think? And I'd say, "Well, that sounds interesting." or, "That sounds a bit obvious," and so on. It just kind of happened very organically. But after that conversation I definitely was hoping that we would work together in some way. Because I felt a very close empathy with what he was saying. And there aren't very many people around who are open to the whole idea of magick, you see. It's very out of fashion! People are very suspicious and ill-informed about the idea. (dog barks)

R/S: *Speaking of magick, to what extent do you practice?*

GEN: (pause) A lot.

R/S: *Is it part of your art?*

GEN: Oh yeah, has to be. Completely. Or I would say it's the other way around—my life's a part of the magick that I do—everything that I do is second to that, and is controlled by it, including me personally. It's the one thing that everything else comes second to. I mean, I only do that because my whole experience tells me that it *works*, and I have quite definite physical evidence that that way of living, or whatever, or of looking at things—that *vision* of things—definitely works, for me at least. Whether it would for everybody, I don't know, but for me it does.

R/S: *Do you think magick has to have a kind of form?*

GEN: No, I think that's why a lot of people are confused about it. I think it changes all the time. And like I said, it's just a structure that you can apply to the world, a philosophical structure that you can apply, that makes things more likely to happen. I mean, basically what you do is—*you have to have a very strong vision and direction*. You have to have something that you can really focus on that you want to be like, or you want to get to, or a kind of person you want to be. And the kind of things that you want that person to generate in the world. And then you have to just try to maximize the possibility of that happening, by avoiding the things that might distract you from it, or destroy it, or block it. So it's kind of a *removal process*, you're removing everything that's in the way. So that it becomes more and more likely that you're going to get to it. And if you actually do or not isn't the thing; the fact is, you get further to it that way than if you don't. And you can only do that by not wanting to dictate what happens to yourself. You can't be in control of that, because you don't understand all the forces at work. Because everybody in the world and all the forces in the world are affecting your destiny...

You see, you have this vision of *destiny*, and then *fate* is what actually takes place. A lot of people think they're the same thing and they're not. So what you try and do is—maximize the chances of fate not interfering with you going towards the destiny. And the destiny can actually change, you see, because certain times fate cannot be stopped. And it does deflect you and the vision as it mutates. You might still think: "I would rather have been that, but I can't get there, so what's the most useful thing I can still get to?" You apply that, and you find that also, a lot of other things, material things, also appear as a byproduct.

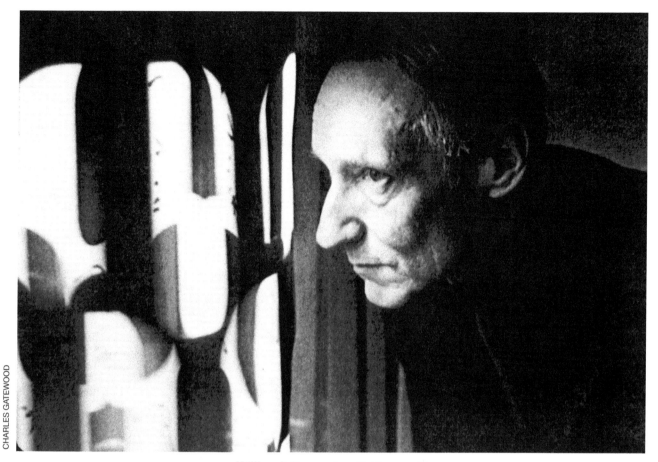

CHARLES GATEWOOD

William S. Burroughs with Dreamachine.

If you sat down and said: "Oh, I can get a car if I want." Well, I *could* get a car if I wanted, but I don't *need* a car, I don't really *want* a car, really pure. Therefore it wouldn't appear. Things only actually happen like that when it's a completely pure thought and it's not really a selfish thought. That's only how I can actually explain it from my experience... Things happen through the will. Everybody's had that experience in some way, even to thinking of somebody and the phone rings, or—You sometimes can go out and know that you'll get a taxi immediately, you just know you will. Another time you can go out and know it would take an hour. And you can't explain how you know it, but sometimes you just know things will occur.

R/S: *Do you get that in dreams? Do you predict things in dreams?*
GEN: No, I never predict anything in dreams. But when I dream I always dream about certain... there's about two or three locations. And different things take place but the locations are the same.

And I can remember things about them from before, in a new dream, like: "Oh, if I go around *that* corner, that's where the bridge is; but I don't want to go over the bridge this time, 'cause that was really bad news last time I was dreaming, so I'll go over the other way." And you can actually change the pattern of what's happening within a dream, because you remember the sort of landscape, or whatever. But you can't actually know what's happening in the dream as a story—you just know the places in it.

R/S: *Have you had super-ordinary experiences?*
GEN: Yes.
R/S: *Could you tell me—*
GEN: No... It's always very hard to prove things like that anyway, because you could say, for example: There was a shop in the market where I took an old television to get fixed, and the guys in there just kept messing me about. And I kept going in and asking for it back, and they took it to pieces and they never put it back together again.

And I remember very clearly thinking, I wish that place would burn down.

And then it burned down that night, and everything in the shop was totally destroyed. Well, I could say I made that shop burn down, because I remember it being a very clear, pure—just for a couple of seconds it was just like I *saw* it rather than *thought* it. Somebody might say either I foresaw what was going to happen anyway, and that's why it made me think of it. Or I would say I made it happen. Or somebody else would say it was just coincidence. There's no way you can *prove* what happened. All I know is, I thought about the shop being destroyed by fire and it was.
R/S: *Do you think it matters if—*
GEN: No, I don't think it matters what the reason was at all. It's *interesting*, but it's not a sort of vitally important point to find out.

R/S: *If I change the question... Have you encountered a very super-ordinary experience? Or supernatural?*
GEN: Yeah. There's a friend in Poland.

83

The mother of the girl on the front of *D.o.A.* And I was talking about things like that, and she was saying that she was in the countryside with that little girl when she (the little girl) was much smaller. And there was a river, and somehow she went for a walk, and the child was on one side of the river and she was on the other side—I can't remember all the details. But the main point of the story was that there was this river between her and the kid. And the kid had had an accident, and she sort of was trying—*How* to cross the river? Then she looked, and there was a little bridge, sort of a wooden plank, right across, and she walked across it. And when she turned around there was no plank...

Her friends who'd been looking after the kid came back and said, "How did you get across the river?" And she said, "I walked across." And they said, "But how could you?" And she said, "I don't know... but I did." And she can't explain anything except that for a few moments there was some way that she could walk across, which in her eyes looked like a plank, but wasn't necessarily anything at all. (Just like some people can walk on red hot stones and we couldn't; for a few moments they're able to do something which is completely illogical. And it's interesting, because maybe that's what— you know, they say that Jesus walked on the water. Well, it must be possible. But nobody knows why.) All she knows, and all that matters, is that somehow she walked across the river and got to her little girl... And she hadn't got wet feet, or anything, so she didn't hallucinate it and wade across.

You know, most people have those experiences, and yet still are very sceptical of those kind of things being possible. The main thing is just that you should always try to keep expanding, and always try to keep active.

R/S: *Being receptive is very important... you have to be very receptive...*
GEN: Oh! Receptive. I thought you said *deceptive*! Right. You have to be receptive all the time, so that you can *mutate*...
(end of tape)

...One example I used with people to try and make them update their conception of magick is—you get the old-fashioned or everybody's archetypal view of it, which is a guy in robes with a wand saying sort of Latin incantations and so on. But the *modern* magician uses a Polaroid camera and a cassette recorder, like this. Because you use what's the appropriate tool to the time you live in.

Debbie.

So in the medieval ages that was appropriate, because it fitted the culture, with a very sort of strong religious cult. But now that's not appropriate. *A computer, a cassette recorder, and a Polaroid is what's appropriate; and a video camera now.* Because you're dealing with what's *powerful*, and what *works*, and what manipulates what happens. That's what it's about. And you apply your will to what's already available to make things happen...

And it's a very selfish idea in one sense, because the whole point is that you're trying to make the world how you want it, so that you get the maximum pleasure!

R/S: *I was going to ask you, is it important to record it...?*
GEN: Well, I *used* to think you had to. And Aleister Crowley used to say that you should always keep a magickal diary, which meant you make notes of everything that happened. And Cosey and I both used to keep diaries all the time, for a long time. And then we stopped. Now I'm not so convinced that you need to follow it. I still am very interested in documentation. I always try and get hold of as many souvenirs and so on as I can. In a sense, now, I think the diary's just transferred into the interviews that we do, they're kind of a document. It's just unfortunate that a lot of the people who actually write them leave out the bits that I'm more interested in them preserving. So, in a sense, it's a much more inaccurate form. But I don't worry—ultimately it's an editor somewhere who's going to wreck it, not usually the journalist. That's the trouble. You could write something that's really sensible and clear, and then some editor could chop out like one sentence which happens to be the crucial sentence, but be-

cause they're not interested, they don't understand. And it can completely alter everything else...

I still think it's always worth trying to communicate. But I still keep notes very occasionally if something seems particularly useful to analyze or remember. I scribble notes down in a small diary or a notebook, but I'm not as methodical as I used to be. Partly I don't have as much spare time. I would have to do it at three in the morning when I'm usually too tired to make the effort. I just don't feel like writing six pages of notes and ideas at three in the morning quite often... which is a pity.

R/S: *When you were keeping notes, did you get a kind of cycle? Did you feel that after seven years or whichever number you have, you're coming back to a kind of original point?*
GEN: I think that happens, but I didn't notice it through keeping notes. Although sometimes I look at notes in retrospect and discover that there were things there which are the same as I thought I've only just thought of, and I'd forgotten completely. The *good* thing about keeping notes is that you *do* forget lots of things that you discover or learn and so, if you had a good system, it would be better, because you can often waste a lot of time learning things two or three times! And then forgetting again, and then suddenly...

Another thing I'd really like to do (but I don't get the time and the energy), is to make notes of the books that I read. Just copy out all the odd paragraphs and sentences that I really, really like. To save a lot of time I would just then read the condensed version of everything I've learned from the books that I've read. But there again, it requires a lot of effort and time. So I've accepted that at the moment, the activities that we're doing have to take precedence over that, and that later on, when I'm a boring old fart, I can spend more time being more scholarly and making notes and reading more and being more methodical, just for my own personal development. At the moment I'm kind of partly doing personal development and partly kind of engaged with the public—in their development too, you see. Which seems a useful thing to be doing, as it happened. I mean, it wasn't something I realized would get to this extent, but as it has, then I have to accept that and go along with it while it's happening.

R/S: ...*The outside world, how do you cope with that?*

GEN: Not very well. That's why I'm a bit crazy, that's why I get so depressed sometimes, 'cause you can be aware that so many things are *possible*, and that it *is* possible to make lots of things happen without doing too much damage to other people, and that you can meet people that you really like and you're glad to have met, even if it's briefly or for a long time. And then you look outside at what actually most people are living like, and it's just so... depressing, you know. It's like rubbing shit in your face.

I mean, it's not because they are individually horrible people or stupid people, it's just the collective result of this society or whatever, or the way people think at the moment—which is bad, and destructive, and really uncreative, you know. And the other thing that's sad is that most people really, if they were given the chance, want to be told the truth, and want to develop themselves, and do want fuller, more interesting lives.

But the few people who run the countries—the politicians, the big businessmen, the mass media people—they enjoy being in power, they enjoy being the ones who dictate. And they have a vested interest in keeping everybody else as stupid as possible, because it's easier to lie to stupid people, it's easier to control stupid people, and stupid people ask less questions! So it's quite obvious that the basic process that's going on is that: there are a few people trying to keep the rest stupid and ignorant and ill-informed, so that they can manipulate them. And they're doing it purely for themselves, just for their own ego and satisfaction, these few people. But they don't even do anything *useful* with it, you know; it's not like they're doing something really fantastic and exciting with that. They're just petty, pathetic housewives that are running countries—really pathetic people with no imagination or vislon.

I mean, at least somebody like Hitler had *vision!* And did something pretty exciting. It was a corrupted vision. But I was thinking about this whole idea we were talking about: that you can maximize the chance of things happening if you have a vision. And I think that's what happens with people like Hitler and Idi Amin and so on—is that they apply the forces of magick without understanding all of them. Or, they apply them and understand them, but for very selfish reasons, which is why eventually it has to end up destructive, because you're using a positive thing for a negative reason. Which means it has to kind of suck in on itself in the end.

But that's how somebody like Hitler could get so much done in ten years. *He kind of went from cavalry to space travel in ten years!* Just from this vision; from applying incredibly strongly this vision. So he was applying the laws of magick completely, but he was *mis*applying them, because he wasn't genuinely concerned with everybody else. And that's where the big break comes. I mean, I often wonder why, but I do feel a genuine concern for everybody else, even though half the time I hate everybody! It's a kind of weird situation: on one level I hate the human race, for being so stupid and destructive for so long, but I can't help but want to try and improve things.

R/S: *You die, otherwise...*

GEN: I guess so. And then every now and then you meet one or two individuals who you think it's worth being around just to meet them. And that's the best bit of all, is just to meet people you can talk to and communicate with.

But I reckon that's how it happens. I don't think people understand how simple politics really is. It has all to do with those forces being applied, and misapplied, or corrupted. In the case of Britain I think it's not so much they're applied as they're suppressed. All that energy that could be utilized to go towards a vision, is just going around nowhere. And that's why you get all this conflict, and *useless* conflict, not just like riots, but even unions versus management, and so on. Because there's all this creative energy that all those people have somewhere in them, with no direction. It's not channeled by education, or anything. There's no encouragement to apply your will to anything in Britain, so it's kind of a negative magic, it's like a suppression of potential.

In other countries, they encourage that power, but they encourage it into a very destructive direction, a very sterile direction. Russia is a very sterile application of that energy; they apply it to completely uninteresting things, like bigger armies, and everybody being supposedly equal. They could do so much more. A good application of that energy is the space shuttle—something totally fantastic, that you wouldn't think could happen. But when you realize we can do things like that, you know, by applying a sort of communal energy ('cause a lot of people worked on it). I mean, why do they waste time with all that other shit? We should be doing things like that!

People wouldn't mind so much living in shitty houses if we were doing fantastic things like that every month, and they thought it was part of what they were doing—that their will was making it happen. I don't think people actually are as obsessed with their living standards as they've been told. It's just—you've got nothing else to think about. If you've got a fundamental satisfaction, you're prepared. That's what people like China have utilized, precisely that. People will go *without*, if they believe in something bigger, you know. But unfortunately most politicians and systems use it for really stupid, negative ends. This planet could be really fantastic and exciting. It could be incredible to be alive on this planet, just the things that are happening and could happen could be really fantastic. You could travel around and be absolutely stunned all the time by what was going on. That's what they should be aiming for: that everybody's absolutely amazed all the time! And don't really notice that oh well, still got a bit of a shitty house with a leaky roof, and so on...

R/S: *But... if we do realize that state (space industry, solar energy, etc) it is possible the tendency toward totalitarianism will become complete disaster.*

GEN: Oh, I think it *will* be misused. Why are those people going to suddenly turn around and make everybody happy? They haven't done it for two thousand years. Why should they suddenly change? *They're* happy, they don't care about us.

I don't think you have to worry about it—you just aim for what's the highest point. You never know, something fantastic could happen. If enough people were aiming for it, it would *make* that happen, 'cause there again the laws would apply: that their will collectively would make everything they wanted, happen...

You need a movement which has no rules... not an anarchist movement, but where it encourages people to express their individuality. That's what we've never had. All these movements always have a set of answers and rules and *these are what we are*. There's never been one where everybody's different, and all they agree on is that they're trying to go in a particular direction, but each one in their own way. We need an *anti*-cult! We have all the cults—what we need is an anti-cult, for all the people who don't fit in.

I was looking at a church that was for sale last weekend (laughter). It was up near Wales, too far away. I'd really like to get a church and start a church.

R/S: *My friend bought a church near Oxfordshire. He's thinking of converting it to a workshop for songwriters.*

GEN: Well, I want keep it as a temple, *the temple of psychic youth.* And if somebody wanted to celebrate something in a ritual, they would invent their own ritual and celebrate it. Everybody could have a totally different one. It's not like most churches where the service is always the same. So it would be like, completely, totally flexible. Most of the time it could be concerts, sometimes it could be a workshop, sometimes it would be empty, it doesn't matter. I want somewhere where it didn't matter *what* happened, where nobody had to feel anything *had* to happen, either.

---

R/S: ... *What was your most horrifying experience?*

GEN: Most horrifying. (laughs) Do you mean what's my biggest fear? [long pause] Being betrayed, which leads to the fear of being betrayed again. And the feeling of not being able to trust people when you want to.

R/S: *What was your funniest?*

GEN: (musingly) Fun-ni-est. I don't know. I don't remember funny things much. They're kind of very transient; they're funny at the time and then you forget them... Well, I do. Don't know... I'm not that bothered about things being funny. It's nice when they are, but it doesn't worry me much. So I guess that's why I don't really remember them so well.

R/S: *What was most shocking?*

GEN: (long pause) I don't know. I expect the worst of people, so it's very hard to be shocked. Don't know. I'm sometimes surprised at how *banal* people are, or how stupid people are. But 'shocked' is a very extreme feeling, isn't it? I don't know. It implies so much importance to something, and I don't think I give anything quite that much importance, nothing individually. I'm shocked, I suppose, by the fact that I'm even alive. I mean, I find the whole idea of being alive and that you're going to be alive for so long and then you're going to get older and die—*that*'s just really impossible to understand or grasp... very strange. Every day I think about that. How weird it is, thinking *I'm going to die, I want to exist.*

---

I actually died twice!

R/S: *Twice? Came back twice?*

GEN: Some people wish I hadn't, I think! I've stopped dying. Next time, I reckon, will be the real one. Third time, I'm lucky...

R/S: *What happened?*

GEN: While I was dead, you mean? Nothing at all. I only remember once hearing a doctor say: He's already had it, there's no chance. Or something like that.

R/S: *Maybe you didn't have enough time to wander around...*

GEN: I don't think you do remember anything. Why should you? You're in a different state. Why should you remember a previous state? It's like assuming that everybody's *people*—it's the human trait to think that god is like a man, and that when you're dead you can still remember things and experience things the same as you do when you're alive. That's ridiculous! People think you can walk around and talk and pick things up and have a meal—I don't see why you should. I don't think we're conscious of anything after we die. That doesn't mean that things can't happen or that something doesn't go on. But I don't see why this piece of you should be in any way connected with the next piece.

R/S: *Do you get disturbed by that?*

GEN: No, I hope it's true. I think it'd be far worse if you could remember being alive. That would be horrible (laughs). I'd rather think that there's absolutely nothing at all.

The trouble is, that if there's absolutely nothing at all, certain things that I believe have happened and certain things that I've experienced—it's not possible to explain them in any way at all. So I think *something* goes on... but what it is, whether it's just that the brain is able to continue in some form—the energy of the brain can sometimes, in certain people, continue—I really don't know. I don't mind. Everything's a gamble anyway, you know. And maybe the Christians are right and we'll all get told off for being sinners, and we'll all be very upset that we didn't believe them at the time we were here. *I think it's unlikely...*

---

R/S: *Do you believe that contemporary art and industry could become a progressive form?*

GEN: ... I believe that individuals should always try and expand and develop themselves to the most potential, and so should the society and the technology and everything that people express themselves through, so obviously it should always be a progression. I hate nostalgia, you know, I really do. All forms of nostalgia. That is, in the sense of culture. I think individuals—

You obviously remember things from your own past, which is reasonable enough because all those things are things that you've learned from... So you're reminding yourself where you've come from. But that's different than applying it in a cultural way where people refuse to think about new solutions by copying old ones—like going back to rock'n'roll. Going back to realist painting because they can't think what to do after abstract painting. People who actually avoid decisions by going backwards—that's different. Which is what I think of nostalgia as: a means to avoid making decisions about how to keep moving.

Even individual nostalgia can be destructive if you start to live in the past and be obsessed with it. You know you should remember what's happened but not overemphasize it. It should always be seen as just the way that you got through, on the way to wherever you're going. It should all be aimed still at going forward somewhere, not going back. I think going forward almost anywhere is better than going back. Even going forward to the end of the world is better than going back!

---

R/S: ... *Why are you doing music?*

GEN: Well, one reason: it's a platform for propaganda. And it's also a way to apply our ideas to show that without any musical training or background, through applying our philosophy to music we made the music work as well; therefore, we're not just talking bullshit. The philosophy must have *something* in it or the records wouldn't have worked and we wouldn't have had an influence worldwide. Just even with something we're not skilled at doing...

---

THE LION IN A CAGE

We live in limbo and thirst for freedom. Freedom of all forms of movement. To escape from existence in a world focused on perpetuating self-doubt and self-limitation. A dance of life is a dance of death. A body its cage. Time and mortality its bars. Deviate and escape.

Vested interests of every kind want us lazy and atrophied. Every waking moment conspires to constrain our potential both physical and mental, yet we have no responsibility to anybody to exist on any plane.

Man's fall from grace is his fall from inner security. His defeat is his surrender to conditioned boundaries imposed by the strict regime of acceptability instead

of the natural honesty of his individual instinct that recognizes all things to be in a state of flux. Music can express this flux freely in a flexing of rhythm and sound. Music is ecstasy, mystery and power divined by those who see no separation between private and public in their attitude to all moments of daily life. The motive for a meal, music or making love become the same. To simply find and be yourself without guilt, without competition, without games.

We are trained to not even *want* to think. Decondition the condition. Conditioning is control. Control is stability. Stability is safety for those with a vested interest in control. Let's go out of control. What breaks this cycle is a psychic jolt. Music is magick, a religious phenomena that short circuits control through human response. The moment we forget ourselves and end the limbo-dance we enter a world of struggle, joy and clarity. A tragic but magickal world where it is possible to accept mortality and thereby deny death. Experience without dogma, anguish without shame or sham. A morality of anti-cult. Occult culture. Its rituals collective yet private, performed in public but invisible. White souls stripped bare to reveal bleeding yet hopeful sadness. The rites of youth. Our alchemical human heritage, encased like a cadaver in black suit.

To live is to either exist, or to struggle against imposed controls and fight for an individual destiny, vision and expression. Franz Kafka said:

"I do not hope for victory. I do not enjoy the struggle for its own sake, I could only enjoy it because it is all I can do. As such the struggle does indeed fill me with a joy which is more than I can really enjoy, more than I can give, and I shall probably end by succumbing not to the struggle but to the joy."

Genesis P-Orridge
London, December 1980

That's why I wrote the sleeve notes on the Clock DVA album [above] the way I did. To try and say, "It's time to start telling people abstract ideas." And it doesn't really matter what's *on* the record—it's just a good way to generate people, people's ideas...

Why write sleeve notes just about the music? Why not write about a way of life—to stimulate people's ideas and thoughts. And a lot of people say it did that, which is nice. I just wish there was more of that happening, generally.

...Like we were saying earlier, magick is a system of *applying the will*. And different people can apply it in different ways. Hitler applied it his way, we apply it our way. The intention is personal. It's like saying that anybody who has a gun is a murderer—that's not true. This is the trouble with people that write kind of half-hearted political things in the press—they think that anybody that talks about the will is a fascist. And

that's obvious bullshit. That's like saying everybody who has a car is a drunken driver—they're not. Most people that drive cars drive them for functional reasons, and occasionally you get somebody who's an idiot, or who's malicious. The same applies with... applying the will to making things happen.

And it just so happens that they always pick on Adolf Hitler because he's a very spectacular case. That's one person out of millions and millions and millions of people. And the true form of fascism is to think that everybody who tries to be an individual is fascist...

... Basically, he was probably very much like we are, but he chose the political arena. And when you choose the political arena and you're successful in

any degree, very weird things happen, because it's on such a scale that you can't control it any more. And suddenly—nobody knows—nobody knew—nobody was in control. There wasn't anybody strong enough to control what happened in there, because they were unleashing forces on a scale that nobody *can* control. That's why I'm interested in the individual and not in the mass. And precisely why I've been interested in the individual is anti-fascist, and I always think that the mass is what is fascist—*mass* movements and *mass* systems of thought.

But of course, the people who propagate them, who say they're socialists, don't want you to start thinking that way. So they choose the obvious target, which is the isolated individual, to dis-

tract you. But I think that Russian socialism, most forms of mass socialism or mass *anything*, are quite obviously bad systems, evil systems, and they're aimed at suppressing individual expression and satisfaction. The whole thing is deliberately reversed to camouflage the people who are the real enemies!.,. the people who want a drab "mass culture" with no expression. It's just a very, very old technique to pick on anyone who says they want to be an individual or develop themselves to their full potential.

I don't see why even power should be evil in itself—it obviously is not. Because it's energy which you can use to do things, you know, and some very religious people get power and energy and use it for very good things—so do doctors, so do scientists. But that's always conveniently forgotten, and all they ever do is say What about Charles Manson? What about Adolf Hitler? That's all they ever say—it's like a dirge, you know, it's like an incantation or something. And they do it because they're frightened of themselves. They're frightened of themselves because they don't know how to control themselves… because they haven't learned to apply their own discipline.

I think as long as you don't try and become a politician, you do minimal damage. In "politician," I include people like Jim Jones, too, who's a very recent example. Some people, once they see the power they can actually exercise, want to always test it, and check it, and never trust that it's true, and start to worry about losing it, 'cause they're always testing their followers more and more and more! And it inevitably must lead to either suicide or murder—that's the ultimate test! And that's what happened with Manson and Jim Jones and the Moonies and so on. All these different very, very sort of extreme groups. They test and test and test people, because they're based on a very insecure foundation. But the people at the top haven't developed their own self-discipline.

See now, individuality's about self-discipline and self-reliance and is therefore a far safer philosophy than anything else. Because an individual has no need or desire to go out and do damage to others.

R/S: *I want to go back to your (relationship) with Derek Jarman. Did you see the film first, before you did the music?*
GEN: Yes. Actually, that's not strictly true, 'cause I'd already made a cassette with Stan, hadn't I? And then we saw the film, and I played the cassette to the others and said, "What do you think of *this*—just as an idea?..." and it went quite well, and we worked from that idea.

R/S: *And it just coincided?*
GEN: Yes, just random chance. But then, Cosey and Sleazy and Chris and I reworked from just the sounds that were on the original cassette, with the video of the film to watch at the same time, to make it more exact. But we didn't want the music to be focused, to have any sort of obvious high point or any orchestral kind of flow. We wanted it to be very intangible, just like the film is. There aren't any moments that are more important in the film. So, the soundtrack in the sense of a *musical* sense is very unsatisfactory, I think, if you listen to it as a musical soundtrack. But we wanted it to be equivalent to the actual images, which was that you couldn't hold onto it, and think, "Ah, yes, this is the important moment, it's getting more exciting… it's now less exciting"—we didn't want to *direct* anybody. And that's actually quite hard to do, 'cause the whole thing with music is that it tends to have high points and low points and so on and be very emotional. So we had to try and destroy that usual function.

…What you do obviously contains *you*, or it should. That's why I can enjoy records by people that other people wouldn't expect me to, because I actually like the *people* who make them. And when I listen to them I remember the people who made them, and I believe in the people who made them, so I can enjoy the music even though it's something totally alien to my style. Knowing the people is really important.

I'm obsessed with the people who do the things and the way they *live*, you see, not what they actually produce. That's why I like to try and meet people whose work I like, and hopefully, it's really good if you meet them and you actually *still* like them. Then it's really good, because it's like double reinforcement, and everything they do is much more useful and important to you. Of course, there's always that gamble that you won't like them, and then you won't like their work anymore! I've been lucky—most times my instinct has been okay and I've actually liked the people who've done things that I liked. It's only occasionally that it doesn't work. Then it's interesting, 'cause you can think, "Well, that's interesting. Why? Why did I think it was so useful? Why is the person not how

I would have expected him to be in his life?"

R/S: *Derek Jarman has a concept of home movies… What do you think of your music being used in that kind of activity?*
GEN: That's what we've always said. On the first LP when we did it ourselves, it said on the back that we wanted to do things for films, and for other people as well… To go with other things, and for factories as well. We said we hoped that people would contact us and ask us to do things like that. And also, we called the records *reports*, which is to say that they are like home movies of *sound*. They were reports, they weren't like necessarily completely finished musical gems. They were exploring things, which is like home movies are…

R/S: *What did you think of the film Throbbing Gristle made with Derek?*
GEN: I liked it a lot… I was really pleased. [It was] a really unusual way to do a film with a group playing. It's like a painting…
R/S: *His films are like that, the more you see it, the more you see something new—*
GEN: And all those little people in the background. They're all tiny. They're all in hell. Dante's Inferno. I think it's a really, really good film, actually. Of course, *Time Out* didn't like it; they said it didn't mean anything… no story to it.
R/S: *I think Japanese media seem to be quicker to catch that kind of trend. A few years ago maybe, people insisted on stories, but now they say the story is finished…*
GEN: It's a whole new zen, isn't it? Which is a really good basic discipline, because it says there's no specific answer… and you have to fall back on yourself. You can change the answer—which is how life really is—that's what experience is actually like! The trouble with the western way is—it tries to impose a set of rules on something which has no rules. They think that life and work and daily living can be regimented with rules, and that there are laws to it like there are laws to mathematics. And it's obviously untrue—because everybody is totally illogical the way they live—they change day-to-day, they have moods, things happen completely by accident. You don't know today that you might not be hit by a car tomorrow. So how can you have a rule? It's a totally insane idea.

When it goes wrong, instead of thinking Oh well, having all these rules is a

mistake, they try and *reinforce* the rules, and make the rules even stronger, and impose them even harder... instead of accepting that it doesn't work, and that people just aren't like that. I mean, it's so obviously a stupid idea, and yet they can't understand it, and it's just the *biology* of people. There's no way it makes sense, and yet they keep on and on for hundreds of years trying to insist that we can be regimented like some...

Well, it's breaking down all the time, isn't it? But instead of them accepting that they've made a basic mistake at the beginning, they just keep trying to impose it harder and harder, saying we need more law and order, we need more discipline (in the bad sense—not the sense we mean—in the sense of making people do what we tell them). They organize; it's all into organized images. It's not an accident that the western culture has adminstration and bureaucracy, it more or less is *all* bureaucracy now. There's almost nobody actually working anymore—everybody's organizing!

...If you don't train people to solve problems (because they assume everything works according to the rules), then when they find the rules don't work, they have no ability to survive! Whereas if you train people to find solutions from an early age, then if things don't work out, they try and change what they're doing, and apply new ideas to make something work. Obviously a much more sensible approach! But then common sense is not in high esteem in our society, is it?

R/S: *What kind of common sense?*

GEN: Like I said—applying solutions to problems as they occur with what's available—that's what I think of as common sense. And not putting your hand in a fire. You apply that same analogy to ways of behaving. But they don't seem to do that in our society, they don't apply that kind of rule. They set up systems that are inevitably going to cause conflict, and also not going to actually work. But they still set them up!

COSEY: As long as they've got people fighting against each other, they won't fight against *them.*

GEN: We said that earlier—they have a vested interest in keeping people stupid and distracted.

COSEY: That's why they're quite happy with our punks and skinheads and—

GEN: They're quite happy to have a Brixton too! That's what they should have all done in Brixton—march to Parliament and then burn that! Or they should have marched to Buckingham Palace and climbed over the fence and smashed the windows. Some of them would have been shot but it would have been amazing. There would have been something done then! There's no way they'd sit back and do nothing then. (Gen sings Handel's *Hallelujah* chorus)

R/S: *What is your fetish?*

GEN: What is my fetish? It varies day-to-day.

R/S: *What's today's fetish?*

GEN: Today's fetish? I don't know, I've kind of become rather un-fetish-y at the moment. I think you only develop fetishes when you're feeling a bit dissatisfied... to give an extra edge to things. To give you a little extra adrenalin buzz when you're feeling a bit lethargic. If you're feeling basically reasonably stable and contented, you don't have any sort of

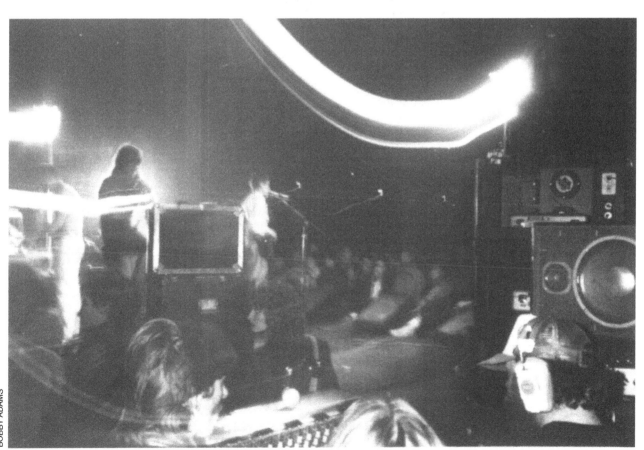

BOBBY ADAMS

TG in SF, Kezar Pavilion.

motivation to develop things...

I quite like bondage pictures—still really like them... I think that what happens with a true fetishist—a very obsessive fetishist—it grows from dissatisfaction. And that's why you can be a part-time fetishist.

COSEY: I think it grows also from some kind of failure somewhere along the line, as well.

GEN: Well, that's a sort of form of dissatisfaction!

COSEY: It's a need to have something that no one else has, only you have—

GEN: That's when it gets to a true fetish proportion. But most people nowadays—

I think it's healthy that most people are interested in exploring various aspects of sexuality... they don't feel as suppressed, they can explore things and find out what they enjoy or don't enjoy and express themselves much more freely.

R/S: *What's your current fetish?*

SLEAZY: Girls. (laughs)

GEN: He's *on the turn.*

SLEAZY: Tying people up. Boys, that is.

GEN: Your true fetish, though, is castration.

SLEAZY: That's not a fetish, because it's not connected to an object. That's an *obsession*... that's a bit different...

COSEY: Not really. Fetishes are also situations, sort of situation-fetishes—you have quite a few.

GEN: Persuasion—he likes.

SLEAZY: Getting people to do what they wouldn't have done otherwise. I think it's really good when you do something to somebody and they're excited by it, and they like it, but at the same [time] they're kind of—

R/S: *Pouting?*

GEN: It was *him* that suggested the title of "Persuasion." And it was Cosey that suggested the title of "Discipline"... When we're really stuck I say to them, "What do you want me to sing about tonight?" and then they'll give me a title... And "Discipline" was originally spontaneous.

COSEY: It *was*, because we're basically into what we're talking about at the time!

GEN: It's nice, because the twelve-inch single of "Discipline" (the version in Berlin) is actually when it was invented. It's actually us writing the song on the spot from the word, just before we went on. She said, "Discipline" and we did it. Just made it up. And I liked the fact that there are actually records of us inventing something; you are actually there when it was actually happening. It's a nice feeling when that happens, 'cause *you're* just as surprised when it all jells and comes together and *seems* like a completely finished thing immediately... It's like being a medium where something just comes through, and you're not blocking anything. It's like almost watching from *outside* this thing happening.

R/S: *Do you feel you come from somewhere else?*

GEN: You mean another planet or something? Sometimes.

R/S: *Where?*

GEN: Oh, I don't know. I think most people do. The more I've met people, the more I've found that's true. I used to call it "the alien brain," or that I came from an alien brain. We even used to do shows called "The Alien Brain." A lot of people I've talked to have said they felt like that. And I used to walk along and I actually could feel like I was a little alien person inside my skull looking through these two holes. It wasn't my body at all, I was just pretending that this was me, and I was actually somebody *occupying* that body. I think it must be a very common feeling. I think most people who feel it suppress it because it frightens them, or they stop feeling like that when they're quite young. But the people I know, like Derek... most of the creative people I know in whatever way, that's one of the symptoms of being more creative is that you don't lose that feeling! And a lot of people seem to go through a thing of feeling that They're not my real parents—that they're adopted or something, and they weren't at all. I don't know why that happens. At least once, they get a really strong feeling that it's not their real parents and nobody's told them. I used to enjoy that feeling. I liked it. I suppose it's the desire people have, a subconscious desire at least, to feel unique or special, 'cause it makes life more bearable to feel special. And so, maybe it grows from that; maybe it's just a trick in the subconscious to make you feel better or more worthwhile. But if it is, that's fine!

R/S: *Then you can think maybe you'll go somewhere else.*

GEN: Oh, that doesn't worry me, really doesn't—I'm not bothered either way. I certainly don't think that worrying about what might happen after you're dead is a very good reason to do things. And I don't like the idea that people are only good because they're scared of what happens after they're dead!

I think you should be good because you want to be good. And if you can do everything you do assuming that there's nothing after death, I think that makes it far stronger. If you're not expecting a sort of payoff later, if you're not doing it because you feel blackmailed or terrified. You're doing it because it's a genuine desire to *do* something, good *or* bad. It's far more healthy!

**"Information exchange is the *only* way to ever get real change ..."**

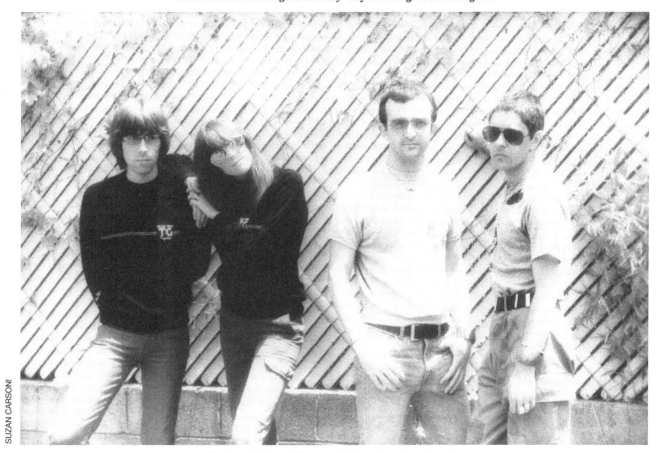

SUZAN CARSON!

**Chris and Cosey, Sleazy and Genesis in Los Angeles.**

# COMPLETE DISCOGRAPHY OF THROBBING GRISTLE

(Records where possible are in order of their release. Coum records have been released with different labels, covers etc. All known variants are listed.)

(up to 1st August 1981)

## On INDUSTRIAL RECORDS:

**(IR 0002)**—*Second Annual Report* LP by Throbbing Gristle. There are only 785 copies of this first pressing. Center labels are white with Death Factory Industrial Logo. Covers were plain white with small self-adhesive sticker in top right hand corner on front; large sticker with sleeve notes was stuck in center on back. Enclosed was a small black and white sticker saying "Nothing Short Of A Total War," a red and black TG lightning flash sticker and a xerox strip warning about technical shortcomings of this pressing.

**(IR 0003)**—"Untied"/"Zyklon B Zombie" 45 by TG. Original pressing by Industrial Records had cream center labels with very blurred Death Factory logo and picture sleeve. After approximately 20,000 sales re-pressing was taken over by Rough Trade and the single was re-cut with messages scratched in the center: "Salon Kitty" on the "ZBZ" side and "437 666 OTO" "RE-CUT 4 NOV 79" and "20,000 DOWN" scratched in the "United" side. The center section of "ZBZ" with Cosey's guitar was cut extra loud also as an improvement upon the original version. This version still had the cream/white labels with blurred Death Factory logo. Some were sold without picture sleeves though not many. January 1980, Industrial Records re-released "United" with a new version of "Zyklon B Zombie" (one minute longer with train noises, rain and burning flesh) with black center labels and white and abstracted Death Factory logo. There were 1,000 copies only in white vinyl with messages scratched in the center: on the "United" side "Memorial Issue"; on the "ZBZ" side "The End Of The Line." A further 1,000 copies of this version were pressed exactly the same as the white vinyl version mentioned above except they were pressed in crystal clear vinyl.

**(IR 0004)**—*D.o.A. The Third And Final Report* of TG LP. Full color sleeve of young girl listening to record player. First 1,000 copies contained the following enclosures: One large card calendar with full color photo of small girl on bed; one black and white postcard of Cosey's niece Debbie, who is heard talking on track 2, side 2, "Hometime." Center labels were black and white printing. No messages scratched in first pressing. A second re-cut version was pressed later. Although the material was the same it was cut so that it looks as though there are 8 tracks of equal length on each side. None of the spirals between tracks actually coincide with the end of a track. It has "Still Alive" scratched into the center of side one. There are only 1,000 copies with the Structuralist Spirals.

**(IR 0008)**—*Twenty Jazz Funk Greats* by TG LP.

Full color cover of TG on Beachy Head cliffs. Center labels are lilac/pink with white printing. First 2,000 included enclosure of black and white poster of the group outside KFJC radio station in San Jose, California. Photo by Clay Holden. 5,000 only copies of this version existed. This LP was re-cut on 11/30/79 and a message "Ah Pook Was Here" scratched in the center on side 2.

**(IR 0009)**—*Heathen Earth* by TG LP. The first 785 copies only were pressed in see-through blue vinyl as a reminder of the original pressing of *Second Annual Report*. Center labels on all copies were blue. All other copies of this LP were black vinyl. No messages scratched in. Printing on center labels was white. A silhouette of dog's teeth was added to the center labels as well as the usual Death Factory logo. Cover was brown and cream gatefold with four individual portrait photos of group members printed in blue inside.

**(IR 0013)**—"Subhuman"/"Something Came Over Me" 45 by TG. Center labels of TG lightning flash logo with white central stripe and red flash. No Death Factory logo. Message "White Stains" scratched into B side. Picture sleeve in black and white. Sold in camouflage-printed plastic bag.

**(IR 0015)**—"Adrenalin"/"Distant Dreams (Part Two)" 45 by TG. Center labels of TG lightning flash logo with black central stripe and red flash. Messages "Second Attempt" and "Trident Rool" on A side in center. Black and white picture sleeve. Sold in camouflage-printed plastic bag.

## On FETISH RECORDS:

**FET 2001**—*Second Annual Report* by TG LP. After the first 785 copies on Industrial Records were sold, this LP was given to Fetish Records to officially continue to press it and guarantee its

availability. The first 2,000 copies had a square black, white and red TG lightning bolt logo on front cover but with mat finish. The notes on the back of the cover had the *wrong* track titles for side one and spelled "COOM" instead of COUM Transmissions. Center label was a large TG flash logo in black, red and white on side one and white label with similarly wrong track listings on side 2. The 2,000 copies were pressed off exactly the same plates as the original 785 copies on Industrial. These plates were then destroyed. Enclosures were a questionnaire and an A4 size collage including the original sleeve notes. No messages. This LP was re-cut in March 1979 from the master tapes. It was re-pressed by Fetish Records with a high gloss finish sleeve. The LP title *Second Annual Report* was added to the back sleeve and track titles on the back sleeve were corrected. Center labels were *not* corrected, but remained the same as before. Message "Assume Power Focus" was scratched into center of side 2. In June 1981 this LP was re-cut again. This time the entire LP was re-cut with the music playing backwards and a chamber music ensemble was mixed into side 2 throughout. The center labels were finally corrected and both sides were modernist versions of the TG flash logo with small lightning bolt in black, red and white. Messages on side one were scratched in: "Trained Condition Of Obedience" and "Thanks Paul Morley." On side 2: "Who is Dave Farmer-Nanavesh." Enclosure was a large sticker replica of the original sleeve notes. Only 2,000 copies of this backwards *Second Annual Report* were issued in the gloss TG logo covers as before. All subsequent pressings of this backwards version were in the black and white gloss sleeve with a photo fo the logo cover reduced in size with a black border.

**(FET 006)**—"Discipline" 45 12" by TG. Center labels cream with black printing. Glossy picture sleeve of TG group stood outside ex-Nazi Ministry of Propaganda in Berlin on front with Val Denham holding Hitler youth dagger center back. Message "Techno Primitive" scratched on side A and "Psykick Youth Squad" on side B. No enclosures. Grey, cream black cover.

## On FETISH RECORDS: A Boxed Set

**(FET 2001)**—*Second Annual Report* LP by TG. Red, black and white center labels. All mastertape re-cut with music backwards and chamber music mixed throughout side 2. Messages "Thanks Paul Morley" and "Trained Condition Of Obedience" scratched into center of side one and "Who Is Dave Farmer-Nanavesh?" scratched into side 2. Reduced black and white photo of TG logo cover with black border on front of sleeve.

(FET 2004)—*D.o.A. The Third and Final Report* of TG LP. Blue, white and black center labels of TG flash logo. Message "Like Some People and Babies" scratched into center side one. Black and white photo of original front cover with new inset reduced on front of sleeve with black border. Track titles on back.

(FET 2005)—*Twenty Jazz Funk Greats* by TG LP. Center labels pink, black and white TG flash logo. Message "Into Funk First" scratched center side one. Cover reduced black and white photo of original front sleeve photo with mystery additional figure in grass. Black and white back sleeve. Black border round photo on the front.

(FET 2006)—*Heathen Earth* LP by TG. Center labels TG flash logo in cream, black and white. Message "Dedicated to Brion Gysin" on side one and "Music for Dream Machines" [sic] on side 2 scratched in. Cover *not* gatefold. Black and white photo of original front reduced with black border. Back is of 4 photos of TG, originally inside.

(FET 2007)—*Mission Of Dead Souls* live LP by TG. Taken from last ever TG disconcert in Kezar Pavilion in San Francisco 5/29/81. Center labels TG flash logo green, black and white. Cover photo of fog in San Francisco with black border. Message "A State Of Third Mind" scratched center side one, and "Give Rod A Nod" scratched into side 2.

All the above five albums come in a limited edition of 5,000 only sets in a strong cardbox with historical archive booklet on TG with photographs and text. Available from October 1981 until they run out. (The catalog number of the boxed set will be FUX 001.)

## PASS RECORDS (Tokyo, Japan)

(PAS 1001)—*Twenty Jazz Funk Greats* by TG LP. Licensed from Industrial Records. Same sleeve but mat finish. Paper strip with Japanese text wrapped around cover. Enclosure of poster. One side with Japanese text about TG, collages and lyrics in Japanese. Other side with Clay Holden's photo of TG plus additional text about TG and this LP by G. P-Orridge. (This text in English.)

N.B. PASS RECORDS intend to issue *Second Annual Report* with a new front cover and updated sleeve notes in 9/81. They also intend to release a compilation album of tracks off all Industrial Records singles by all artists to be called *The Industrial Records Story*. It remains to be seen if these do materialize.

## SORDIDE SENTIMENTAL (Rouen, France)

(SS 45001)—"We Hate You (Little Girls)"/"Five Knuckle Shuffle" 45 by TG. Limited edition of 1,560 copies only. Came in double gatefold A4 size sleeve. Enclosures: text by Jean Pierre Turmel, collages by G. P-Orridge. Cover artworks by Yves Surlemont and Lou Lou Picasso. Yellow center labels with black print; cover yellow, blue, black and white. "Five Knuckle Shuffle" is Yorkshire slang for masturbating.

## ADOLESCENT RECORDS (San Francisco, USA)

(ARTT010)—"We Hate You (Little Girls)"/"Five Knuckle Shuffle" 45 by TG. Exactly same versions as released on Sordide Sentimental. Normal single bag with picture sleeve. Design by Stan Bingo of Mortuary Safes.

## NICE RECORDS (Bologna, Italy)

(Not known)—"You Don't Know"/"Damaru Sunrise" 45 by TG. Taken from live concert at Sheffield University, 1980. Available with Red Ronnie's fanzine and free in special TG retrospective issue of same. Possibly available through Italian Records of Bologna.

## ITALIAN RECORDS (Bologna, Italy)

(Not known)—*Twenty Jazz Funk Greats* LP by TG with same master tape, same cover design released August, 1981. No more details known.

(Not known)—*D.o.A. The Third And Final Report* by TG LP. Exactly same tape and packaging as the original.

## ROUGH TRADE (U.S. Inc.)

(ROUGH US 23)—*Throbbing Gristle's Greatest Hits* by TG LP. Subtitled *Entertainment Through Pain*. Center labels: color photos of left shoe and right shoe. Includes, treated with extra reverb and echo, versions of "Hamburger Lady," "Hot On The Heels of Love," "United," "Six Six Sixties," "Blood On The Floor," "Twenty Jazz Funk Greats," "AB/7A," "Subhuman," "Adrenalin" and a backwards version of "Slug Bait" called "Tiab Guls." Also, a mystery voice/message at the end of the side Right Shoe. Front cover photo a full color kitsch parody of Martin Denny sleeve Hawaiian-style, back cover kitsch photo of TG with extensive present-time hallucinogenic liner notes by Claude Bessy. Budget price.

## ZENSOR RECORDS (Berlin, West Germany)

(Not known)—*Funeral In Berlin* by TG LP. Recorded digitally live in SO 36 Club in Berlin, 11/7-8/80. All previously unreleased material.

## Miscellaneous Curios

(Sink 1)—*Starting Swimming* live compilation LP on STIFF USA. Second track side one "In The Congo" by the Bongos features Cosey Fanni Tutti, Chris Carter and Genesis P-Orridge of TG. Released July, 1981.

(DLP 03)—*Vibing Up The Senile Man* by Alternative TV LP. Features percussion by Genesis P-Orridge on three tracks ("Release The Natives," "Serpentine Gallery" and "Graves of Deluxe Green"). Released on Deptford Fun City Records early 1979.

(CLP 01—*Alternative TV Live at The Rat Club* live LP. Recorded and produced on Sony cassette by Genesis P-Orridge. Features the voices talking in background of members of TG and Monte Cazazza. Released on Crystal Records 1979.

(A RED 2)—*Business Unusual* compilation LP. Features "United" by TG. Released on Cherry Red Records 1978.

(IR 0005)—"To Mom On Mother's Day"/"Candyman" 45 by Monte Cazazza. Features all musical backings by TG.

(IR 0010)—"Something For Nobody" by Monte Cazazza 45 EP. Features contributions by Cosey Fanni Tutti of TG.

## BOOTLEGS (as far as known)

(Not known)—*Music From The Death Factory: Throbbing Gristle Live.* Limited edition bootleg from West Germany. Cut direct from live cassette (IRC 20) recorded at the Factory in Manchester, England. Cover (front) black and white with green electronic zig zag lines. Back cover railway siding at Auschwitz/Birkenau concentration camp top half with typeset track listings below. Center labels like front cover: black with green zig zag line, TG corporate logo. Includes *all* material on the original cassette. Released on DEATH RECORDS. Excellent production, extremely rare (possibly only 50 copies). Probably released in 1980-81. This bootleg is recommended and is sanctioned in retrospect by TG themselves. Wish more copies were around. Buy if you can.

(LTM 1022)—*Second Annual Report* by TG. Released by CELLULOID RECORDS in France. Without permission or payment. This is a *pirate* record. Cover: white copy of *original IR* version of this LP but on back has Celluloid logo and address. Very bad quality. TG do *not* sanction this record and ask people to *not* buy it. Destroy all copies everywhere!

(LTM 1036)—*D.o.A Third And Final Report of TG.* Released by CELLULOID RECORDS in France. This is a *pirate* record and was not sanctioned by TG, who received no payment. Cover is an exact copy of original. Distinguished by Celluloid logo on back sleeve. Center labels of both are also different to IR and Fetish. Destroy all copies, do *not* buy!

NOTE: TG have a very loose attitude to bootlegs. If someone produces a *new* record that did not previously exist, like the *Death Records* LP, or of a live tape they made themselves, etc., we normally don't mind, as long as at least 5 copies are sent to us keep as souvenirs of our work and music. We *do* object to real companies or entrepreneurs (like Celluloid) making exact copies of records we have released ourselves and then selling them all over the world, saying they are officially sanctioned and legitimate. This just makes unscrupulous crooks richer and they do nothing worthwhile with money literally stolen from us and cheated from our supporters. These people are sick and should be destroyed... So genuine enthusiasts who want to use their initiative to make more TG material available on record normally receive a sympathetic and helpful response from us. Pirate crooks who live for money and cheat those few groups who try and to be open and trusting, as Celluloid have done, they receive only our disgust, hate and one day our revenge. They will perish living miserable unhappy lives through their attempts to corrupt an idea they can't understand. TG need do nothing but wait.

Throbbing Gristle Video Cassettes

(IRVC 1)—Heathen Earth
(IRVC 2)—Live at Oundle School

████████████████

TG Cassettes

TG "24 Hours" boxed set of cassettes. Twenty-four of TG's most recent performances plus two C90 cassettes taken from a TG radio interview. Presented in small attache case, complete with personalized handmade collage and various autographed pictures.

(IRC 1)—TG "Best Of... Volume II" C60 Mono inc. "Very Friendly," "Scars of E," "Slugbait," "We Hate You," "Dead Ed."

(IRC 2)—TG live at ICA London 10/18/76 C60 Stereo inc. "Very Friendly," "We Hate You," "Slugbait," "Dead Ed," "Zyklon B Zombie."

(IRC 3)—TG live at Air Gallery, Winchester 7/6/76-8/21/76 C60 Stereo inc. "Dead Ed," "Very Friendly."

(IRC 4)—TG live at Nags Head, High Wycombe 2/11/77 C60 Stereo inc. "We Hate You," "Slugbait," "Zyklon B Zombie." (40 mins)

(IRC 5)—TG live at Brighton Polytechnic 3/26/77 C60 Stereo inc. "Zyklon B Zombie," "Last Exit," "Maggot Life," "Mary Jane," "Record Contract," "One Note One Life One Purpose." (45 mins)

(IRC 6)—TG live at Nuffield Theatre, Southampton 5/7/77 C60 Stereo inc. "Industrial Introduction," "National Affront."

(IRC 7)—TG live at Rat Club, London, 5/22/77 C60 Stereo inc. "Tesco Disco," "Fuck Off Cunt," "One pound thirty pence Wolverhampton," "Goldilocks and the Three Fingers."

(IRC 8)—TG live at Highbury Roundhouse, London 9/29/77 C60 Binaural Stereo inc. "Hit by a Rock," "Blood on the Floor," "You Here Me Here."

(IRC 9)—TG live at Art School, Winchester 11/11/77 C60 Binaural Stereo inc. "Dead Head," plus mainly instrumental.

(IRC 10)—TG live at Rat Club in The Valentino Rooms, London 12/17/77 C60 Binaural Stereo inc. "White Christmas," "Tesco Disco," "Knife in My Side," "Urge to Kill," "Assume Power Focus," "Wall of Sound."

(IRC 11)—TG live at Brighton Polytechnic 2/25/78 C60 binaural inc. "E-Coli," "Anthony," "Why does Carol eat Brown Bread?" He's My Friend." Wall of Sound."

(IRC 12)—TG live at Architectural Association, London 3/3/78 C60 Binaural Stereo inc. "Dead Ed," "Wall of Sound," plus mainly instrumental.

(IRC 13)—TG live at Goldsmiths College, London 5/18/78 C60 Stereo inc. "IBM," "It's always the Way," "Hamburger Lady" (first version), "Dead on Arrival" (first version), "Wall of Sound."

(IRC 14)—TG live at Industrial Training College, Wakefield 7/1/18 C60 Stereo inc. "IBM," "Family Death," "Cabaret Voltaire," "Industrial Muzak," "Hamburger Lady," "Slugbait," "Mother Spunk," "Five Knuckle Shuffle," "Whorle of Sound."

(IRC 15)—TG live at London Film Makers Co-Op 7/6/78 C60 Stereo inc. "IBM," new After Cease to Exist soundtrack, "Hamburger Lady,"

"Mother Spunk," "Five Knuckle Shuffle."

(IRC 16)—TG live at The Crypt, London 11/11/78 C60 Stereo inc. "Whistling Song," "Tesco Disco," "E-Coli," "High Note."

(IRC 17)—TG live at Centro Iberico, London 1/21/79 C60 Stereo inc. "Persuasion," "Day Song," "Five Knuckle Shuffle," "Wall of Sound."

(IRC 18)—TG live at Ajanta Cinema, Derby 4/12/79 C60 Stereo inc. "Weapon Training," "Eee Ahh Oooh," "Convincing People," "Chat Up," "Hamburger Lady," "Day Song," "Persuasion," "Five Knuckle Shuffle."

(IRC 19)—TG live at Now Society, Sheffield University 4/25/79 C60 Stereo inc. "Weapon Training," "Convincing People," "Hamburger Lady," "Chat Up," "Day Song," "Persuasion," "Five Knuckle Shuffle."

(IRC 20)—TG live at The Factory, Manchester 5/18/79 C60 Stereo inc. "Weapon Training," "See You Are," "Convincing People," "Hamburger Lady," "His Arm was Her leg," "What a Day," "Persuasion," "Five Knuckle Shuffle."

(IRC 21) TG live at Guild Hall, Northampton 5/26/79 C60 Binaural Stereo inc. "Wall of Sound," "No Bones," "Ice Cool Down," "They Make No Say," "Hamburger Lady," "Day Song," "Saw Mill."

(IRC 22)—TG live at YMCA, London 8/3/79 C60 Binaural Stereo inc. "Convincing People," "Hamburger Lady," "Still Walking" (first version), "Persuasion," "Day Song," "Five Knuckles Shuffle," "Wall of Sound."

(IRC 23)—TG in the studio. "Pastimes"/"Industrial Muzak" C60 Mono/Stereo inc. Previously unreleased studio recordings. A side mono. B side stereo.

(IRC 24)—TG live at Butlers Wharf, London 12/23/79 C60 binaural Stereo inc. "Gloria Leonard," Six Six Sixties," An Old Man Smiled," "Anal Sex," "Chariot and Galley."

(IRC 25)—TG live at Leeds Fan Club 2/24/80 C60 Binaural Stereo inc. "Six Six Sixties," "Subhuman," "The World is a War Film," "Something Came Over Me," "Don't Do What You're Told Do What You Think."

(IRC 26)—TG live at Scala Cinema, London 2/29/80 C60 Binaural inc. "An Old Man Smiled," "Subhuman," The World is a War Film," "Something Came Over Me," "Don't Do What You're Told Do What You Think."

(IRC 27)—The Leather Nun at Scala Cinema, London/Music Palais Kungsgatan 2/24/80 Binaural Stereo 11/30/79 Mono C60 inc. "Prime Mover," "No Rule," "I'm Alive," "Here Comes Life," "Ensam I Natt," "Varfor Svek Du," "Search and Destroy," "Slow Death."

(IRC 28)—Monte Cazazza live at Leeds Fan Club/ Scala, London/Oundle School 2/24/80-2/29/80-3/16/80. All Binaural Stereo C60 inc. "First Last," "Distress," "Kick That Habit Man," "To Mom On Mothers Day," "Mary Bell," "Sperm Song," plus some instrumentals.

(IRC 29)—Live at Goldsmiths College, London 3/13/80 C60 inc. "An Old Man Smiled," "Russ," "Subhuman," "Heathen Earth," "World is a War Film," "Don't Do What You're Told Do What You Think." A side binaural stereo, B side stereo.

(IRC 30)—TG live at Oundle Public School 3/16/80 C60 Binaural inc. "An Old Man Smiled," "Subhuman," "Heathen Earth," "Something Came Over Me," "The World is a War Film," "Don't Do

What You're Told Do What You Think," "Wall of Sound," Also available on video cassette.

(IRC 31)—Clock DVA White Souls in Black Suits C60 Stereo. A side: "Consent," "Discontentment," "Still/Silent," "Non." B side: "Relentless," "Contradict," (film soundtrack keyboards assemble themselves at dawn) "Anti-Chance." Previously unreleased material. Mail order version includes booklet.

(IRC 32)—Chris Carter The Space Between C90 Stereo. A/B sides mainly instrumental. No track titles at present, recordings from 1978-80, some in binaural stereo. Previously unreleased material. Includes leaflet.

(IRC 33)—TG live at Sheffield University 6/10/80 C60 binaural stereo inc. "Heathen Earth," "Strangers in the Night," "We Said No," "Flesh Eaters."

(IRC 34)—Richard H. Kirk (of Cabaret Voltaire) Disposable Half-Truths. A side: "Synesthesia," "Outburst," "Information Therapy," "Magic Words Command," "Thermal Damage." B side: "Plate Glass Replicas," "Insect Friends of Allah," "Scatalist," "False Erotic Love," "L.D.50," "L.D.60," "Amnesic Disassociation." Stereo C60. Mail order version includes booklet.

(IRC 35)—Cabaret Voltaire 1974-1976 C60 Stereo. A side: "The Dada Man," "Ooraseal," "A Sunday Night in Biot," "In Quest of the Unusual, "Do the Snake," "Fade Crisis." B side: "Doubled Delivery," "Venusian Animals," "The Outer Limits," "She Loved You."

████████████████

TG Chronology

*TG founded September 3rd 1975*
Air Gallery, London July 6th 1976
ICA Gallery, London October 18th 1976
Hat Fair, Winchester August 21st 1976
Nags Head, High Wycombe February 11th 1977
Polytechnic, Brighton March 26th 1977
Nuffield Theatre, Southampton May 7th 1977
Rat Club, London May 22nd 1977
Highbury Roundhouse, London September 29th 1977
Art College, Winchester November 11th 1977
Rat Club, London December 17th 1977
Polytechnic, Brighton February 28th 1978
Architectural Association, London March 3rd, 1978
Goldsmiths College ATC, London May 18th 1978
Industrial Training College, Wakefield July 1st 1978
Film Co-Op London July 6th 1978
Crypt, London November 11th 1978
Centro Iberico, London January 21st 1978
Ajanta Cinema, Derby April 12th 1979
Nowsoc, Sheffield April 25 1979
Factory, Manchester May 19th 1979
Guildhall, Northampton May 26th 1979
YMCA, London August 3rd 1979
Butler's Wharf, London December 23rd 1979
Leeds Fan Club, Leeds, Yorkshire February 24th 1980
Scala Cinema, London February 29th 1980
Goldsmiths College, London March 13th 1980
Oundle School, Peterborough March 16th 1980
Sheffield University, Yorkshire June 10th 1980
So 36 Club, Berlin November 7th 1980
So 36 Club, Berlin November 8th 1980

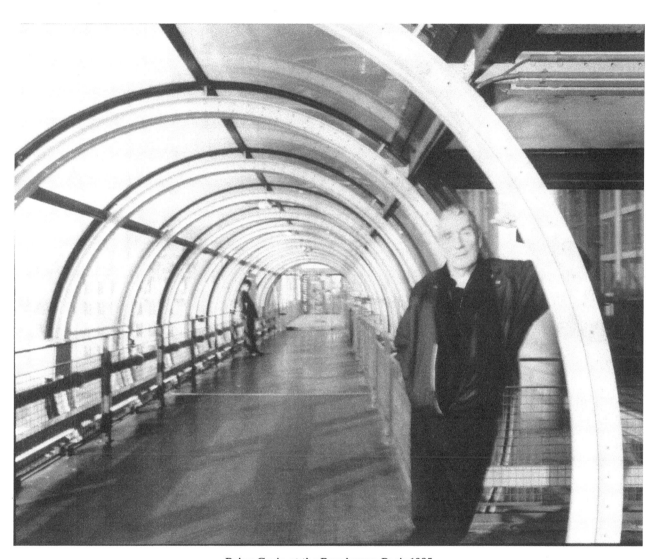

BOBBY ADAMS

**Brion Gysin at the Beaubourg, Paris 1985.**

Kunsthofschule, Frankfurt November 10th 1980
Heaven, London December 23rd 1980
Lyceum, London February 8th 1981
Vets Auditorium, Los Angeles May 22nd 1981
Kezar Pavilion, San Francisco May 29th 1981

*TG terminated June 23rd 1981*

ANTONY BALCH

**William Burroughs, rue Git le Coeur.**

Printed in the USA
CPSIA information can be obtained
at www.ICGtesting.com
JSHW061422170924
69940JS00001B/1